MARK KISTLER'S
IMAGINATION STATION...

DRAWING IN 3-D IS COOL!

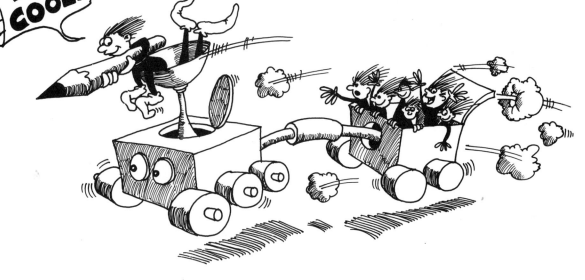

A FIRESIDE BOOK
Published by Simon & Schuster

NEW YORK LONDON TORONTO SYDNEY TOKYO SINGAPORE

FIRESIDE
Rockefeller Center
1230 Avenue of the Americas
New York, New York 10020

Copyright© 1994 by Mark Kistler

FIRESIDE and colophon are registered trademarks
of Simon & Schuster Inc.

Designed by Stanley Drate and
Ellen Gleeson/Folio Graphics, Inc.

Manufactured in the United States of America

10 9 8 7 6 5

Library of Congress Cataloging-in-Publication Data is available.

ISBN: 0-671-50013-9

To my friend and sailing mate Clem Bushman,
the man with the perpetual grin.
May the wind always fill your jib.

Special Thanks

Deborah T.	Administrative Support
Mike Krahulik	Panel Inking and Coloring
Shelley Harshe	Fax Operations, Research Support
Dawn Klose	Administrative Support
Madrona Wilcox	Student Inking, Duplication Support
Debbie McAngus	Panel Inking, Summer School Coordination
Patrick Catalano	Legal Services
Ken Willis	Computer Programming Support
Carol Mann Agency	Literary Agent
Dave Dunton	Publishing Editor
John Paul Jones	Production Editor
Stanley Drate	Designer
Ellen Gleeson	Designer

Enthusiasm Maintenance Team (My Cool Family!): Helen and Ralph Harner, Joyce Kistler, Harry Schurch, Helen Kistler, Bonnie, Mari, Stephen, Tina, Ian, Karl, Melissa, Debbi, Andrea, Clark, Ellen, Carly, Candy, Greg, Maggie, Eric, Brendan, Tim, Quirt, Tammy, Devon, Ariel, Greg R., John and the Dock M crew, Todd, Donna, Robert and Louis, Molly, Sarah, Denise, Jason, Shawn, Meagan, Gino, Bridget, Jenny, Sara, Kristy, Tammy P., Leitha, Clinton, James and Linda C., Beth, Craig, and you!

More Thanks

Bill	F.B.I. Printing
Eric	The Mailing House
John	J.M. Television
Scott	Rilleysimmons, Inc.
Crew	Kinko's Copy Center
Mike	Federal Express
Crew	Carlsbad Post Offices
Linda	B&L Typesetting
Richard	R.B. Silkscreens
Dinah	I.P.S. Programming Services

Corporate Public Television Support Thanks:

Aaron Brothers Art Mart (For all the great art supplies, equipment, tables, art chairs, and set pieces for my Public Television series).

Theme music for the Public Television series *Imagination Station*—Red Grammer.

THIS RADICAL BOOK BELONGS

TO: _Isaal Fairbank_

Who also just happens to be (*check off boxes that apply*) . . .

- ☑ A super-*cool* person!
- ☑ A *total* genius!
- ☑ A *great* reader!
- ☑ A *brilliant* artist!
- ☐ A *wonderful* humanoid!
- ☑ A *unique* individual!
- ☑ A drawing animal!
- ☑ A computer whiz kid!
- ☑ A library dweller!
- ☐ (*Fill in your own*) _____
- ☐ _____
- ☐ _____
- ☐ _____
- ☐ _____

What's Where

Hi! Hey! Ho!

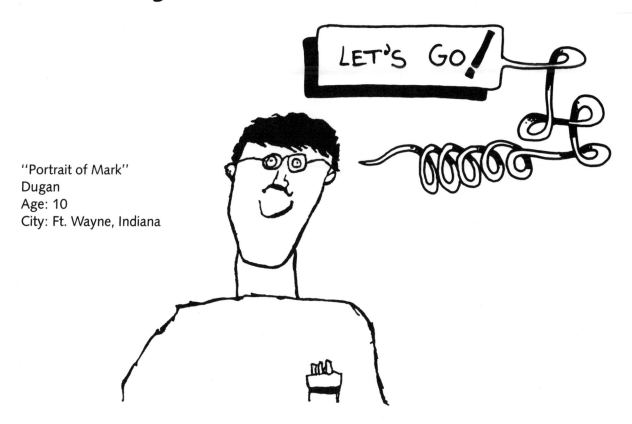

"Portrait of Mark"
Dugan
Age: 10
City: Ft. Wayne, Indiana

The best way for us to start our 3-D drawing adventure is for me to introduce myself. Hi! My name is Mark. I'm going to be your drawing teacher over the next thirty-six awesome imagination-soaring art adventures. The picture of me above was sketched by Dugan, one of my cool drawing students from Fort Wayne, Indiana. He gave me this nifty portrait after I visited his school with my drawing assembly. Nice picture, eh? I think he made me look very intellectual! Just think of me as the navigator aboard your Pencil-Power Imagination Rocket to creative success!

"Imagination Rocket"
Rafael
Age: 11
City: Houston, Texas

If I look familiar, you probably recognize me from my role as Commander Mark in public television's children learn to draw series *The Secret City.* Or as Captain Mark from the television series and book *Mark Kistler's Draw Squad!* My new public television series, *Mark Kistler's Imagination Station,* should be airing in your city. Check your television guide.

Over the last fifteen years I've had a blast teaching geniuses like you how to draw in 3-D! It still amazes me that over thirty million children in seventeen countries have learned how to draw with me! How totally cool! That's a whole lot of imagination power!

F.B.I. Warning!

Before we go any further, I'm required by the F.B.I. to print the following warning . . .

Federal Bureau of Imagination Warning

"Mug Shots"
Jane S.
Age: 9
City: Columbus, Ohio

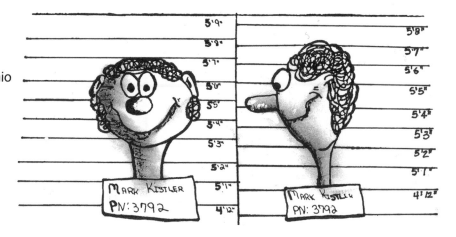

Alert: It has been determined by the Imagination Patrol at F.B.I. headquarters that *Mark Kistler's Imagination Station* motivates children to draw nine hours every day. Due to this increase in creative-thinking time, excessive television viewing has dropped significantly.

Caution: Before starting any drawing adventure with Mark Kistler, be sure to have plenty of sharp pencils and paper available to avoid loud, obnoxious art attacks.

"Imagination Launch"
Jon H.
Age: 40+
City: Indianapolis, Indiana

Now, are you ready to take off? Let's start with a few quick warm-up sketches to see how you are drawing *now*—as compared to how you'll be drawing at the end of the book. Take a few minutes to sketch the objects below. When you're finished, turn the page and sign the "Less Television, More Drawing" Legally Binding Contract!

WARM-UP SKETCHES

① Draw a dinosaur.

② Draw a dolphin.

③ Draw a rocket.

④ Draw your brother or sister or friend with a wild hairstyle.

TAKE YOUR TIME AND DRAW THE OBJECTS IN THE BOXES ABOVE. USE THIS PAGE AS A COMPARISON TO MONITOR YOUR RAPID PROGRESS!

The "Less Television, More Drawing" Legally Binding Contract

"No to TV, Yes to Drawing!"
C. Ross
Age: 8
City: Los Angeles, California

Be a "Ninja POWER Artist"!

I am so tired of all the ridiculous, violent, crazy stuff that is scheduled on television for you geniuses to watch. I'm even more tired of all the ridiculous, violent, crazy video games that companies churn out for you kids to buy. In fact I'm really *mad* about it! I used to love playing video games in airport terminals during my teaching travels. I would always carry extra quarters in my pocket, just in case I had to wait for a plane. (I usually spend one day a week in airports. Yawn!) I refuse to put my quarters in ridiculous, violent, crazy video games, so now I'm totally out of luck. I can't find any fun, cool, creative video games at any airports or video arcade stores. They are all violent and crazy! Major bummer, dudes!

So, here's the plan, Stan. Here's the game, Jane. Read the contract below and sign it! Instead of watching the average five hours of television most kids in the world watch every day, draw instead!

The scary thing is, if you add up all those 5-hour television days, it would equal 35 hours a week, 140 hours a month—or 1,680 hours a year! That's 29,960 hours before you reach the age of eighteen!

Uuuuuuuuugh. That means that if you don't cut back on your television time now, you will spend nearly three years staring at that ridiculous, violent, crazy stuff before you turn eighteen! Just think of how many masterpieces you could draw, how many neat books you could read, or how many friends you could meet in 29,960 hours!

The "Less Television, More Drawing" Legally Binding Contract

I, (your name) _____,
being of brilliant mind and sound body, do hereby solemnly swear
to watch much less television and spend more time drawing totally
cool, amazing, awesome, unbelievably wonderful 3-D imagination
adventures. I realize that if I fail to practice my drawings at least
one hour each day, I run the risk of allowing my brain
to turn into a giant marshmallow.

Legally Binding Signatures

My Name:

My Cool Parental Role Model:

Majestic Royal Classroom Teacher:

Pawprint of My Pet:

Mark Kistler's Imagination Station

Here We Go!

Since you have read through the introduction and completed the pre-test, I'm guessing that you are seriously going to art-attack this book. Either that or you are standing in the bookstore reading this, wondering just what kind of wild man would write such gibberish.

Before you start your sketching frenzy, I want to explain the layout of the lessons. Each lesson consists of two drawings, two practice Possibility Pages, and a Genius Student Drawing. There are thirty-six lessons with over seventy drawing adventures (whew, a lot of pencil lead). If some of the drawings look familiar, it's because I originally wrote this book as my script log for the public television series *Mark Kistler's Imagination Station*. The drawings in the book are some of the ones I've drawn on TV. Am I an organized artist, or what? Next time you're watching me on TV, scan through the Drawing Directory (on the next page) and you will be able to follow along even easier!

You do not need a TV to enjoy this book! Consider this book your handheld remote learning station, with your pencil as your handheld high-tech remote-control imagination laser. Yes! I think we have finally discovered the perfect alternative to all those mind-numbing violent video games! Forget all those handheld video game toggles. Instead, use that quarter to buy a pencil!

Consider this drawing book as your portable art laboratory. Take it with you on trips, to school, to church, and especially when you're in the car running Saturday errands with your mumsie or papa. Remember last Saturday when "I'll be just a minute" turned into an hour at the store?!? Yup, turn a boring errand into a drawing journey to the land of dinosaurs.

Although I've written this book as a series of thirty-six lessons, I know you're probably going to do exactly what I did—turn immediately to the Drawing Directory, find the drawing that fits your mood, and flip to that page. In that case, why am I writing this introduction, when you are already drawing on page 211? Keep your pencils sharp and your dreams on the tip of your nose!

Mark Kistler's Imagination Station Drawing Directory

Today we learn how to draw a 3-D Bronto Baby learning how to talk and a really cool Tyrannosaurus Rex racing his 3-D Dino Car. We'll browse through the Genius Student Mail and learn these Genius Words: *brilliant, foreshortening,* and *horizon.* Sound fun? Grab your paper and pencil. Let's draw!

The rocket-powered Pterodactyl soars through space in this awesome 3-D drawing lesson. Then we learn how to draw dazzling Dino Town, complete with overlapping mountains with zillions of windows! The Genius Words we learn today are *genius, overlapping,* and *shading.*

Sir Lancelot in his suit of 3-D armor patrols the lunchroom, while King Arthur climbs his two-story breakfast table in today's lesson. The Genius Words we learn in this adventure are *adventure, horizon, shading,* and *bonus.*

Today we learn how to draw the world's largest 3-D breakfast bowl and Leonardo's amazing high-tech automated Drawing Chair! The Genius Words we'll learn are *adventure, horizon, shading, placement,* and *bonus.*

Let your imagination soar up to the stratosphere to draw the awesome 3-D Cool Cloud Castle in the sky. Then jump in your puffy cloud vehicle for another 3-D drawing adventure. Today's Genius Words are *explore, overlapping, size, foreshortening,* and *shading.*

Today we are going to launch your imagination-powered 3-D Pencil Rocket into space to dock at the super-deluxe Multimodule Space Station. Awesome art adventure! Today's drawing lesson is a galactic experience! The Genius Words to learn are *prodigy, size, contour, placement,* and *bonus.*

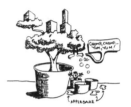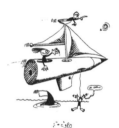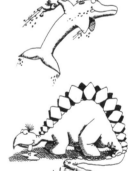

In today's adventure we'll draw the Charismatically Caring Cockatiel and the Carnivorous Crocodile. The Genius Words to learn are *overlapping*, *daily*, *shadow*, *bonus*, and *virtuoso*.

The 3-D "E" Building and the high-tech 3-D lettering lesson. The Genius Words to learn are *foreshortening*, *horizon*, *bonus*, *shading*, and *maestro*.

Today we visit the Mysterious Moon Mansion to meet the Mighty Moon Dude. The Genius Words to learn are *overlapping*, *density*, *foreshortening*, *daily*, *shadow*, and *alliteration*.

Today we scuba dive to the bottom of the ocean to visit the Clam Colony. Along the way we'll draw the cool 3-D Papa Seahorse. The Genius Words to learn are *renaissance*, *foreshortening*, *bonus*, and *daily*. Be sure to finish the Super Story Starter.

Today we are protecting the planet Earth from pollution with our 3-D Satellite Space Sweeper and the Pollution-Pounding Trash Masher. We'll take a look at some more Genius Student Mail and learn these Genius Words: *environment*, *attitude*, *placement*, and *shading*.

It's a bird! It's a plane! No, it's Genius Pickle in 3-D! He's flying to rescue the one-point-perspective Pickleville City. The Genius Words to learn are *achiever*, *contour*, and *size*. Remember to keep your goals on the tip of your nose!

Today we'll draw two facial expressions of an artist preparing to draw. The 3-D expressions of *exasperation* and *enlightenment* will help you learn the Genius Words: *astonishing*, *shading*, and *attitude*.

Today we'll draw two more expressions of artistic delight, *intent* and *elation*. We will also begin a Super Story Starter and browse through the Genius Student Mail. The Genius Words to learn are *marvelous*, *contour*, *size*, and *overlapping*.

Hold on! Here comes Texas Rex, the hip-hop happening cool Tyrannosaurus Rex, with his pal the Laughing Lizard! Prepare yourself for a cool Story Starter and some great drawings from the Genius Student Mail. The Genius Words to learn are *character*, *shadow*, *bonus*, and *daily*!

Wwoooaahh! It's cold up north during the winter. *Brrrrr!* Today we'll draw a cool 3-D Polar Dome, otherwise known as an igloo. Our second drawing is the Popular Polar Dude. The Genius Words to learn are *magnificent*, *alignment*, and *texture*. Remember to finish your Creative Challenge and your Super Story Starter.

Let's take a ride in the 3-D Giant Jumbo Jet today! We'll soar through the clouds and beam over to the High-Tech Hovering Helicopter. The Genius Words to learn are *motivation*, *proportion*, *thickness*, *blocking*, and *action lines*.

Today we'll learn how to draw a two-point-perspective castle with 3-D vanishing points! Our second drawing is the Knights Around the Really Round Table. The Genius Words to learn are: *vanishing points*, *alignment*, and *purpose*.

Fasten your seat belt! We're launching on a 3-D space quest, exploring the nine planets in our solar system with our astronomically positive attitude! Today's Super Story Starter will really get your brain humming while you learn these Genius Words: *intellectual*, *size*, *foreshortening*, and *shading*.

Just wait until you draw this awesome 3-D Thumbs-Up Tower! It's so cool! Then, if that's not enough excitement for one day, we'll go ballooning beyond the biosphere. The Genius Words to learn are *ambitious*, *thickness*, *alignment*, *tapering*, and *bonus*.

Three drawing students created their own 3-D cool critters; we'll draw them today. When you draw the Laith Bug, the Andrea Bug, and the Matt Bug, you'll be bugged out! The Genius Words to learn are *gracious*, *placement*, and *overlapping*.

Today we'll meet Mr. Melf and his trusty Bubble-Blowing Macromonster! The Super Story Starter will get your pencils writing away, and the Genius Student Mail is fantastic! The Genius Words to learn are *fantasy*, *blocking*, *drooping*, *overlapping*, and *shading*.

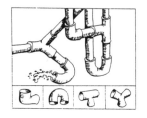

Today we'll learn how to control curving shapes with contour lines in Contour Contortions. Our second 3-D drawing is Pondering Plumbing Possibilities. We actually design an underground water-tube transportation system! The Genius Words to learn are *voyage*, *volume*, *depth*, and *bonus*.

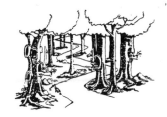

Today's drawing voyage begins with a 3-D tree, Rooted with Integrity. Gnarled roots overlapping one another make for a cool picture! Our second drawing is a twisting tree trail through a Forest of Giant Ideas! The Genius Words to learn are: *integrity, tapering, size,* and *attitude.*

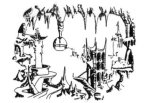

Today we'll spend the entire lesson on one advanced drawing, the Stalactite City. This is a cool cavern of stalactites, stalagmites, caves, terraces, waterfalls, and an awesome 3-D castle. The Genius Words to learn are *exceptional, blocking, overlapping, bonus, thickness, shading,* and *attitude.*

On your mark, get set, *draw!* Speedy Spinach sprints through our first 3-D drawing. Watch out! He's heading straight for Spinachville! We'll begin an action-packed Super Story Starter and tour through the Genius Student Mail. The Genius Words to learn are *imagination, foreshortening, shadow, overlapping,* and *placement.*

Let's draw a 3-D High-Tech Dream-Beam Idea-Amplifying Helmet! You'll need it because we're going on a dream quest! Keep your goals on the tip of your nose to be a dream achiever! Our second drawing is a curling 3-D Dream-Achiever Award Ribbon. Cool! The Genius Words to learn are *journey, blocking, bonus,* and *daily.*

The Tally

To help you keep track of your awesome 3-D drawing progress, check off each item as you learn it in the lesson.

Lesson	Page	Item	Completed	Date
Introduction	9	Book Plate		
Introduction	16	Warm-Up Sketches		
Introduction	17	Less TV Contract		
Introduction	19	Here We Go!		
1	41	Dino Baby Practice Page		
1	41	Dino Baby Wall Mural		
1	41	The Genius Word Is:		
1	43	Racing Rex Practice Page		
1	43	Super Story Starter		
2	47	Pterodactyl Taxi Practice Page		
2	47	Pterodactyl Contest		
2	47	The Genius Word Is:		
2	49	Dino Town Practice Page		
2	49	Library Visit		
2	49	Mail Mark a Drawing		
3	53	Knight Practice Page		
3	53	The Genius Word Is:		
3	55	Kings Table Practice Page		
3	55	Create Home Video		
4	58	King's Breakfast Practice Page		
4	58	The Genius Word Is:		
4	58	Parents' Expression		
4	60	DaVinci's Desk Practice Page		
4	60	Mail Mark a Drawing		
5	64	Cloud Town Practice Page		
5	64	The Genius Word Is:		

The Tally Continued:

Lesson	Page	Item	Completed	Date
5	64	Under-Table Mural	_____	_____
5	66	Cloud Dude Practice Page	_____	_____
5	66	Super Story Starter	_____	_____
6	70	Pencil Rocket Practice Page	_____	_____
6	70	The Genius Word Is:		
		_____	_____	_____
6	72	Space Station Practice Page	_____	_____
6	72	Super Story Starter	_____	_____
7	76	Lunar Landing Practice Page	_____	_____
7	76	The Genius Word Is:		
		_____	_____	_____
7	76	Moon Mural Challenge	_____	_____
7	78	Moonmobile Practice Page	_____	_____
7	78	Moon Mural/Mobiles	_____	_____
8	82	King Clam Practice Page	_____	_____
8	82	The Genius Word Is:		
		_____	_____	_____
8	82	Color the Clams	_____	_____
8	84	Trumpet Tower Practice Page	_____	_____
8	84	Super Story Starter	_____	_____
9	87	Treasure Chest Practice Page	_____	_____
9	87	The Genius Word Is:		
		_____	_____	_____
9	87	Book Fish Challenge	_____	_____
9	89	Shark Practice Page	_____	_____
9	89	Ten Species of Shark Challenge	_____	_____
10	92	Tree Town Practice Page	_____	_____
10	92	The Genius Word Is:		
		_____	_____	_____
10	92	Library Visit Challenge	_____	_____
10	94	Tree Transplanting Practice Page	_____	_____
11	98	Pencil Sloop Practice Page	_____	_____
11	98	The Genius Word Is:		
		_____	_____	_____
11	98	Super Story Starter	_____	_____
11	100	Creative Wave Practice Page	_____	_____
11	100	Super Story Starter	_____	_____
12	104	Diving Dolphin Practice Page	_____	_____

The Tally Continued:

Lesson	Page	Item	Completed	Date
12	104	The Genius Word Is: _____		
12	104	Super Story Starter	_____	_____
12	106	Angel Fish Practice Page	_____	_____
12	108	Mail Mark a Drawing	_____	_____
13	110	Slobbery Stegosaurus Practice Page	_____	_____
13	110	The Genius Word Is: _____	_____	_____
13	110	Sculpture Challenge	_____	_____
13	112	Brontosaurus Mama Practice Page	_____	_____
13	112	Super Story Starter	_____	_____
14	116	Flapping Flags Practice Page	_____	_____
14	116	The Genius Word Is: _____	_____	_____
14	116	Calculator Paper Challenge	_____	_____
14	118	Treasure Map Practice Page	_____	_____
14	118	Mail Mark a Drawing	_____	_____
14	118	Super Story Starter	_____	_____
14	119	Listing of Renaissance Words	_____	_____
15	121	King Koala Practice Page	_____	_____
15	121	The Genius Word Is: _____	_____	_____
15	121	Buy Spiral Sketchbook	_____	_____
15	123	Kangaroo Practice Page	_____	_____
15	123	Super Story Starter	_____	_____
16	127	Cockatiel Practice Page	_____	_____
16	127	Library Visit Challenge	_____	_____
16	127	Color Your Cockatiel	_____	_____
16	127	The Genius Word Is: _____	_____	_____
16	127	Thirty-one Cockatiels Challenge	_____	_____
16	129	Carnivorous Crocodile Practice Page	_____	_____
16	129	Research Quest	_____	_____
16	130	Mail Mark a Drawing	_____	_____

The Tally Continued:

The Tally Continued:

Lesson	Page	Item	Completed	Date
22	165	Mail to a Friend Challenge		
22	167	Stacked Pyramid Practice Page		
22	167	Pyramid Contest		
22	168	Pop Math Quiz		
22	169	Mail in Your Self-Portrait		
23	171	*Intent* Practice Page		
23	171	The Genius Word Is:		
23	171	Create Your Drawing Bag		
23	173	*Elation* Practice Page		
23	173	Draw Family Portrait		
23	173	Mail Your Family Portrait Video		
22	175	Imagination Station Practice Page		
23	175	Super Story Starter		
23	176	Facial Expressions Contest		
23	177	Draw Your Teacher		
24	179	Texas Rex Practice Page		
24	179	The Genius Word Is:		
24	179	Buy Nonrepro Blue Pen		
24	179	Memo Pads for Grandma		
24	181	Laughing Lizard Practice Page		
24	181	Super Story Starter		
25	184	Thirty-Second Sixteen-Cube Challenge		
25	185	Sixteen Cubes Practice Page		
25	185	The Genius Word Is:		
25	185	3-D Gift Wrap Challenge		
25	187	Polar Dome Practice Page		
25	187	Super Story Starter		
25	189	Polar Dude Practice Page		
25	189	Super Story Starter		
25	190	Mail Giant Ice-Cube Stack to Mark		
25	191	Renaissance Word Quiz		
26	193	Jumbo Jet Practice Page		

The Tally Continued:

Lesson	Page	Item	Completed	Date
27	193	The Genius Word Is:		
27	193	Super Story Starter		
27	195	Hovering Helicopter Practice Page		
27	195	Visit the Airport Challenge		
27	199	Two-Point Castle Practice Page		
27	199	The Genius Word Is:		
27	199	Two-Point Castle Mural Challenge		
27	201	Knights' Round Table Practice Page		
27	201	Super Story Starter		
28	205	Imagination Launch Practice Page		
28	205	The Genius Word Is:		
28	205	Drawing Video Challenge		
28	207	Space Quest Practice Page		
28	207	Super Story Starter		
28	209	Solar System Practice Page		
28	209	Library Research Challenge		
29	213	Thumbs-Up Tower Practice Page		
29	213	The Genius Word Is:		
29	213	Super Story Starter		
29	215	Biosphere Balloon Practice Page		
29	215	Hot-Air Balloon Family Portrait Challenge		
30	219	Laith Bug Practice Page		
30	219	The Genius Word Is:		
30	219	National Public Radio Challenge		
30	221	Andrea Bug Practice Page		
30	221	Send Story to a Friend Challenge		
30	223	Matt Bug Practice Page		
30	223	Lifelong Dream Challenge		
31	227	Mr. Melf Practice Page		
31	227	The Genius Word Is:		
31	227	Super Story Starter		

The Tally Continued:

Lesson	Page	Item	Completed	Date
31	229	Macromonster Practice Page		
31	229	The Jigsaw Puzzle Challenge		
32	231	Contour Tubes Practice Page		
32	231	The Genius Word Is:		
32	233	Plumbing Possibilities Practice Page		
32	233	Super Story Starter		
33	237	Roots of Integrity Practice Page		
33	237	The Genius Word Is:		
33	237	Super Story Starter		
33	239	Idea Forest Practice Page		
33	239	Read Dr. Seuss's *Oh the Places You'll Go*		
34	241	Stalactite City Practice Page		
34	241	The Genius Word Is:		
34	241	Super Story Starter		
34	243	EARTH Practice Page		
35	247	Speedy Spinach Practice Page		
35	247	The Genius Word Is:		
35	247	Super Story Starter		
35	249	Spinachville Practice Page		
35	249	Kitchen-Table Can Sculpture Challenge		
36	253	Dream-Beam Helmet Practice Page		
36	253	The Genius Word Is:		
36	253	Super Story Starter		
36	255	The Dreamer Practice Page		
36	255	Publish Your Stories Challenge		
36	257	Dream Award Practice Page		
36	257	Rent Home Video *Rudy*		
36	257	Twenty Dream-Beam Ribbons Challenge		
36	258	S.M.I.L.E.S.		

Heroes Inspire!

My heroes have inspired me to draw every day. They have motivated me to pursue my wild and crazy dreams with *relentless passion!* Your art heroes will do the same for you. I've listed just a few of my art heroes below. You list yours, too!

My Art Heroes

George Schulz	Bill Waterson	Mona Brookes
Georges Seurat	Martin Handford	Mike Schmid
M. C. Escher	Theodore Giesel	Jacques Cousteau
Suzi Spafford	Jim Davis	Gene Roddenberry
Ray Bradbury	Fred Rogers	Clive Cussler
Joyce Kistler	Walt Disney	

Your Art Heroes

(Mark "Cool Dude" Kistler!)

Drawing in 3-D with the Twelve Renaissance Words

What does 3-D mean? I've asked zillions of kids this question at school assemblies all over the world. My audiences have responded with some very creative answers: "Three-D means wearing funny-looking glasses to watch a movie." "Three-D means using different colors in your drawing." "Three-D means making your drawing look real." and my favorite: "Three-D means making your drawing pop out of the paper so it looks like it's about to bite you on the nose!" Since you are such a scientific-minded art student, I'll share with you the actual definition of 3-D. Once you understand what this means, you will be able to learn how to create this effect in your drawings.

"Three-D" is an abbreviation for "three-dimensional." Three-dimensional means having height, width, and depth. Most people draw in two dimensions. They use *height* and *width*, but they do not understand how to create the illusion of *depth* on their paper. If I asked your parents to draw me a tree, they probably would draw something like this:

This tree has height from top to bottom, and it has width from side to side. This tree is 2-D, or two-dimensional, because it doesn't have any depth. Without depth, drawings look flat. With depth, drawings look as if you can reach right into the picture and touch the object.

This tree is drawn in 3-D. It has height from top to bottom. It has width from side to side. It also has *depth*: It looks as if you can walk deep into the picture and sit down among the roots of the tree. You don't need funny-looking glasses or different color combinations to draw in 3-D. You just need to learn a few words.

This is your face before you learn how to draw in 3-D. Your face after you learn how to draw in 3-D with the Twelve Renaissance Words!

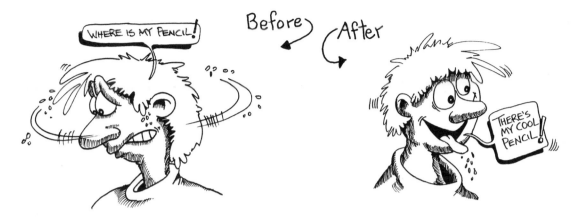

Learning how to draw in 3-D is super, super-easy!

Learning how to draw in 3-D is as simple as learning twelve simple words. These twelve words have been used by great artists for over five centuries. Once you learn these words, you will be able to draw anything from your imagination, or anything you see in the world around you, in perfect 3-D!

On the opposite page I've listed the Twelve Renaissance Words for you. These words have been used by artists for more than five hundred years to create the illusion of *depth* in their artwork. Remember, when you create depth in your picture, you are adding the third dimension. You are drawing in 3-D!

The Twelve Renaissance Words of Drawing in 3-D!

Over the next two hundred pages you will become very familiar with these words. Each of the words below will help you conquer that flat piece of paper to create the optical illusion of *depth*, or 3-D! Each of the words will help you make one object look closer to your eye than another object in your drawing.

Our goal is to make your drawings look as if you could reach right into them and pick up the objects. Or as kids at my school assemblies say, "Let's make the drawings look as if they are popping out ready to bite my nose!"

Some folks have told me that copying artwork is wrong or bad. I don't agree at all. I believe copying artwork is great, fantastic, and wonderful! The best way to learn how to draw in 3-D is by copying other 3-D art! When you are copying, you are learning techniques that will help you create your own 3-D drawings. The more you copy, the more you will learn. The more you learn, the more you will draw. The more you draw, the less you will have to copy! Got it? Don't worry if at first all your drawings look just like mine. As you work your way through the lessons, your 3-D drawing confidence will really blast off. You will begin adding all sorts of nifty cool things to your drawings that I haven't even thought of. When this starts to happen, it means that you're beginning to develop your own style. When you develop your own artistic style, you become a true power art animal!

The Twelve Renaissance Words Contest!

Each time I use one of these words in the drawing lesson, you need to put a check mark next to the word. Why? Because we are going to have a cool contest! Be among the first one hundred students to mail me an accurate count of how many times I use each Renaissance Word in the drawing lessons and you will win ten zillion billion million dollars! Or a fairly cool $16 Imagination Station T-shirt! (Whichever I happen to have in my office at the time.) It pays to learn the Twelve Renaissance Words of drawing in 3-D!

1. **Foreshortening:** Squishing a shape to make one part of it look as if it's closer to your eye than the other.

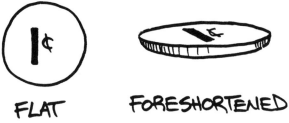

Each time you come across this word in the lessons, put a check mark in this space:

2. **Placement:** Place objects that you want to appear closer to your eye lower on the surface of your drawing. Place objects that you want to appear farther away higher on the surface of your drawing.

Each time you come across this word in the lessons, put a check mark in this space:

3. **Size:** Draw objects that you want to appear closer to your eye larger than objects that you want to appear farther away from your eye. Large objects look closer.

Each time you come across this word in the lessons, put a check mark in this space:

4. Overlapping: When you draw an object in front of another object, it will look closer to your eye. If you want to make an object look really far away from your eye, tuck it behind another object in your drawing. This is called overlapping.

Each time you come across this word in the lessons, put a check mark in this space:

5. Shading: By adding darkness to the edge of an object on the side that faces away from your light source, you will push that edge away from your eye.

If I had to choose one of these twelve words that I thought was the most important, I would choose *shading*. Shading is a POWER word for Ninja POWER Artists. With shading you can make any drawing, even a flat 2-D picture, look super-three-dimensional!

Each time you come across this word in the lessons, put a check mark in this space:

6. Shadow: When you draw darkness on the ground next to the shaded side of an object, you will create the illusion that the object is really sitting on the ground. There are several types of shadows we will be learning in the upcoming lessons.

Each time you come across this word in the lessons, put a check mark in this space:

7. **Contour:** When you draw lines curving around the surface, or contour, of an object, you give that object volume. You make that object appear to be popping out of the paper.

Each time you come across this word in the lessons, put a check mark in this space:

8. **Horizon:** By drawing a line behind your object, you create a reference line for the ground in your picture. Everything you draw below that line will appear to be sitting on the ground. Everything you draw above that line will appear to be floating or flying in space.

Each time you come across this word in the lessons, put a check mark in this space:

9. **Density:** When you draw things very light and less distinct than darker objects in your picture, they will appear to be farther away. Darker objects with more detail look closer than lighter, hazy objects. Think of looking out a window in a tall building. The buildings and trees across the street look clear, and you can see lots of detail. The buildings and trees farther away look a little hazy, with less recognizable detail. This is because of the atmosphere between yourself and the object. Or if you're in a big city, it's caused by pollution. Yucko!

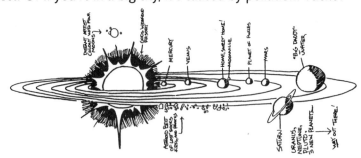

Each time you come across this word in the lessons, put a check mark in this space:

10. **Bonus:** Ah! My favorite word of all! While you are drawing, always think, "What bonus ideas can I add to my drawing to make it look more brilliant, more cool, more absulutely totally amazing?" When you add bonus ideas, you are adding your own unique *style* to your picture! Some of my favorite examples of adding bonuses to drawings are the *Find Waldo* books by Martin Handford. He adds so many bonuses to his drawing that you can barely find his pal Waldo!

38 Each time you come across this word in the lessons, put a check mark in this space:

11. **Practice:** These Renaissance Words aren't worth a hill of jelly beans without daily practice. Some brilliant thinker once said practice makes perfect. Well, I say, "Practice makes drawings look totally 3-D." Cool! I'm very profound at times.

Each time you come across this word in the lessons, put a check mark in this space:

12. **Attitude:** A super-positive mental attitude is very important when you are trying to learn a new skill. Whether it's learning how to ride a bike, play the violin, or draw in 3-D, you've got to believe in yourself. You've got to believe you can and will learn to do it. Not only just learn it, but master it to the point of being a world-famous expert.

For example, let's say that you are just learning how to ride a bike. You get on the seat, hold the steering wheel straight, put one foot on the outer pedal, and push off the ground with your other foot. As the bike begins to move, you begin thinking to yourself, "What am I doing? I can't ride a bike! This is totally crazy! I'm going to crash! I'm going to fall over and bounce on the street like a rubber ball! Help! Help!"

How far do you think you will get with this kind of negative thinking? Not far at all, I guarantee.

This quiet thinking inside your head is called *self-talk*. Everyone self-talks with themselves twenty-four hours of every day. This self-talk is amazingly fast, several hundred words a minute, much faster than you can speak out loud. Having a super-positive mental attitude means training yourself to self-talk in a "Yes I can do it," positive way.

Now let's try that learning-how-to-ride-a-bike scenario with a super-positive mental attitude. You get on the seat, hold the steering wheel straight, put one foot on the outer pedal, and push off the ground with your other foot. As the bike begins to move, you begin thinking to yourself, "Hey, this is easier than I thought! I can do this. This is really cool. Im a bike-riding machine. I'm a pedaling animal! I'm going to go to the Olympics!"

How far do you think you'll go? Do you think you will learn how to ride a bike faster? I do.

Each time you come across this word in the lessons, put a check mark in this space:

EPISODE 1 Dinosaurs, Dinosaurs
Dino Baby

❶ Here we go on our first drawing! Draw *big*! Draw your picture twice the size of mine!

❷ A lot of drawings start with this *foreshortened* shape!

❸ *Foreshortening* means squishing a shape to make one part look closer to you!

❹ Add the *shadow*!

❺ Add the *horizon* and *shading*.

❻

❼

COOL! In our very first 3-D drawing adventure, we've used four of the twelve Renaissance Words. These words have helped artists draw and paint in 3-D for over five hundred years! Learn these twelve words and you'll be drawing brilliant 3-D masterpieces.

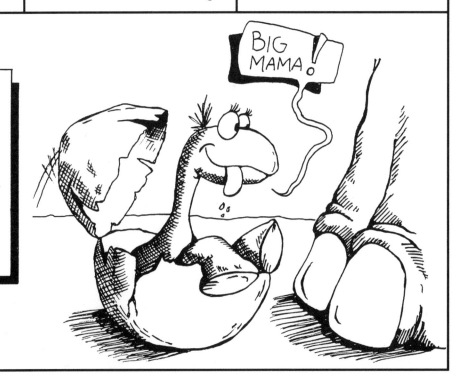

Pondering Pencil Possibilities Practice Page

> *PRACTICE, PRACTICE, PRACTICE!*

YOU DRAW GIANT DINO BABIES HERE:

TODAY'S GENIUS WORD: **BRILLIANT**

> I've left this huge blank space for you to practice your drawing. Remember to make your drawings much larger than mine. I have to keep my drawings contained in a small lesson space, but you don't! You can practice your drawings on huge sheets of paper taped to your door! (When you tape humongous pieces of paper to your door, get your parents' permission. Do the dishes or something before you ask them! Be sure to fill up the entire piece of paper with hundreds of sketches on both sides. No wasting trees!)

BRILLIANT: Distinguished by an unusual mental keenness or alertness. Basically, a person who thinks like you! Your picture in the dictionary next to this word!

Racing Rex

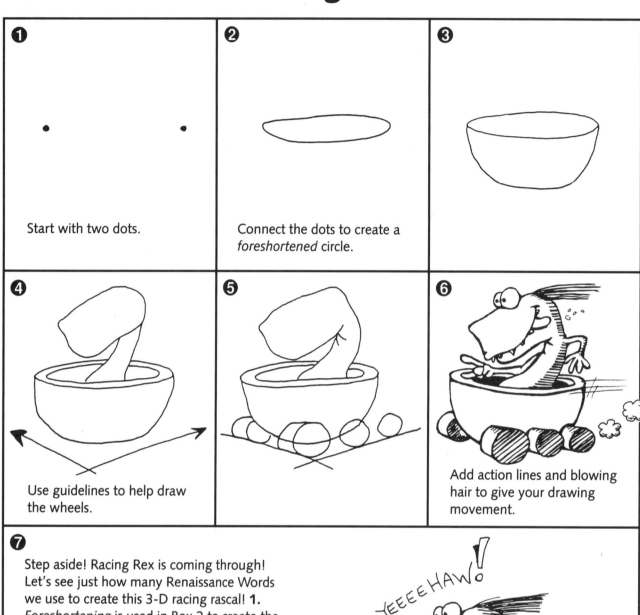

① Start with two dots.

② Connect the dots to create a *foreshortened* circle.

③

④ Use guidelines to help draw the wheels.

⑤

⑥ Add action lines and blowing hair to give your drawing movement.

⑦

Step aside! Racing Rex is coming through! Let's see just how many Renaissance Words we use to create this 3-D racing rascal! **1.** *Foreshortening* is used in Box 2 to create the top of the Dino Car. **2.** *Overlapping* is used in Box 4 to tuck the Dino dude inside the Dino Car. **3.** *Size* is used in Box 5 to make the near wheels appear closer. The wheels get smaller as they move away from your eyes. **4.** *Shading* is used in Box 6 to create that hard-edged look, pushing the dark areas away from your eye. **5.** *Shadow* is used in Box 7 to make the Dino Car appear hovering or flying over the ground. **6.** *Horizon* is used to establish where the ground is. Wow! We used six of the twelve Renaissance Words of 3-D drawing in just one drawing adventure! Cool! Let's learn more on the next page!

YEEEEHAW!

Pondering Pencil Possibilities Practice Page

PRACTICE, PRACTICE, PRACTICE!

DRAW YOUR OWN RACING REX BELOW:

SUPER STORY STARTER:

Texas Rex's hand gripped the brake-release bar inside his Dino Car. His eyes darted down the steep hill, scanning for any rocks or debris that might catch in his wheels. "All clear!" he screamed, slamming the brake release down into the cockpit. He lunged foreward, using his body weight to increase the Dino Car's speed. Wind began blowing Texas's hair back, causing tears to stream down his cheeks. "Yeeeehaw!" Texas Rex shouted as he approached the first turn . . .

Now, you finish the story! Why is Texas Rex racing his Dino Car down a steep hill? Is he wearing a seat belt? Where did he get his Dino Car? What happens next? Only you can answer these questions. Only you know how the story ends! Quick, mail me your story ending! I can't wait to read what happens next! My address is on page 262.

Super-Splendid Student Sketches

"Rex"
Robert Askins
Age: 11
City: Cypress, Texas

Every artist draws or paints with his or her own unique *style*. Some people draw with a dark, heavy-line style. Some draw with a very light whisper style.
Some draw with a very tedious, exact, hard-edged style. Some even draw with a very loose and rough style, as in the Robert Askins drawing above. What kind of style do you draw with?

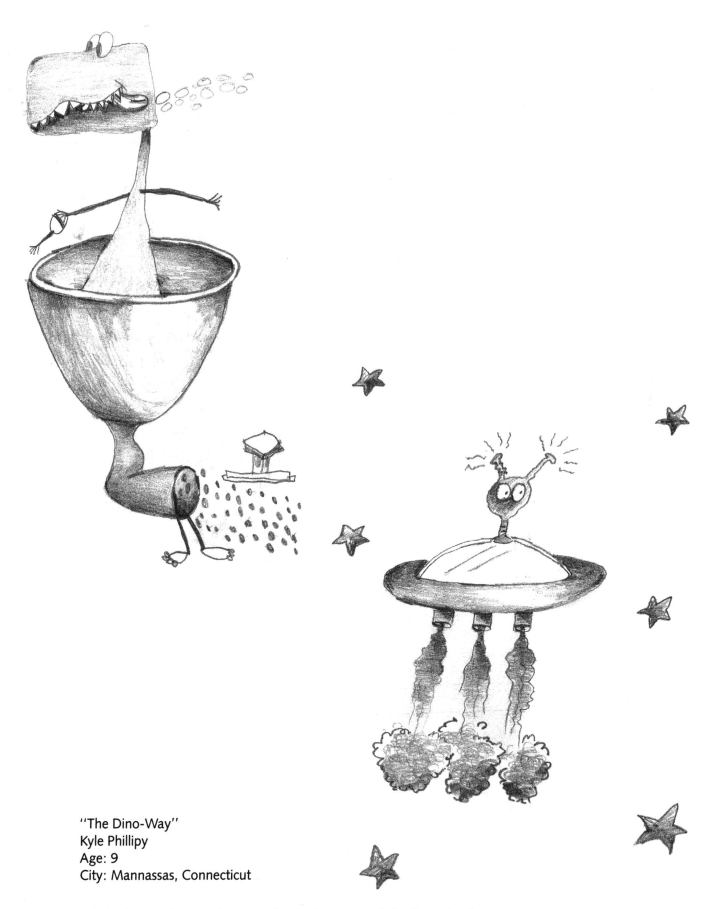

"The Dino-Way"
Kyle Phillipy
Age: 9
City: Mannassas, Connecticut

Kyle had a 3-D drawing lesson with me when I visited Fletcher School in Mannassas, Connecticut.
Kyle gave me these two flying space drawings. Intense shading, Kyle! At age 9 your drawings
already look professional! Shading really enhances the 3-D look of your drawing.

Dinosaurs in the Sky
Pterodactyl Taxi

①

Let's block in our drawing, just as the professionals do!

②

③

④

Overlapping is used on the eyes to make one look closer.

⑤

Your drawing should be at least triple mine in size!

⑥

Contour is used to give this cool creature's smile some depth.

⑦

Add *bonus* ideas like the rocket thrusters, the Bungee Boy, and especially the action lines. Bonus ideas will really invite people to spend time gazing into your 3-D masterpiece. Art is like dessert for your mind. When people spend time looking at your work, it means they find it visually *delicious!*

Pondering Pencil Possibilities Practice Page

PRACTICE, PRACTICE, PRACTICE!

Draw 1,000,000 ptotally pterrific Pterodactyls below.

TODAY'S COOL WORD: **GENIUS**

Let's have a contest! Let's see who can draw the most Pterodactyls on one piece of paper! Be sure to use *overlapping* and *shading!* Mail your contest drawings to my address on page 262.

GENIUS: Extraordinary intellectual power manifested in creative activity. In other words, *genius* is what people say about you when you are drawing!

Dino Town

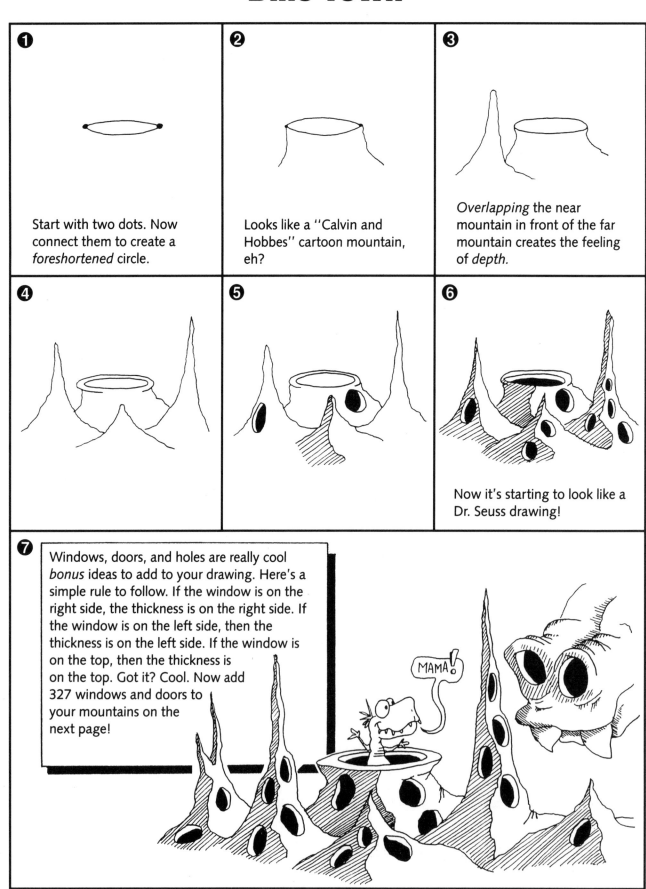

1 Start with two dots. Now connect them to create a *foreshortened* circle.

2 Looks like a "Calvin and Hobbes" cartoon mountain, eh?

3 *Overlapping* the near mountain in front of the far mountain creates the feeling of *depth*.

4

5

6 Now it's starting to look like a Dr. Seuss drawing!

7 Windows, doors, and holes are really cool *bonus* ideas to add to your drawing. Here's a simple rule to follow. If the window is on the right side, the thickness is on the right side. If the window is on the left side, then the thickness is on the left side. If the window is on the top, then the thickness is on the top. Got it? Cool. Now add 327 windows and doors to your mountains on the next page!

MAMA!

Pondering Pencil Possibilities Practice Page

PRACTICE, PRACTICE, PRACTICE!

Fill this entire page up with *overlapping* mountains!

I love studying other artists' work for ideas to improve my 3-D drawing. Yup! I still practice every day! Bill Waterson draws fantastic monsters, space creatures, planet scenes, and forest trails in his comic strip ''Calvin and Hobbes.'' His 3-D drawings are awesome!

Gary Larson draws great 3-D animals and interior rooms in his comic strip ''The Far Side.'' Martin Hanford is the master of detail in his *Find Waldo* children's book series. Go to your library and check these books out. Better yet, buy copies of these books at your local bookstore to build your own *idea-bank* reference library at home. Pick one drawing from one book a day to copy, study, and learn!

Super-Splendid Student Sketches

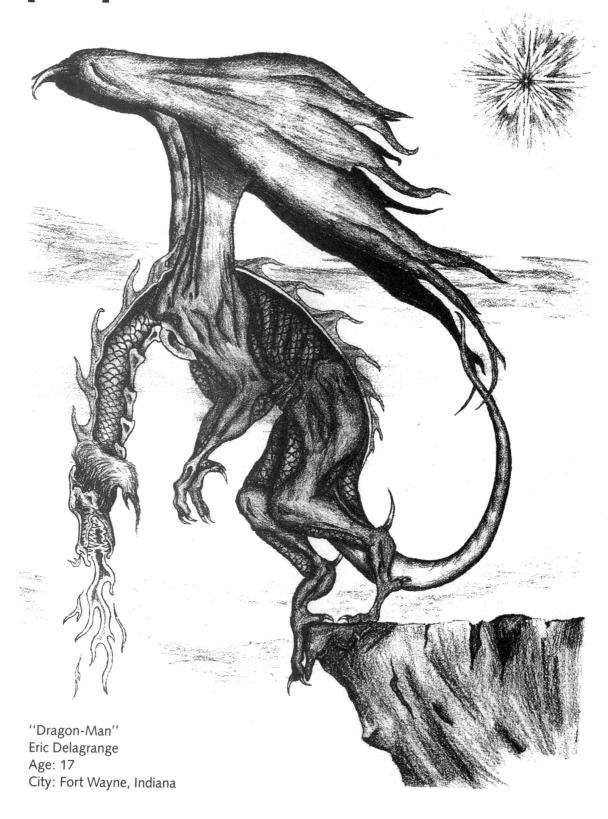

"Dragon-Man"
Eric Delagrange
Age: 17
City: Fort Wayne, Indiana

Eric used a dark cloud behind his dragon to give his picture the feeling of *depth*. He drew his dragon *overlapping* the background cloud to push the cloud far away from your eye. This is a wonderful example of drawing in 3-D! He created the third dimension of depth by pushing parts of his picture away from our eyes while pulling others toward our eyes! Fantastic! Why don't you mail me your drawings to use in my next book? My address is on page 262.

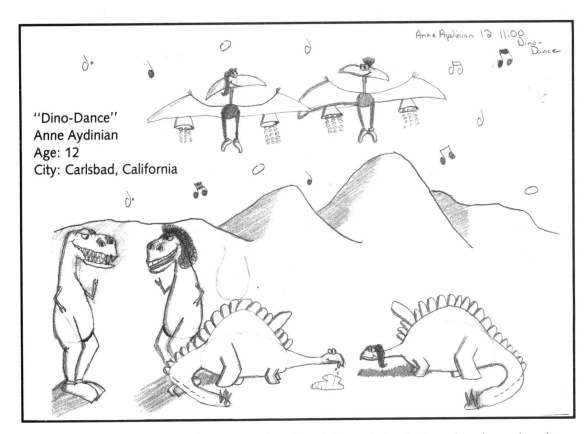

"Dino-Dance"
Anne Aydinian
Age: 12
City: Carlsbad, California

The three dimensions of 3-D drawing are *height, width*, and *depth*. Anne has drawn her dinosaurs lower on the paper to make them appear closer than the mountains. She has successfully used *placement* (Renaissance Word). Can you find where she used *shadow, shading*, and *bonus* (Renaissance Words)?

Stephanie used a black background to create a drastic *contrast*, making the horses really pop out of the paper! She added the furry creatures lower on the paper, using *placement* to create *depth*. The Moon rocks, stars, and flying horses are good examples of using *bonus* ideas to enhance your masterpieces! Always try to add brilliant bonus ideas to your drawings.

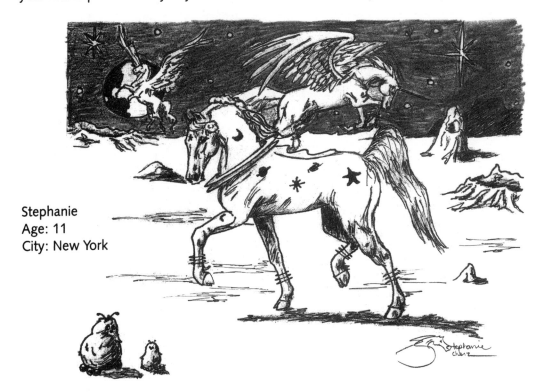

Stephanie
Age: 11
City: New York

Knights of the Drawing Table
Knight of the Drawing Table

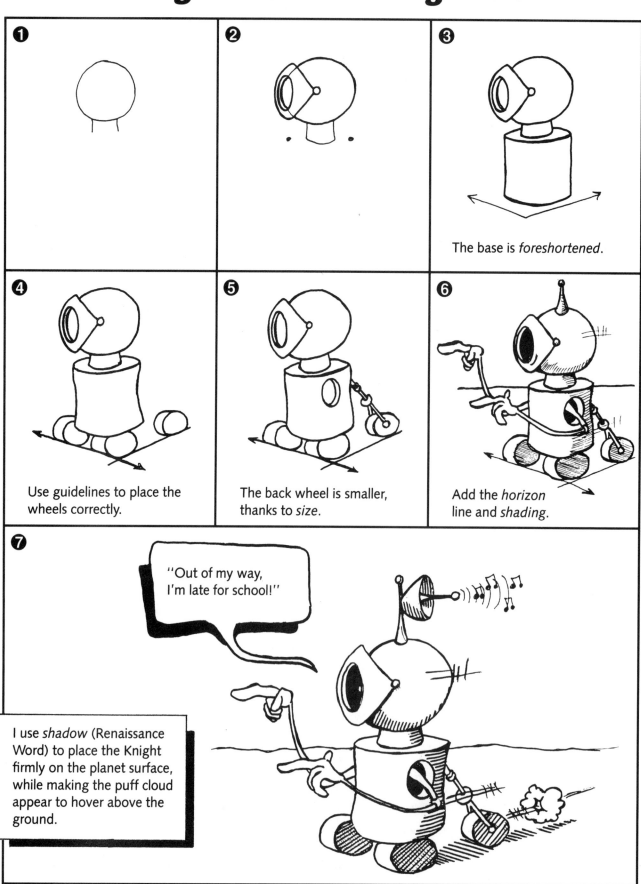

①

②

③ The base is *foreshortened*.

④ Use guidelines to place the wheels correctly.

⑤ The back wheel is smaller, thanks to *size*.

⑥ Add the *horizon* line and *shading*.

⑦

"Out of my way, I'm late for school!"

I use *shadow* (Renaissance Word) to place the Knight firmly on the planet surface, while making the puff cloud appear to hover above the ground.

Pondering Pencil Possibilities Practice Page

PRACTICE, PRACTICE, PRACTICE!

Draw an entire tourist rally of knights rolling across the page below. Use *size* and *overlapping* to make the near ones appear closer to your eye.

TODAY'S GENIUS WORD:
ENTHUSIASTIC

Has anyone ever told you that drawing is a waste of time? Many people have told me that before they learned how to draw in 3-D. My response to this outrageous statement is always swift and blunt. "Look at your shoe!" I demand in my "serious" classroom teacher voice. "Look at your watch, look at that car, that building, that bridge!" I continue in an ever increasing volume. "Every single thing that is manufactured on this planet, from your shoelace to your toothbrush, had to be drawn by an artist *first* before it could be made!" I conclude with a triumphant holler, "Drawing in 3-D is designing the future!"

ENTHUSIASTIC: A feeling of inspired eagerness, having zeal! This is how you feel every time you pick up your pencil to draw in 3-D!

The King's Royal Drawing Table

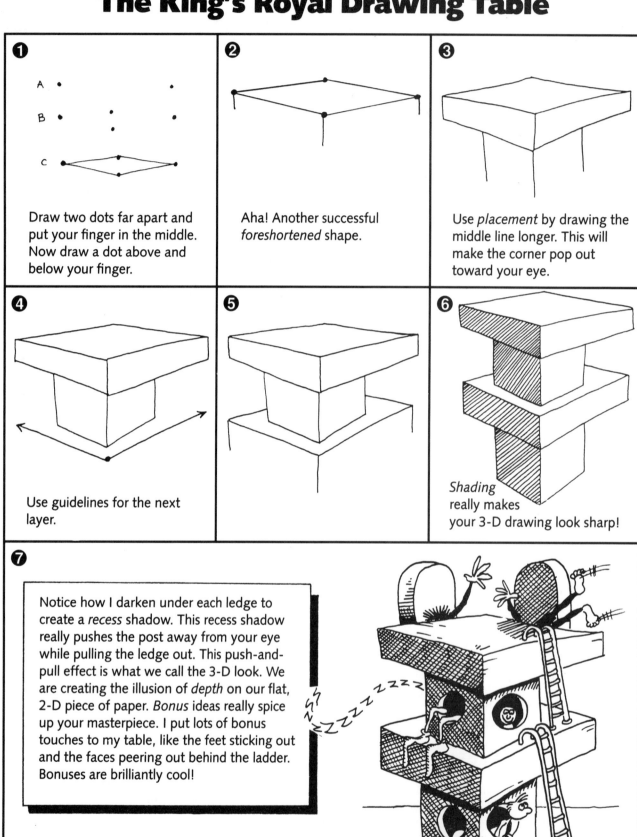

❶ Draw two dots far apart and put your finger in the middle. Now draw a dot above and below your finger.

❷ Aha! Another successful *foreshortened* shape.

❸ Use *placement* by drawing the middle line longer. This will make the corner pop out toward your eye.

❹ Use guidelines for the next layer.

❺

❻ *Shading* really makes your 3-D drawing look sharp!

❼ Notice how I darken under each ledge to create a *recess* shadow. This recess shadow really pushes the post away from your eye while pulling the ledge out. This push-and-pull effect is what we call the 3-D look. We are creating the illusion of *depth* on our flat, 2-D piece of paper. *Bonus* ideas really spice up your masterpiece. I put lots of bonus touches to my table, like the feet sticking out and the faces peering out behind the ladder. Bonuses are brilliantly cool!

Pondering Pencil Possibilities Practice Page

PRACTICE, PRACTICE, PRACTICE!

Draw a 20-story royal breakfast table below. Add lots of ladders, doors, windows, and peeking people. The largest stack ever drawn and mailed to me was over three thousand tables high! It was drawn on a long roll of calculator tape, complete with *shading* and *bonuses*. Mail me your super royal table stack today!

Hey! I have an idea! Why don't you mail me a home video of yourself teaching your family how to draw! Or a home video of your completed 3-D masterpieces!

Maybe I will be able to use the video on my public television show, *Mark Kistler's Imagination Station*! Be sure to videotape in a very bright room. Lots of light is important for broadcast. Look on page 262 for my address.

Super-Splendid Student Sketches

Jesse Smith
Age: 12
City: Los Angeles,
California

Let's see how many Renaissance Words Jesse is using in his cool robot picture. Each Renaissance Word helps Jesse create the illusion that one part of his drawing is closer to your eye than another. He has successfully created the feeling of *depth* in his nifty rendering.

1. *Foreshortening*. The opening of the vent shaft.
2. *Placement*. The robot is lower than the back wall.
3. *Shadow*. The darkness under the humanoid and under the rolling robots' feet.
4. *Shading*. The darkness on the edges of all the objects.
5. *Overlapping*. The right leg of the humanoid is in front of the far one. Both the robots are in front of the back wall.
6. *Size*. The ceiling wall gets larger as it angles toward you.
7. *Bonus*. Look at all the detailed extras on the sidewalk and the humanoid's jet backpack.
8. *Daily*. With this kind of quality in his picture, you know Jesse practices his drawing every day.
9. *Attitude*. What kind of attitude do you think Jesse draws with?
10. *Horizon*. The bottom of the back wall is Jesse's reference horizon line.
11. *Contour*. The bands wrapping around the humanoid's leg.
12. *Density*. This is the Renaissance Word of 3-D drawing that Jesse did not use. He might have used it by drawing smaller, less-detailed objects near the back wall. Maybe next time?

Nice job, Jesse, and awesome 3-D drawing! I can't wait until you mail me more cool renderings!

EPISODE 4 The King's Breakfast Bowl
The King's Breakfast Bowl

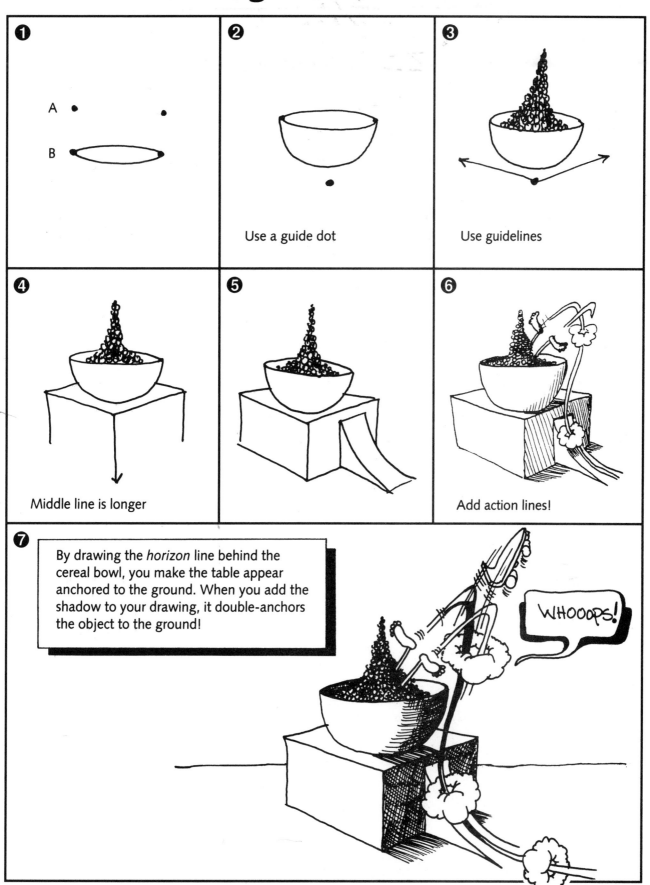

❶

A • •

B ⬭

❷

Use a guide dot

❸

Use guidelines

❹

Middle line is longer

❺

❻

Add action lines!

❼ By drawing the *horizon* line behind the cereal bowl, you make the table appear anchored to the ground. When you add the shadow to your drawing, it double-anchors the object to the ground!

WHOOOPS!

Pondering Pencil Possibilities Practice Page

PRACTICE, PRACTICE, PRACTICE!

Draw hundreds of cereal bowls, all equipped with state-of-the-art roller blade ramps! Be sure to anchor your drawings with *shadows*.

Carry your drawing over to where your parents are sitting and say, "Behold, my dear parental role models, I am a brilliant artistic genius, busy designing the future of this, our very planet!" Show them your drawing and watch the expressions of amazement on their faces!

ADVENTURE: An unusual and suspenseful experience. Whenever you pick up your drawing pencil, you never quite know what's going to happen! Drawing in 3-D is the ultimate imagination adventure!

Da Vinci's Drawing Desk

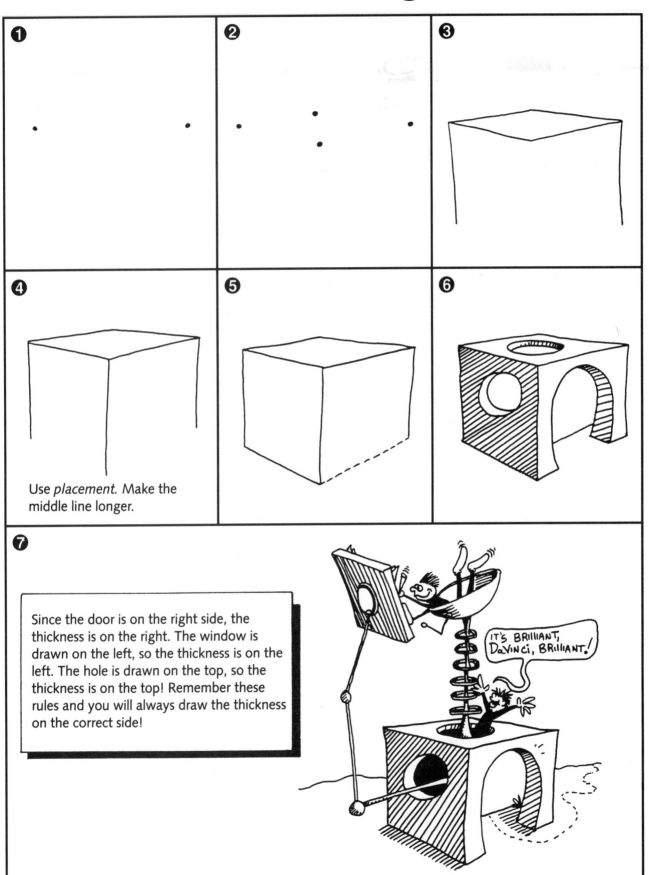

①

②

③

④
Use *placement*. Make the middle line longer.

⑤

⑥

⑦

Since the door is on the right side, the thickness is on the right. The window is drawn on the left, so the thickness is on the left. The hole is drawn on the top, so the thickness is on the top! Remember these rules and you will always draw the thickness on the correct side!

IT'S BRILLIANT, DaVinci, BRILLIANT!

PRACTICE, PRACTICE, PRACTICE!

Draw an entire classroom full of Da Vinci Drawing Desks! Mail me your drawings!

I have the most wonderful job in the whole world. I get to travel all over the planet teaching kids how to draw in 3-D. The most common question kids toss at me during my school assemblies is "Mr. Mark, where do you get all those crazy ideas for your drawings? They are so very, very strange!" I've had this question asked in America, Australia, Germany, Scotland, England, and Mexico. My answer is always the same: "Mind your own business, buddy!" No, I'm just joking. I don't say that. I say, "Books, books, books!" I love looking through the beautiful illustrations in children's books. There seem to be billions of ideas per book!

Super-Splendid Student Sketches

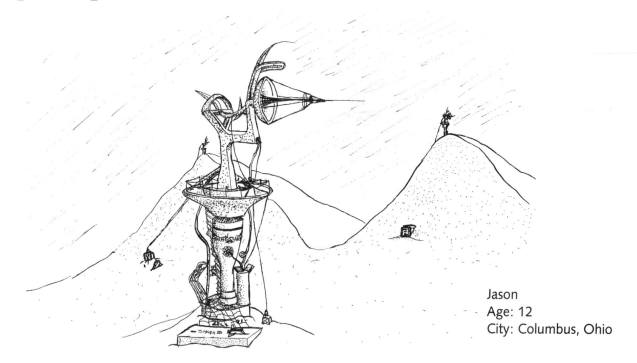

Jason
Age: 12
City: Columbus, Ohio

Jason's Idea-Beam Amplification-Projection Machine is a cool device to beam ideas and dreams between planets. What kind of idea-beam machine will you design? I can't wait until you mail in your sketch!

Carolyn
Age: 9
City: Spokane, Washington

A robot on a tightrope? What will you creative geniuses think of next! Look at all the nice texture on the building! I really like the *shading* in the canyon crevice! Great drawing, Carolyn!

Cindy
Age: 13
City: Denver, Colorado

Cindy's drawing really gets your imagination going. Is the hovering device a giant vacuum cleaner sucking up all the trash off the streets? Or is a UFO causing a gravitational disturbance in Rome? Why don't you write a story about this picture and mail it in to me?

EPISODE 5 The Cool Cloud Colony
The Cool Cloud Town

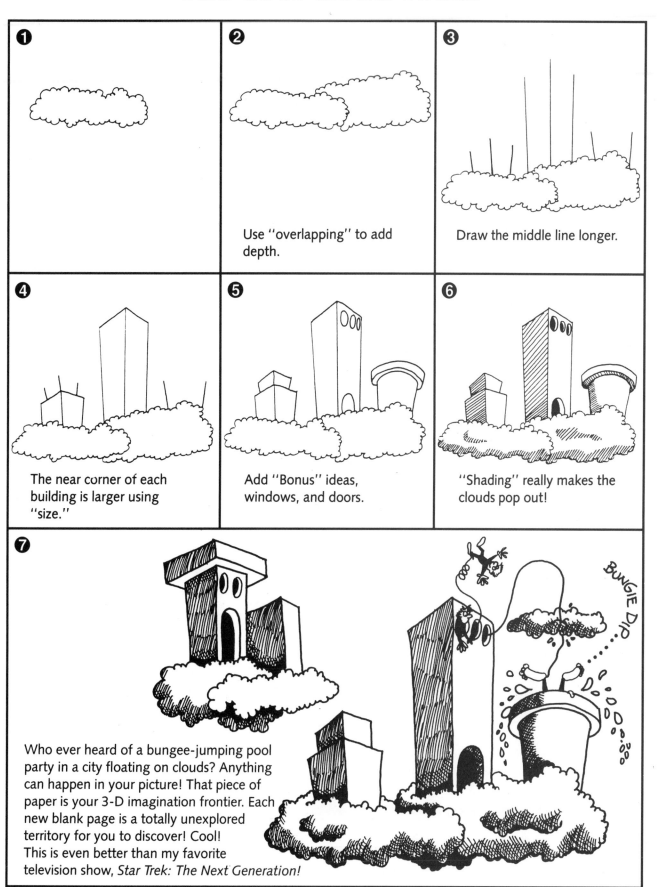

❶

❷ Use "overlapping" to add depth.

❸ Draw the middle line longer.

❹ The near corner of each building is larger using "size."

❺ Add "Bonus" ideas, windows, and doors.

❻ "Shading" really makes the clouds pop out!

❼ Who ever heard of a bungee-jumping pool party in a city floating on clouds? Anything can happen in your picture! That piece of paper is your 3-D imagination frontier. Each new blank page is a totally unexplored territory for you to discover! Cool! This is even better than my favorite television show, *Star Trek: The Next Generation!*

BUNGIE DIP

Pondering Pencil Possibilities Practice Page

PRACTICE, PRACTICE, PRACTICE!

Draw nine to ten hours every day, keep a super-positive mental attitude, and mail me lots of drawings! Draw an amazing cool cloud colony with over a thousand buildings below.

Tape a giant piece of paper under the kitchen table. Lie on your back and pretend that you're Michelangelo painting the masterpiece in the Sistine Chapel! For more great art history projects, look at Appendices C and D.

EXPLORE: To search, for the purpose of discovery! Sounds like a familiar pastime, doesn't it? You explore new drawings every day!

Cloud Dude

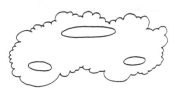
"Foreshorten" the holes.

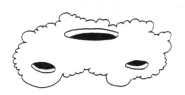
Add thickness to the holes.

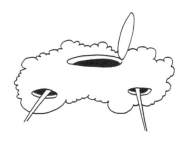
"Overlap" the legs.

Remember to use the thickness rule! Notice how I have drawn the back leg of the cloud jumper shorter than the front two? This is because I've used *placement* (Renaissance Word). Action lines in the hair and the landing-gear flaps give the drawing movement.

Environmentally Sound Popcorn-Propulsion Unit!

PRACTICE, PRACTICE, PRACTICE!

Draw an entire fleet of cloud dudes having a cloud-jumping contest.

SUPER STORY STARTER:

"Hurry up!" Shelley yelled over her shoulder as she steered her cloudmobile over an unusually puffy cloud. "If you don't speed up, the others are going to catch up!"

I'm flying as fast as this thing will go!" Melissa shouted back from her own cloud vehicle. She was nearly fifty meters behind Shelley and falling back steadily.

The day had started out as a nice quiet cloud stroll, with Shelley and Melissa lazily flying around the early morning cloud formations. They had been taking in the sights below when an entire fleet of fourth-graders suddenly swooped up behind them and challenged them to a race!

Now, you finish the story!

Super-Splendid Student Sketches

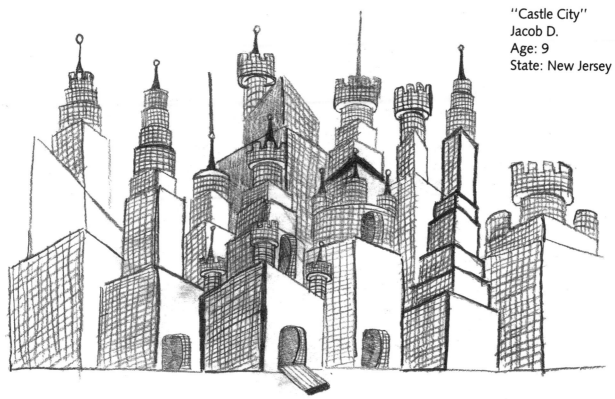

"Castle City"
Jacob D.
Age: 9
State: New Jersey

These two drawings, created by Jacob and Jacob, are marvelous examples of *size*. Notice how the near corners of all the buildings are drawn larger than the far sides? These cities are also drawn from a different viewpoint. They are drawn above your eye level, which makes them appear to be towering above you! The *horizon* line is drawn below the city, instead of behind it, and *shading* really makes each building pop out of the paper. Fantastic looking-up cityscapes, dudes! Keep drawing the great work!

"Cool City"
Jacob
Age: 9
City: San Diego, California

"Super City"
Carol Dawn Hickey
Age: 11
City: Long Island, New York

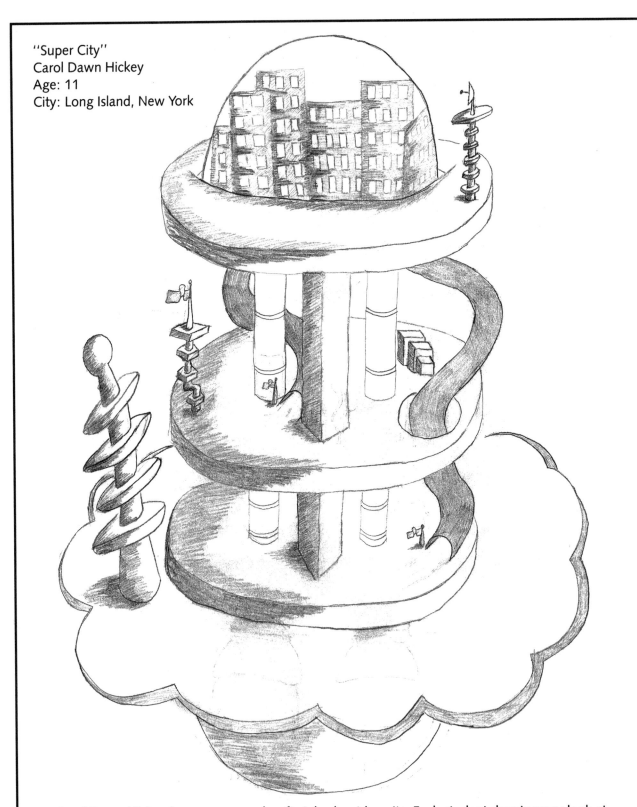

Carol Dawn Hickey has a very round, soft style about her city. Each student drawing you look at in this book has its own unique style. The more you practice your drawing, the more definite your own artistic style will become. Experiment with as many different styles as you can think of, then go to the library and look at illustrations in children's books to study some more!

Pondering Pencil Power
U.S.S. *Genius*

❶

❷

❸

Curve end a lot!

❹

❺

❻

❼

I used *size* on the rocket by drawing the near end larger. This pushes the tip away toward deep space. From now on, for the rest of your brilliant life, I want you to think of this sketch whenever you pick up a pencil. I want you to think of every pencil as your personal imagination-exploration Pencil Power Rocket. Yup! Even when you're 142 years old, I want you zooming your pencil across the paper, time-traveling into deep space, under the ocean, anywhere and everywhere your imagination takes you!

USS GENIUS

Pondering Pencil Possibilities Practice Page

PRACTICE, PRACTICE, PRACTICE!

In the blank space below, draw three giant Imagination Power-Pencil Shuttles. Connect them all together with a cereal-power fuel tube. Now draw galactic planets behind them. Wow! What kind of story can you write about this picture? Mail me your drawings soon. I'm eager to see how you are doing with all this 3-D learning!

Take a good look at the pencil you are holding in your hand. What do you see? Most people see a stick of painted wood with an eraser at one end and a lead point at the other. My goal in this book is to get you to look at that pencil in a new way. I want you to see a Super-High-Tech Time-Traveling Imagination Idea-Transforming Shuttle! Each time you pick up a pencil, I want you to imagine yourself the pilot of this amazing idea-transportation device, ready to launch across that flat surface of blank paper to create totally spectacular 3-D drawings!

PRODIGY: An exceptionally talented child; one with extraordinary gifts. I bet it didn't take long for you to think, "Hey, this word totally describes me!" You are a *prodigy*!

The Orbiting Multimodule Station

❶

A

B

C

❷

Curve the bottom, and add "Foreshortened" holes.

❸

❹

Aha! "Overlapping" again!

❺

❻

❼

When you are shading curved objects like this orbiting space station, it's a good idea to blend the shading. In my drawing I've used an ink pen to shade with a style called *cross-hatching*. Since you are using a pencil, you can take your finger and blend the shading from dark to light. There are shading blending tools you can buy at your local art store. They are called *stumps*. Basically, they are just tightly rolled paper pencils that you rub on your drawing to blend the darkness. You can make your own just by crumpling a piece of scratch paper into a sharp point. Blend your shading on round objects and you will give your drawing that totally professional 3-D look.

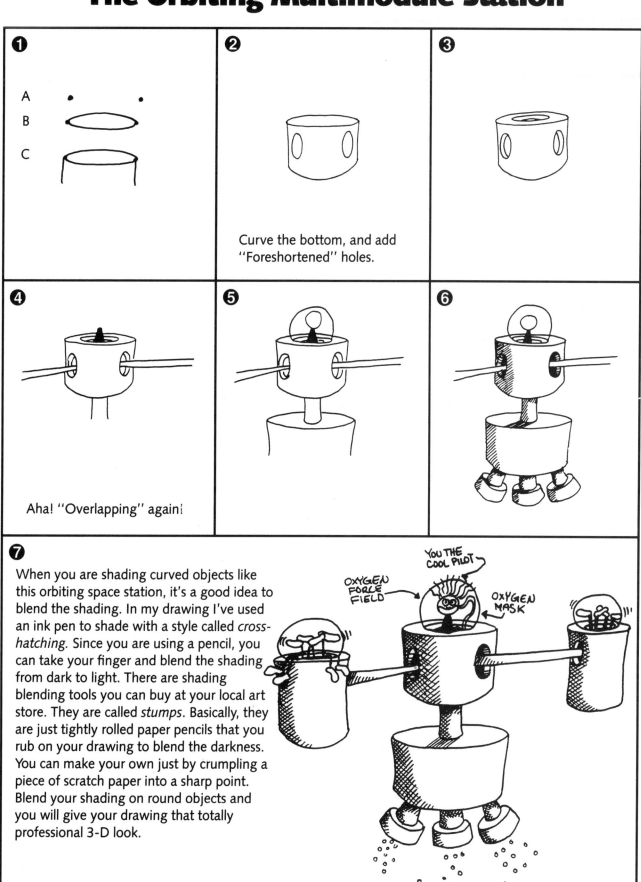

OXYGEN FORCE FIELD

YOU THE COOL PILOT

OXYGEN MASK

Pondering Pencil Possibilities Practice Page

PRACTICE, PRACTICE, PRACTICE!

Redraw the orbiting Multimodule Space Station below. This time, add six modules sticking out of the sides instead of two. Now shade each module extra dark on the side. Using your finger, blend the shading from dark to light. Blending the shading creates a really neat effect. Your friends are going to be thoroughly impressed!

SUPER STORY STARTER:

"Breakfast time!" the first-graders shouted with glee as they dived upside down in the eating modules. Breakfast time was party time for these young space explorers.

Every morning, when the Earth rose over the horizon of the Moon, the first-graders would jump out of their sleeping compartments and rush over to the eating modules. There, several tons of delicious cereal was poured onto the floor of the chamber, and the room became one giant breakfast bowl. It was quite a peculiar sight if you were watching them from a nearby space orbiter. Dozens of little feet flopping around inside the atmosphere shells. Crunching sounds and occasional "yum!" sounds drifting out of the module. "More milk please!" hollered someone as politely as they could, while tunneling through the mountain of cereal.

Now, you finish the story! Where are the first-graders heading? What solar system are they from? Don't they believe in using spoons, or are utensils considered rude on their home planet?

Super-Splendid Student Sketches

Kelly
Age: 7
City: Houston, Texas

Kelly has a great idea with the Double-Module Launch Rocket. I like the way thrusters fire from the top module as well as from the bottom of the rocket. The *horizon* line below the rocket makes the launch a complete success! Fantastic drawing, Kelly!

Mark Wells
Age: 9
City: Tampa, Florida

Even though ten years have passed since I starred in public television's drawing series for children *The Secret City*, thousands of kids still mail me exotic space-city drawings. Mark's super-secret cities use all the twelve Renaissance Words of 3-D drawing. Can you spot all twelve? Cool drawing, Mark, and your name is very cool too!

Mark Wells
Age: 9
City: Tampa, Florida

The Magnificent Moon Base
The 3-D Lunar Lander

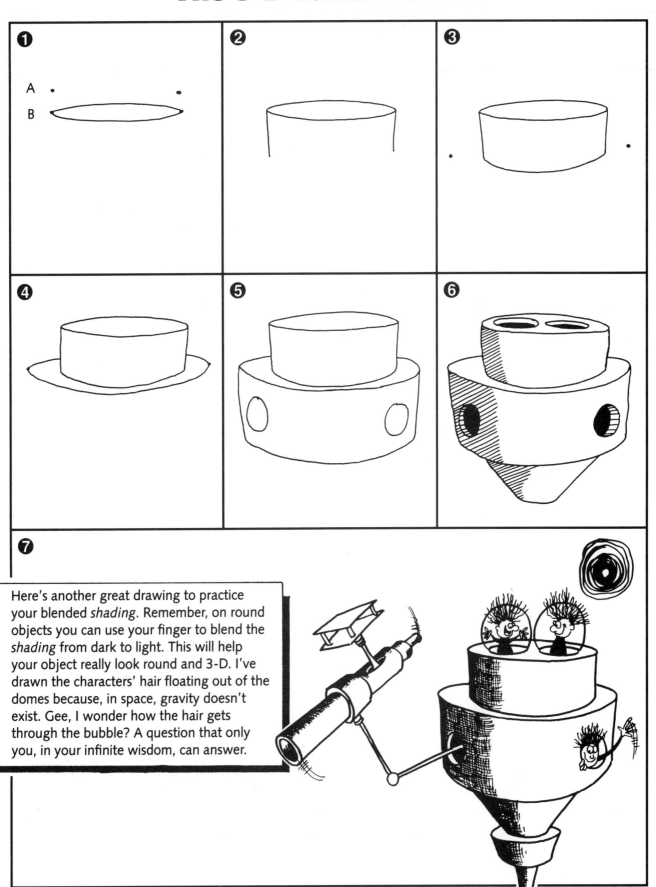

❶

A . .

B

❷

❸

❹

❺

❻

❼

Here's another great drawing to practice your blended *shading*. Remember, on round objects you can use your finger to blend the *shading* from dark to light. This will help your object really look round and 3-D. I've drawn the characters' hair floating out of the domes because, in space, gravity doesn't exist. Gee, I wonder how the hair gets through the bubble? A question that only you, in your infinite wisdom, can answer.

Pondering Pencil Possibilities Practice Page

PRACTICE, PRACTICE, PRACTICE!

What kind of Lunar Lander are you going to draw below?

Today's Creative Challenge: Ask your parents to tape a giant piece of paper to your bedroom wall. Then draw a Moon with thousands of Lunar Landers approaching!

EXTRAORDINARY: Beyond what is common or usual; remarkable. A term your parents use when they look at your drawings.

Moonmobile

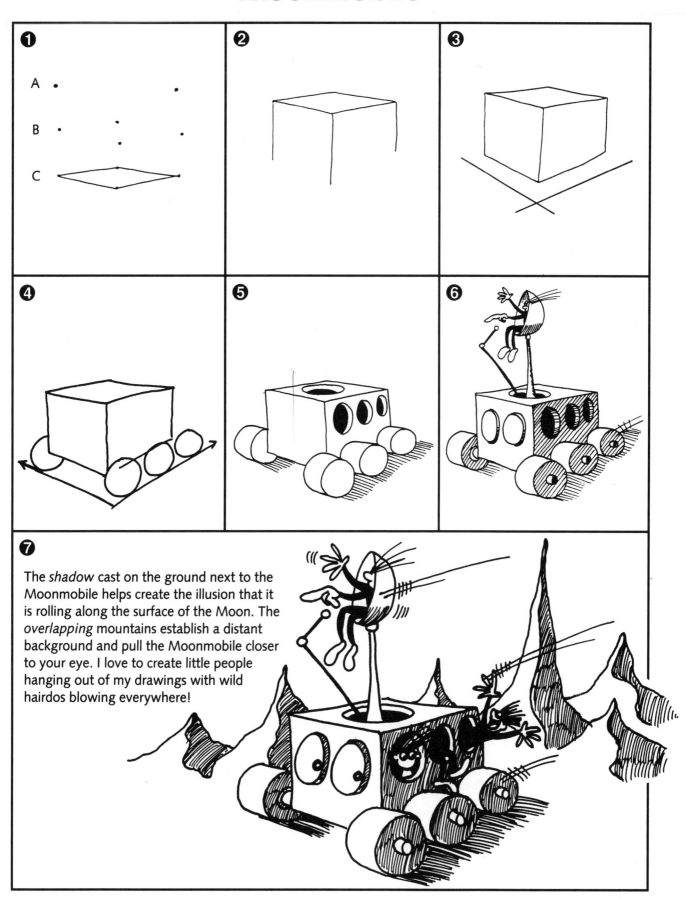

7 The *shadow* cast on the ground next to the Moonmobile helps create the illusion that it is rolling along the surface of the Moon. The *overlapping* mountains establish a distant background and pull the Moonmobile closer to your eye. I love to create little people hanging out of my drawings with wild hairdos blowing everywhere!

PRACTICE, PRACTICE, PRACTICE!

You can draw round Moonmobiles, stacked Moonmobiles, or even Moonmobiles with legs! Draw twenty Moonmobiles below.

Today's Creative Challenge: Now that you have had your parents tape up the giant piece of paper in your bedroom and you have drawn thousands of Lunar Landers approaching, how about adding a long column of Moonmobiles rolling across the surface of the Moon? Try attaching the Moonmobiles to make a 300-mile-long Moon train.

Super-Splendid Student Sketches

Jan
Age: 40+
City: Houston, Texas

Jan went wild with his pencil power during one of my evening family drawing nights at an elementary school in Houston, Texas. He created the most amazing hot dog stand that I have ever seen!

You don't always have to draw cartoons to create the 3-D look. See how Nathan used the twelve Renaissance Words of drawing to illustrate the view outside his window? Always carry your paper and pencil with you. There is always something interesting to draw wherever you are, from bus stops to grovery stores. If you have your pencil with you, you'll never feel bored again.

Nathan Herber
Age: 11
City: San Francisco, California

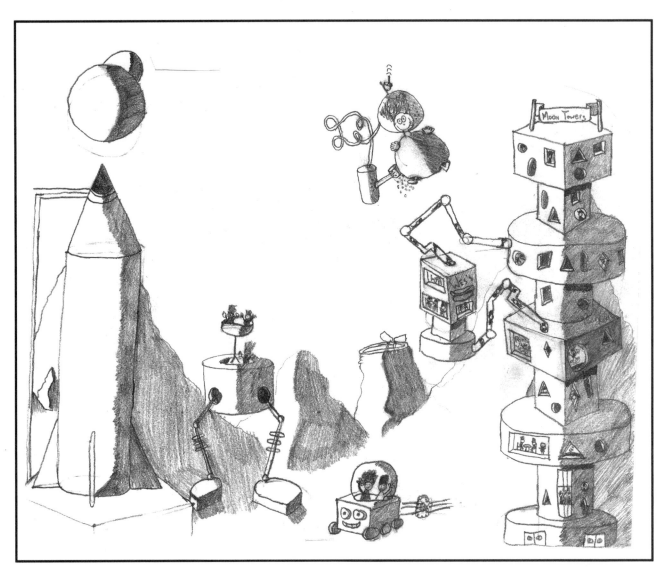

Anne
Age: 9
City: Chicago, Illinois

Wow! Anne has really got the handle on *shading*. I really like the Floating Bubble Dude with the 3-D breathing tank and air hose. What a unique idea!

The Great Undersea Adventure
King Clam

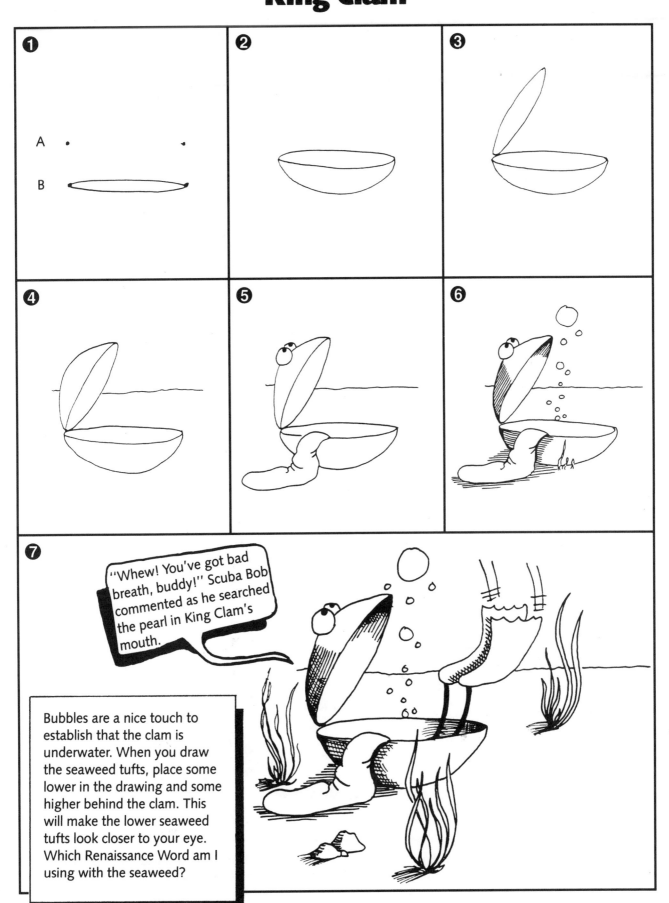

① A • •

 B ⸺

②

③

④

⑤

⑥

⑦

"Whew! You've got bad breath, buddy!" Scuba Bob commented as he searched the pearl in King Clam's mouth.

Bubbles are a nice touch to establish that the clam is underwater. When you draw the seaweed tufts, place some lower in the drawing and some higher behind the clam. This will make the lower seaweed tufts look closer to your eye. Which Renaissance Word am I using with the seaweed?

Pondering Pencil Possibilities Practice Page

PRACTICE, PRACTICE, PRACTICE!

How about drawing an entire underwater scene complete with clams, fish, and a giant whale!

TODAY'S GENIUS WORD: **GOAL**

After you fill up the above blank space with a beautiful undersea drawing, try adding color to enhance your picture. Use color crayons, color pencils, or if you are feeling really adventuresome, try watercolor paints!

GOAL: A purpose or objective; the winning line in a race. If you have a clear goal each and every day, you are going to be a winner in life. My *goal* with this book is to teach you how to draw amazing 3-D adventures. How am I doing?

Trumpet Tower

❶

❷ Place guide dots.

❸ Curve *behind* post.

❹

❺ Add thickness to the windows on opposite sides.

❻

❼

To create the feel of water currents, I curled the hair in a flowing side direction. Try this in your drawing. Action lines on the fish and floating bubbles add movement to the picture. The *thickness rule* applies here: The window on the right has the thickness on the right. The window on the left has the thickness on the left. The window in the middle has the thickness in the middle. Easy! Add a few bricks for a "textured" look.

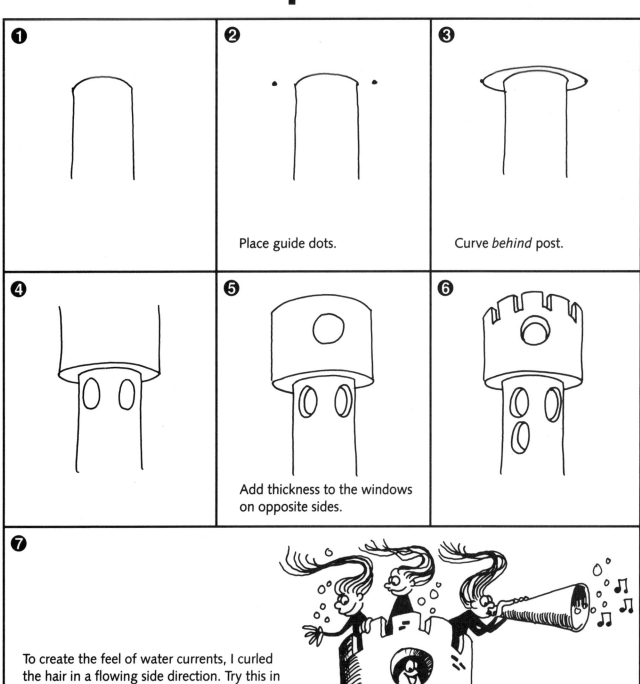

Pondering Pencil Possibilities Practice Page

PRACTICE, PRACTICE, PRACTICE!

Draw the entire 3-D underwater castle below. Try to make the whole castle above your eye so it looks as if you are looking up at it from the ocean floor.

SUPER STORY STARTER:

Karl put the giant trumpet to his lips and blew with all his might. A stream of bubbles sang out of the horn with such force that it shook the castle tower.

"One more time!" his sister Mari coaxed. "We've got to let the whales know what's happening!"

Karl had been blowing message bubbles all morning and felt completely bubbled out. "I can't quit now!" Karl mumbled to himself and gasped in another huge gulp of sea water.

You finish the story! Why are they trying to communicate with the whales? Why are they living underwater? How do Karl and Mari breathe? Finish the story and mail me a copy today. I've got to find out what happens next!

Super-Splendid Student Sketches

Trouble in Twinke VilleRiver

"Trouble in Twinkeville River"
Sean
Age: 10
City: Ft. Wayne, Indiana

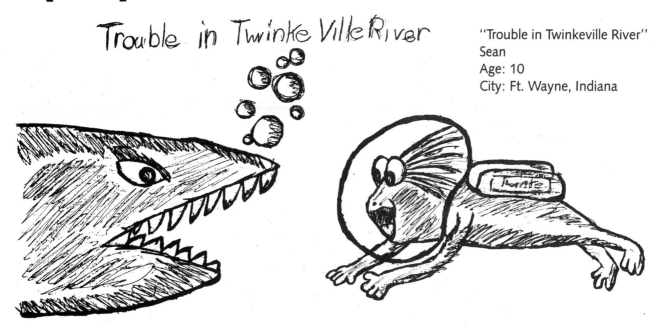

Sean's underwater scuba-twinkie adventure is a splendid example of how you can take an ordinary object and create an entirely new theme for your drawings. Have you ever seen the computer screen saver of the toasters with wings flying through the air? Or how about the M&M cartoon candy dudes? You can make anything into an exciting 3-D drawing!

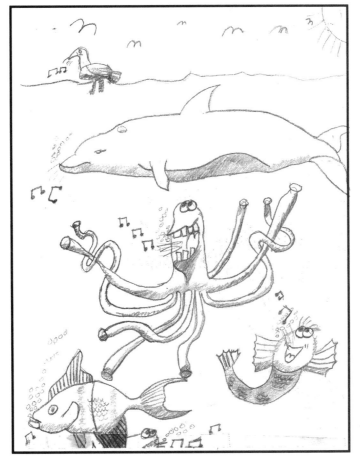

"Song of the Sea"
Betty
Age: 11
City: Seattle, Washington

Music under the sea! It's a Porpoise Party! I love the layered look Betty created by drawing some of the critters on the surface of the ocean and some far below. Totally cool drawing, Betty!

EPISODE 9 An Ocean Odyssey
3-D Treasure

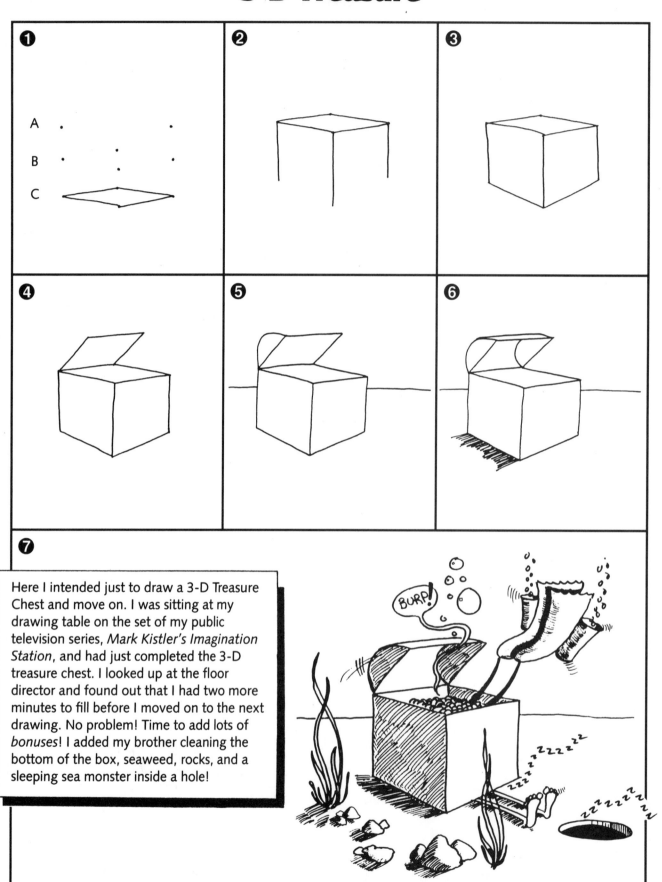

7

Here I intended just to draw a 3-D Treasure Chest and move on. I was sitting at my drawing table on the set of my public television series, *Mark Kistler's Imagination Station*, and had just completed the 3-D treasure chest. I looked up at the floor director and found out that I had two more minutes to fill before I moved on to the next drawing. No problem! Time to add lots of *bonuses*! I added my brother cleaning the bottom of the box, seaweed, rocks, and a sleeping sea monster inside a hole!

BURP!

Pondering Pencil Possibilities Practice Page

PRACTICE, PRACTICE, PRACTICE!

Let's go on a deep undersea treasure hunt! Put on your scuba gear, grab your pencil and paper. Let's go! Draw your scuba adventure below.

Today's Creative Challenge is to create an undersea picture with book fish. Book fish are reading books with fish fins and gills. Similar to Sean's drawing of a scuba twinkie, your book fish can be swimming in a huge school of other book fish, pencil fish, shoe fish, and toothbrush fish!

ODYSSEY: An extended adventurous wandering. Each time you pick up your pencil, you have an imagination *odyssey*!

Thresher Shark

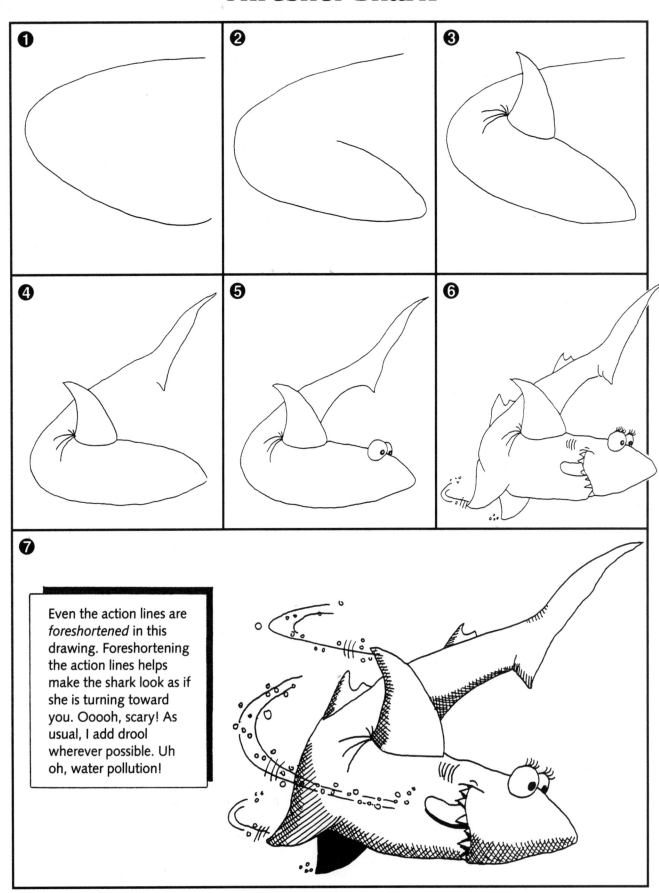

❼

Even the action lines are *foreshortened* in this drawing. Foreshortening the action lines helps make the shark look as if she is turning toward you. Ooooh, scary! As usual, I add drool wherever possible. Uh oh, water pollution!

Pondering Pencil Possibilities Practice Page

PRACTICE, PRACTICE, PRACTICE!

Try drawing 3-D sharks going in different directions. Draw some very small so they appear really far away, and draw some huge to make them look as if they are ready to swim right off the paper!

Today's Creative Challenge is to visit your library and check out two books on sharks. Draw a picture of ten different species of sharks, including the thresher, tiger, blue, nurse, hammerhead, white, and sand sharks. Shark out, dudes!

Super-Splendid Student Sketches

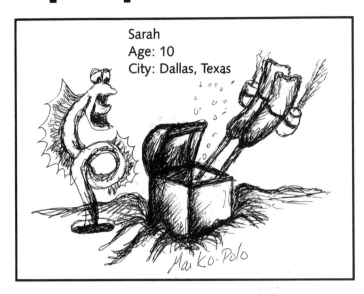

Sarah
Age: 10
City: Dallas, Texas

Mai Ko-Polo

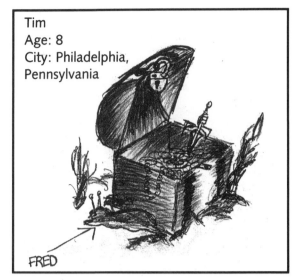

Tim
Age: 8
City: Philadelphia,
Pennsylvania

FRED

Sarah's using a very nice loose sketchy *style* to draw his 3-D Treasure Chest. Remember when I talked about how copying other artists' styles will help you develop your own? Well, here's a perfect example of this. Tim copied my lesson of the Treasure Chest, then added *bonus* ideas, *shading* it with his own unique sketchy style. He's been practicing a lot! Good job, Tim!

Joseph decided to have a poetry attack with his shark drawing! I love getting the poems and stories you kids mail me! You folks are so creatively brilliant, you never cease to amaze me! Like many of the pieces I've received in the mail, I've hung Joseph's poem up in my office. Thanks for the artwork, Joseph!

Once there was a shark of blue,
Who ate sardines, oisters, carrots & stew.
He ate everything his mouth could find
His tummy was bigger than his mind.
Hot dogs, apples, starfish & mustard,
Apple pie, cream puffs, cobbler & custard.
Then one day when he was dining,
He came upon a hook that was shining
He thought it was a great snack
I'm sorry to say, he'll never be back!!

"A Shark of Blue"
Joseph Devens
Age: 9
City: Houston, Texas

90

EPISODE 10 Terrific Tree Town
The Amazon Tree Town

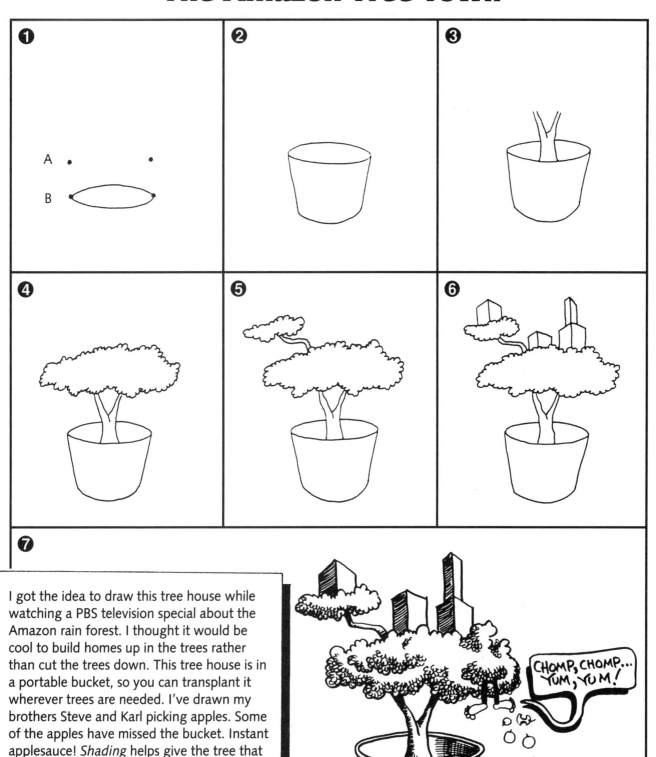

❼

I got the idea to draw this tree house while watching a PBS television special about the Amazon rain forest. I thought it would be cool to build homes up in the trees rather than cut the trees down. This tree house is in a portable bucket, so you can transplant it wherever trees are needed. I've drawn my brothers Steve and Karl picking apples. Some of the apples have missed the bucket. Instant applesauce! *Shading* helps give the tree that puffy texture.

CHOMP, CHOMP... YUM, YUM!

APPLESAUCE

Pondering Pencil Possibilities Practice Page

PRACTICE, PRACTICE, PRACTICE!

Draw an entire forest of mobile Tree Towns in rolling buckets below. Use *overlapping* and *foreshortening*.

Today's Creative Challenge is to visit your local library and check out the book *Fifty Things Kids Can Do to Save the Earth*. Pick five things from the book to do today. You kids are the planet's future!

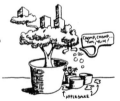

ENVIRONMENT: The surroundings or external condition of an area. Whenever you draw, you are creating a unique *environment* in your picture. You can get billions of ideas for your art from the natural environment of this cool planet, Earth. We all need to work really hard to save our environment.

The Gravity-Resistant Tree-Transplanting Module

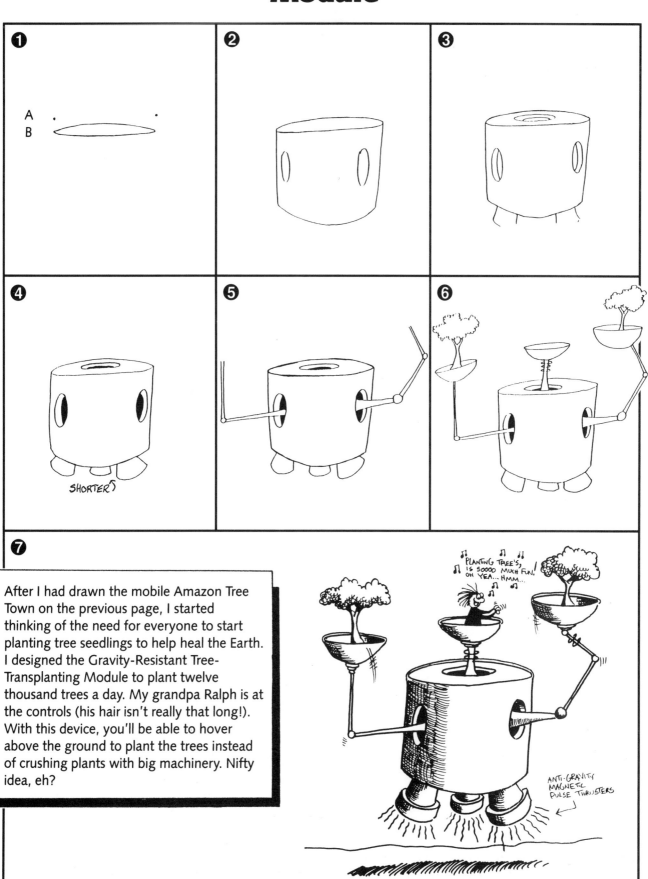

①

A · ·
B

②

③

④

SHORTER

⑤

⑥

⑦

After I had drawn the mobile Amazon Tree Town on the previous page, I started thinking of the need for everyone to start planting tree seedlings to help heal the Earth. I designed the Gravity-Resistant Tree-Transplanting Module to plant twelve thousand trees a day. My grandpa Ralph is at the controls (his hair isn't really that long!). With this device, you'll be able to hover above the ground to plant the trees instead of crushing plants with big machinery. Nifty idea, eh?

PLANTING TREE'S, IS SOOOO MUCH FUN! OH YEA... HMM...

ANTI-GRAVITY MAGNETIC PULSE THRUSTERS

Pondering Pencil Possibilities Practice Page

PRACTICE, PRACTICE, PRACTICE!

There's a huge hole in the forest below. Quick! Draw a team of hovering Tree-Transplanting Modules to replant the area.

The Gravity-Resistant Tree-Transplanting Module may seem like a far-fetched idea, just as the space shuttle was a wild idea thirty years ago. Every invention that we have today had to be dreamed up in someone's imagination! From computers to roller blades, imagination made it happen.

A few years ago, while teaching a summer drawing class near the NASA space center in Clear Lake City, Texas, I actually taught space scientists how to draw in 3-D! The scientists were designing the sleeping modules of the space station and needed to understand how to transfer their ideas into 3-D drawings. These dudes actually sat in with all the kids for the whole week! After a while I couldn't tell the kids apart from the scientists! So much brain creative power in one room, whew!

Super-Splendid Student Sketches

Dee Dee Huffman
Art teacher
City: Bluffton, Indiana

This is a wonderful drawing by a teacher in Bluffton, Indiana. Oftentimes when I visit elementary schools, the teachers have as much fun as the kids! Drawing in 3-D is fun for everyone! Look how she has drawn the detailed thickness on each of the pickets in the fence. I love that kind of cool detail.

Super-Splendid Student Sketches

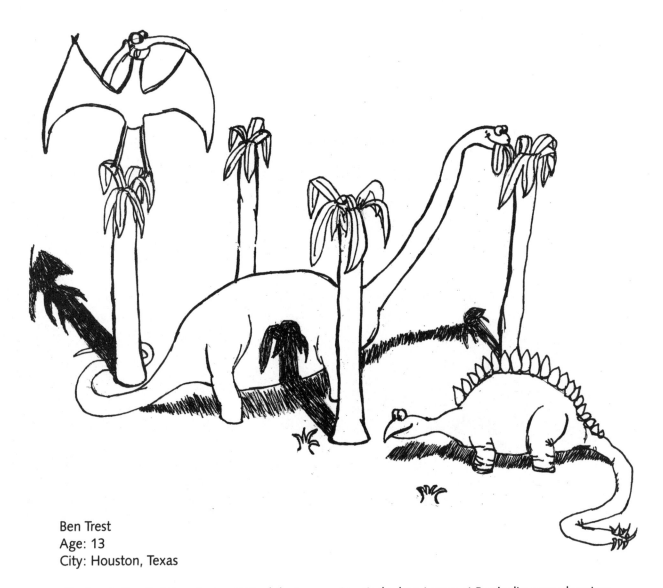

Ben Trest
Age: 13
City: Houston, Texas

Shadow is the first Renaissance Word that comes to mind when I gaze at Ben's dinosaur drawing. By drawing the shadow on the ground under the necks of the dinosaurs, he created the illusion that their heads were high off the ground. Ben was very detail conscious. He even wrote in the time of his summer drawing class, with my name under his. He is going to grow up to be a great time manager!

EPISODE 11 The Voyage of Ideas
The 3-D Pencil Sloop

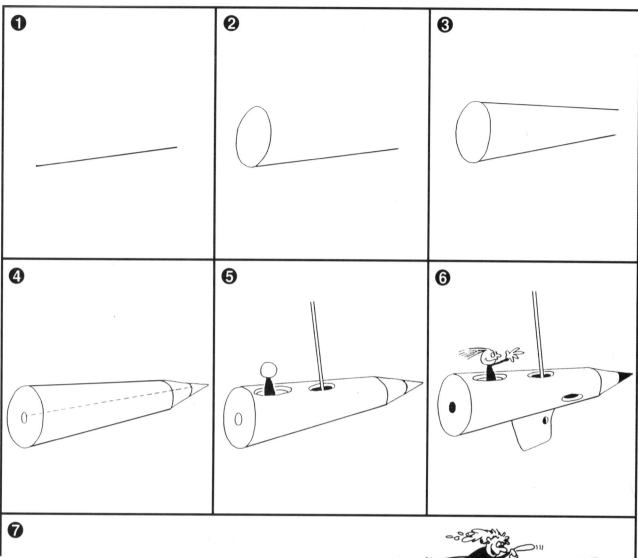

❼

The 3-D Pencil Sloop sails across the Sea of Ideas. I love to sail! When I'm not busy drawing, I rush down to the harbor to sail my Catalina sloop. Of course I always carry my sketch pad and pencil with me, even on a sailboat! I've drawn many things while sailing the blue waters off the coast of southern California and Mexico. Dolphins, whales, flying fish, seagulls, sunfish, starfish, rock islands, sunsets, storm clouds, waves, and even sharks! I've drawn my brother Karl trying to keep the sloop from sailing into outer space. Uh ohh! A dorsal fin flying a white flag? What could this be?

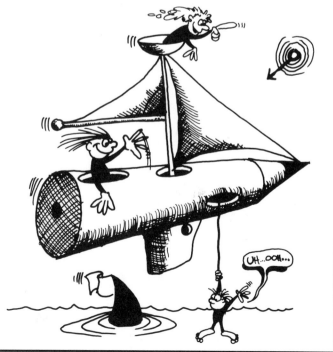

PRACTICE, PRACTICE, PRACTICE!

What do you love to do? I love to sail, so I draw sailing vessels and sea life. Why don't you draw a picture below of something you love to do? I often say that drawing is a window to your soul. Let your drawings reflect your personality. If you love horses, draw an entire planet of horses. If you love football, draw a planet that *is* a football.

TODAY'S GENIUS WORD:
ATTITUDE

SUPER STORY STARTER:

"Hard to the port!" Harry bellowed down from the observation seat high above the boat deck.

"Which way is port?" Joyce responded in a bewildered voice. "You know I'm bad with directions!"

"To the left. It's to the left!" Harry yelled to be heard over the gust of wind. "Look! There she blows! Whales on our starboard—I mean our right side!"

You finish the story! Let me know what happens next, okay?

ATTITUDE: A state of feeling; a manner of carrying oneself; posture. I've listed this as one of the twelve Renaissance Words of drawing because it's very important. If you have a positive, "Yes I can do this!" *attitude,* you can learn how to do anything you set your mind to do!

The Tidal Wave of Creative Success

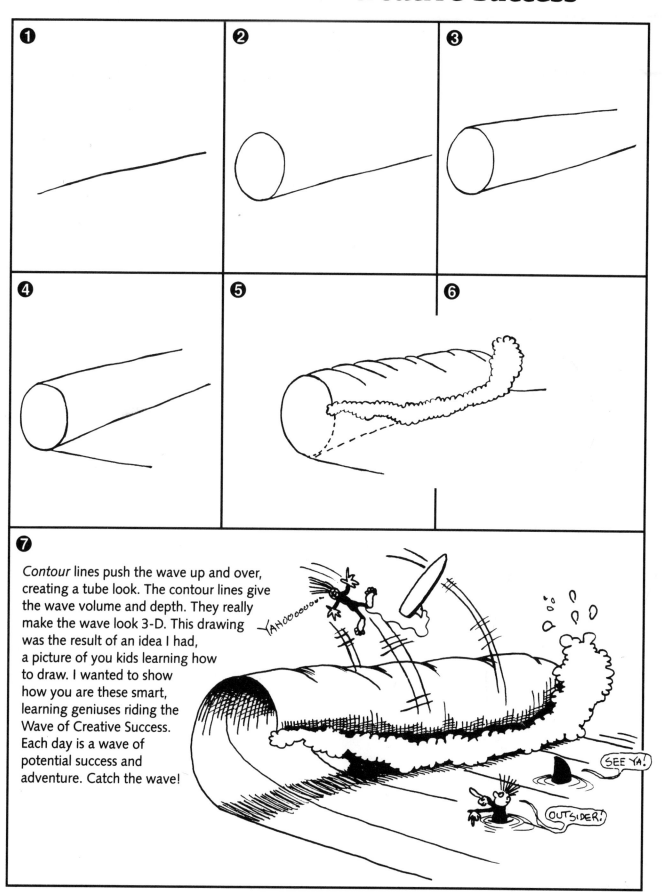

❶

❷

❸

❹

❺

❻

❼

Contour lines push the wave up and over, creating a tube look. The contour lines give the wave volume and depth. They really make the wave look 3-D. This drawing was the result of an idea I had, a picture of you kids learning how to draw. I wanted to show how you are these smart, learning geniuses riding the Wave of Creative Success. Each day is a wave of potential success and adventure. Catch the wave!

PRACTICE, PRACTICE, PRACTICE!

Drawing in 3-D helps you think in 3-D. When you think in 3-D, you can dream in 3-D! I always dreamed of owning my own sailing sloop. I used to stare out into the ocean and dream in 3-D about sailing my very own vessel. It took five years of 3-D dreaming, but it happened! Dreams do come true, especially if you dream in 3-D! What is your big dream? Draw a 3-D picture of it below.

SUPER STORY STARTER:

''Yeeeee haw!'' Ian screamed with delight as he punched out of the back of the enormous wave, completing a near-perfect cartwheel in the air. Ian gulped in a breath of air before he splashed back down to the ocean below.

Suddenly water crashed all around him, almost knocking the air out of his lungs. Ian struggled to swim up to the surface, without much luck. The water was like churning foam. A hard tug reminded Ian that his surfboard leash would pull him back to the surface . . . eventually.

''I sure hope I can hold my breath long enough!'' he thought to himself. Relaxing his struggling arms, he let the leash tug him back to the surface. In the next instant Ian popped out and bobbed in the ocean like a cork.

''Ahhh! Air sure does taste good!'' Ian gasped in lungfuls of fresh air. His surfboard was bobbing next to him. He climbed on and headed back out for the next wave.

You finish the story.

Super-Splendid Student Sketches

Rebecca
Age: 6
City: Carlsbad, California

Ah! Nothing quite like an afternoon sail! Rebecca's fine pencil rendering of a 3-D Floating Pencil Sloop uses lots of *shading* to create *depth*.

Alex
Age: 6
City: Oakland,
California

"Look, Mom! No hands!" Alex's 3-D Surfing Dude doesn't even need a wave to surf! I like the hair blowing back in the wind and the floating seashells.

Anne combined a whole bunch of drawing lessons from our weeklong summer art camp to create this action-packed beach scene. See if you can find my brother's feet sticking out of the sand.

"The Pencil Regatta"
Anne Aydinian
Age: 12
City: Houston, Texas

EPISODE 12 Delightful Diving Dolphins
Dave the Daring Diving Dolphin!

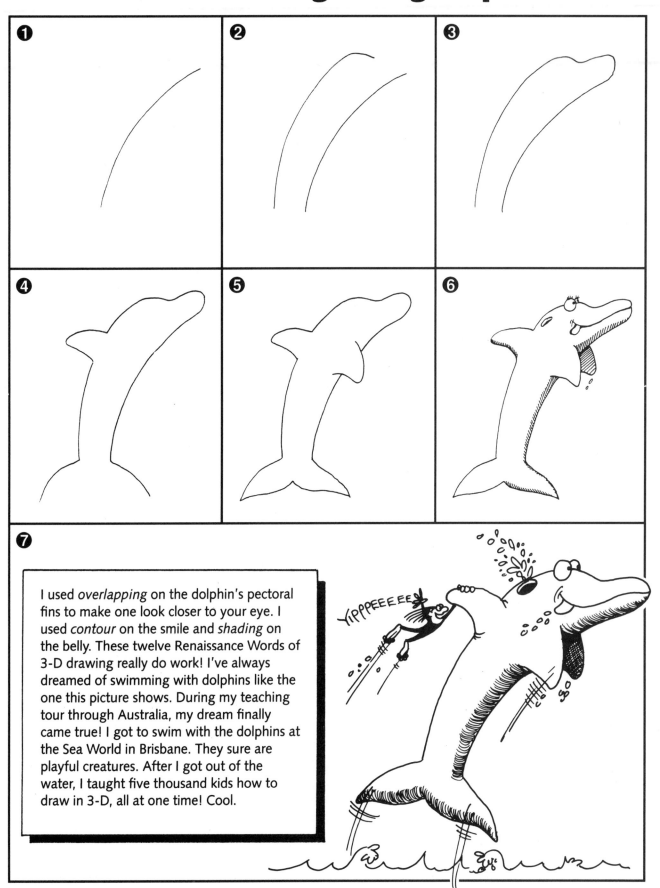

❼

I used *overlapping* on the dolphin's pectoral fins to make one look closer to your eye. I used *contour* on the smile and *shading* on the belly. These twelve Renaissance Words of 3-D drawing really do work! I've always dreamed of swimming with dolphins like the one this picture shows. During my teaching tour through Australia, my dream finally came true! I got to swim with the dolphins at the Sea World in Brisbane. They sure are playful creatures. After I got out of the water, I taught five thousand kids how to draw in 3-D, all at one time! Cool.

Pondering Pencil Possibilities Practice Page

PRACTICE, PRACTICE, PRACTICE!

Draw six dolphins below doing jumping tricks at sunset in the open ocean. Why not add yourself and your friends riding them?

SUPER STORY STARTER:

"Wait, Dave! Don't jump!" I yelled, trying to hold on to his dorsal fin with all my strength.

"IF Willy could do it, so can I!" Dave calmly responded as he swam even faster toward the breakwater wall of the lagoon. The wall was coming up fast. I closed my eyes murmuring, "But Willy was a whale, a very big whale!"

You finish the story.

(Have you noticed that all my Story Starters have people hollering, yelling, and bellowing? I have a very loud imagination!)

SCIENTIST: A person acquiring knowledge through systematic study. So, basically you are a drawing *scientist*! You are acquiring knowledge about 3-D drawing through systematic study, practice, and by having daily art attacks!

The Amorous Angelfish

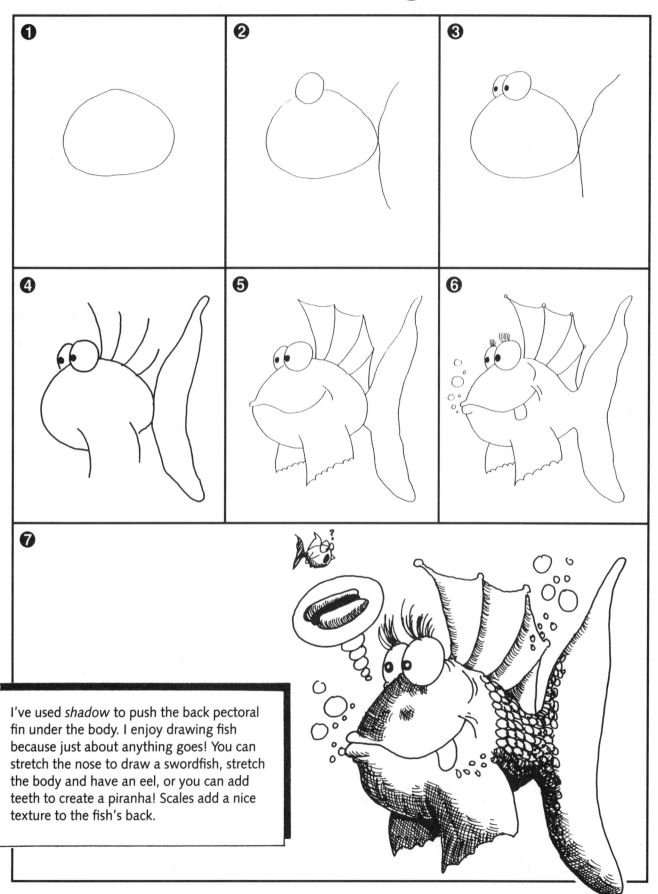

I've used *shadow* to push the back pectoral fin under the body. I enjoy drawing fish because just about anything goes! You can stretch the nose to draw a swordfish, stretch the body and have an eel, or you can add teeth to create a piranha! Scales add a nice texture to the fish's back.

Pondering Pencil Possibilities Practice Page

PRACTICE, PRACTICE, PRACTICE!

Draw a giant fishbowl for your room. Fill it with exotic fish that have all kinds of interesting shapes, fins, and hairdos!

Amy the Amorous Angelfish dreams of eating a delicious gourmet hot dog with mustard!

Super-Splendid Student Sketches

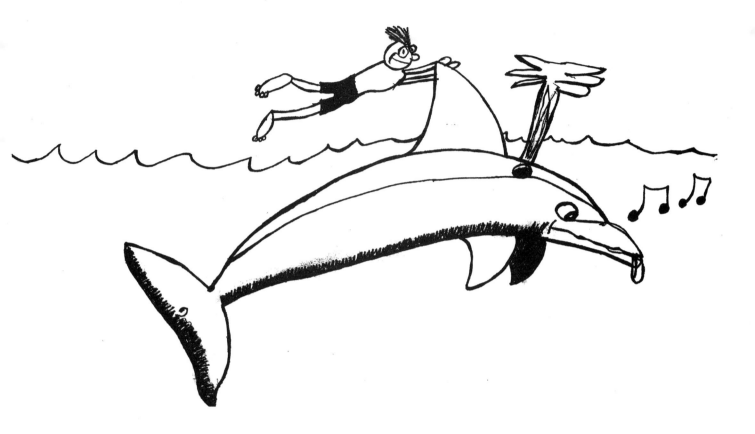

Nick decided to draw himself riding Dave the Diving Dolphin. Notice how Nick has a more realistic *style* in his drawings than I do in mine. He has drawn the eyes properly placed, and the body is more proportioned. You see? Everyone has his own drawing style! Mine happens to be very cartoony, while Nick's is more realistic. Nick is probably going to be the youngest scientific marine-research illustrator in the world! Keep up the great drawing, Nick.

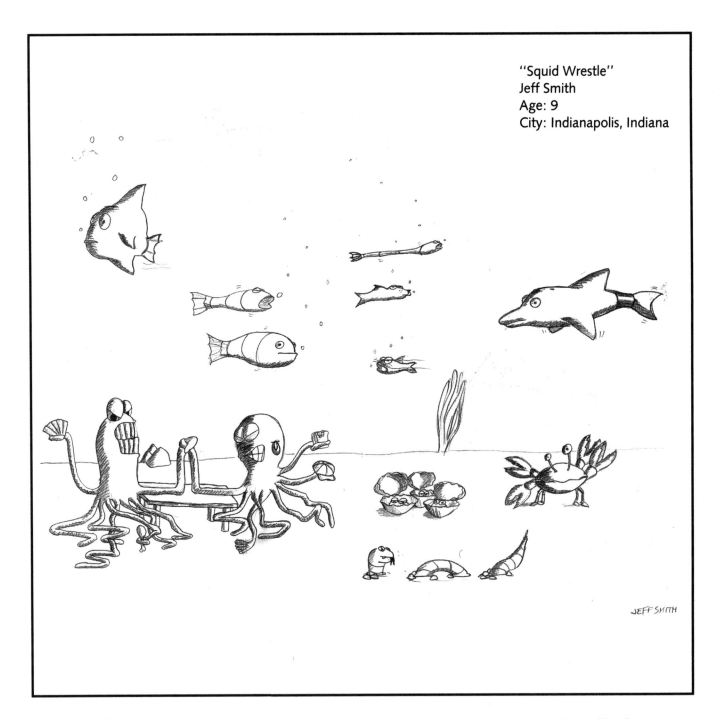

"Squid Wrestle"
Jeff Smith
Age: 9
City: Indianapolis, Indiana

JEFF SMITH

Jeff's drawing style is even more cartoony than mine. He even has squid arm-wrestling! I like the *foreshortened* detail on the clams and the *contour* lines on the fishies. Hey! Jeff even remembered to draw the *horizon* line to show us where the ocean floor is. Thanks, Jeff! Why don't you mail your drawings to me. I'd love to see how you are doing with the lessons. My address is on page 262.

Return to Dino Town
Slobbery Stegosaurus!

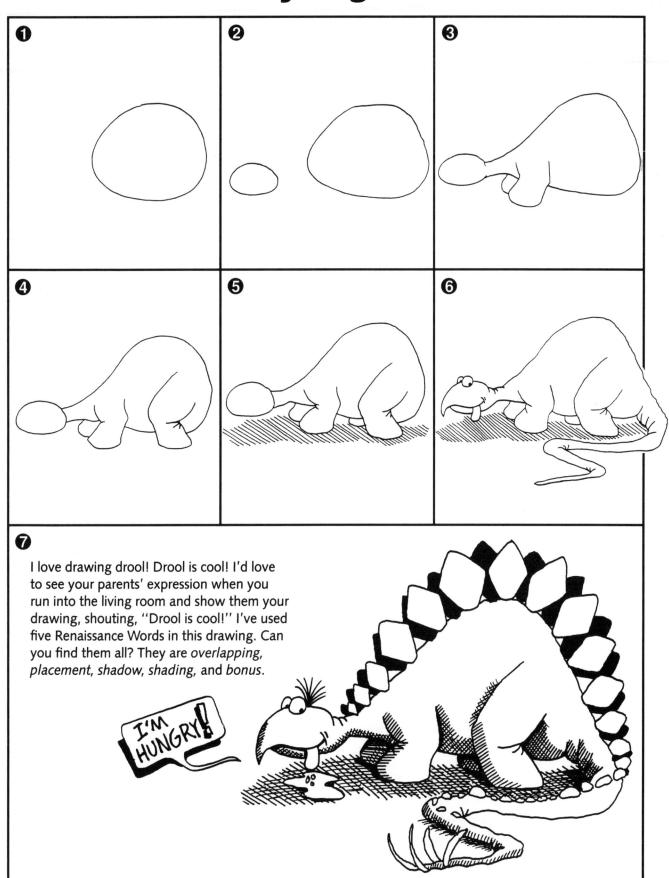

① ② ③ ④ ⑤ ⑥

⑦ I love drawing drool! Drool is cool! I'd love to see your parents' expression when you run into the living room and show them your drawing, shouting, "Drool is cool!" I've used five Renaissance Words in this drawing. Can you find them all? They are *overlapping, placement, shadow, shading,* and *bonus.*

I'M HUNGRY!

PRACTICE, PRACTICE, PRACTICE!

Draw a Stegosaurus ice-skating below. Be sure to draw on lots of safety gear. This dude looks pretty clumsy to me.

TODAY'S GENIUS WORD:
PHENOMENAL

Go to your local toy store and have your parents buy you some colored clay. Take the clay and sculpt a giant Stegosaurus. Now get your sketch pad and draw a picture of your sculpture! Try molding all kinds of dino-creatures, and draw pictures of them all!

PHENOMENAL: Extremely outstanding or unusual; marvelous. Yup! That about sums you up, eh? You are *phenomenal*!

Big Mama Brontosaurus

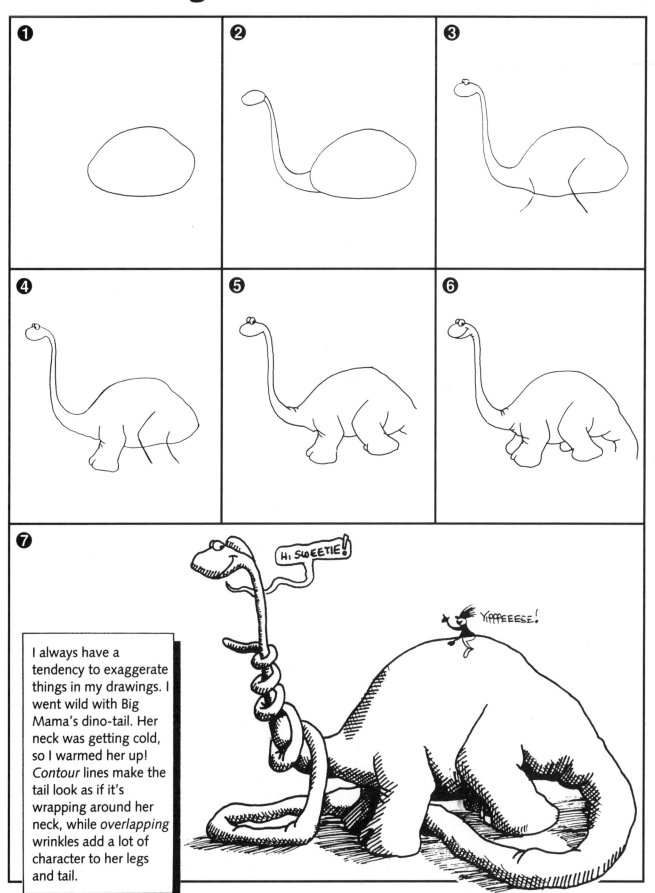

7

I always have a tendency to exaggerate things in my drawings. I went wild with Big Mama's dino-tail. Her neck was getting cold, so I warmed her up! *Contour* lines make the tail look as if it's wrapping around her neck, while *overlapping* wrinkles add a lot of character to her legs and tail.

HI SWEETIE!

YiPPPEEESE!

Pondering Pencil Possibilities Practice Page

PRACTICE, PRACTICE, PRACTICE!

Draw a Brontosaurus with the longest neck in the world. Now draw a group of fifth-graders sliding down her neck like a dino-rollercoaster!

SUPER STORY STARTER:

Sarah jostled her way through the line. It had taken her nearly an hour to get to the front, and now her turn was next! Bronto Mama's head swooped down to where Sarah was standing on the giant dinosaur's back. Sarah giggled when she felt Big Mama's breath, as Mama's huge nose lowered in front of her. Glancing over her shoulder, Sarah waved to the hundreds of kids behind her in line. "I'll see you later!" she yelled as she climbed up on the dinosaur's nose.

Bronto Mama slowly raised her head, carefully stretching her neck so that Sarah would have a nice long slide back down.

You finish the story!

Super-Splendid Student Sketches

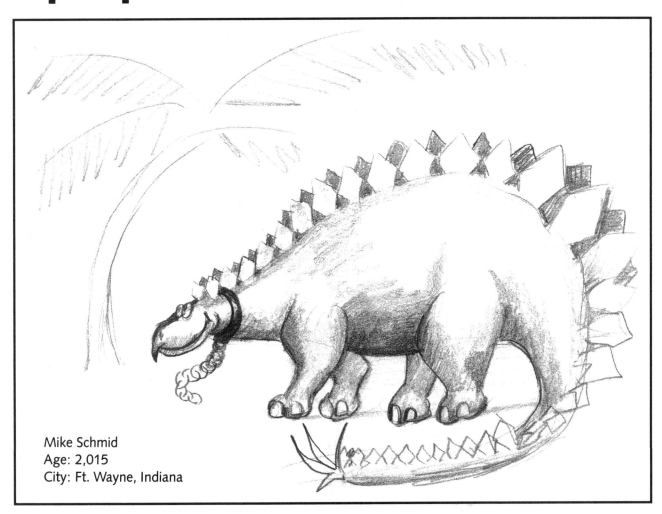

Mike Schmid
Age: 2,015
City: Ft. Wayne, Indiana

This is a 3-D Stegosaurus drawn by a friend of mine at one of my school assemblies in Fort Wayne, Indiana. When I visit elementary schools, even the teachers get to draw in 3-D! Aha! Drawing in 3-D is the perfect use for chalkboards and white boards in classrooms all over the world!

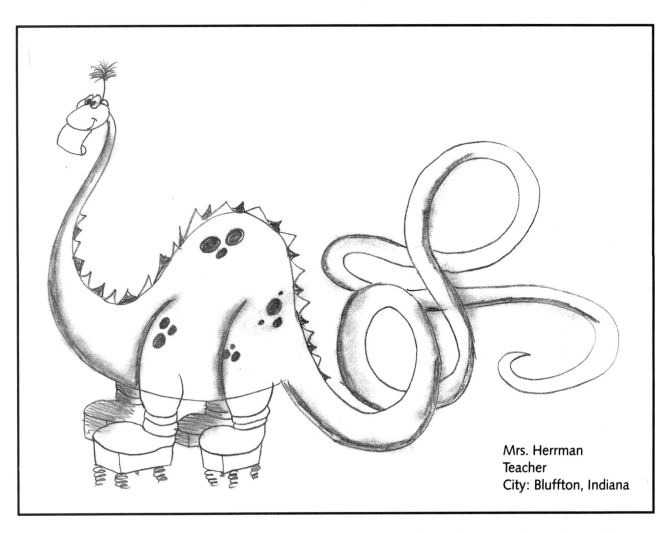

Mrs. Herrman
Teacher
City: Bluffton, Indiana

Mrs. Herrman joined her first-grade class at a drawing assembly with me in Indiana. She used *shadow* on the back legs to make them look farther from your eye. Her dinosaur's tail uses a lot of *overlapping* to curl all over the place! She even added springs to its shoes using *bonus*. Learn the twelve Renaissance Words of 3-D drawing. They really work! Are you putting checkmarks on pages 36–39 each time we use one of the Renaissance Words? I hope so! There's a billion zillion dollars at stake!

Fabulous Flapping Flags
Fabulous Flapping Flags

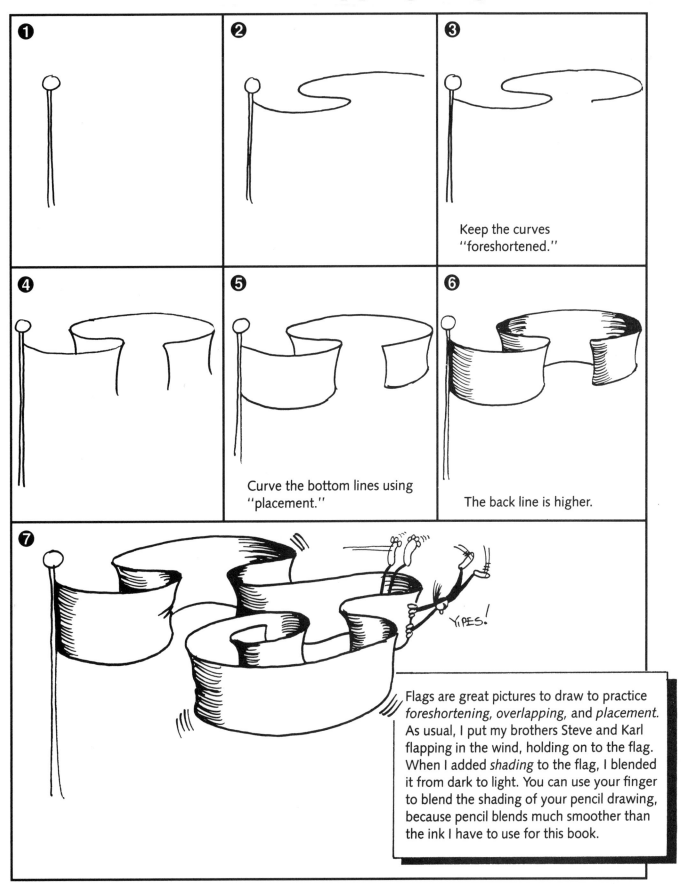

①

②

③ Keep the curves "foreshortened."

④

⑤ Curve the bottom lines using "placement."

⑥ The back line is higher.

⑦ YIPES!

Flags are great pictures to draw to practice *foreshortening, overlapping,* and *placement.* As usual, I put my brothers Steve and Karl flapping in the wind, holding on to the flag. When I added *shading* to the flag, I blended it from dark to light. You can use your finger to blend the shading of your pencil drawing, because pencil blends much smoother than the ink I have to use for this book.

PRACTICE, PRACTICE, PRACTICE!

Fill the blank space below with nine long *foreshortened* flags. Try drawing the flags blowing in different directions. Now try drawing a flag looking up at it above the horizon line, rather than looking down at it below the horizon line.

TODAY'S GENIUS WORD:
EXPERIMENT

Today's Creative Challenge is to get a giant roll of calculator paper and fill both sides of the roll with long, continuous flags. Fill up the entire paper. Don't waste any. Remember that you are an environmentally responsible artistic animal! I enjoy looking at the video covers of the Disney animated videos for children. Those artists at Disney sure know how to draw great 3-D flapping flags and banners! The magic carpet in *Aladdin* is a wonderful drawing of a rolled-flag shape. You can learn drawing ideas from everywhere! Even video covers!

EXPERIMENT: To examine a hypothesis; to learn something not yet known. This word describes the whole process of you opening this book and learning how to draw in 3-D! Pick up your pencil and *experiment* some more!

The Ancient Pirates' Treasure Chest

❶ "Foreshortening"

❷ "Size"

❸ "Placement"

❹ "Contour"

❺ "Overlapping"

❻ "Thickness"

❼ Go wild with Bonus Ideas!

The little person standing in the scroll on the left side is you. To get to the Treasure, you need to climb the tree, swing off the rope into the pool, dodge the shark, and climb into the hole to wake up my brother. Now continue through the roll until you get to the ladder. Climb the ladder, crawl up the tube, jump over the wall into the hot-air balloon. Tie your bungee cord on and bounce down to the treasure!

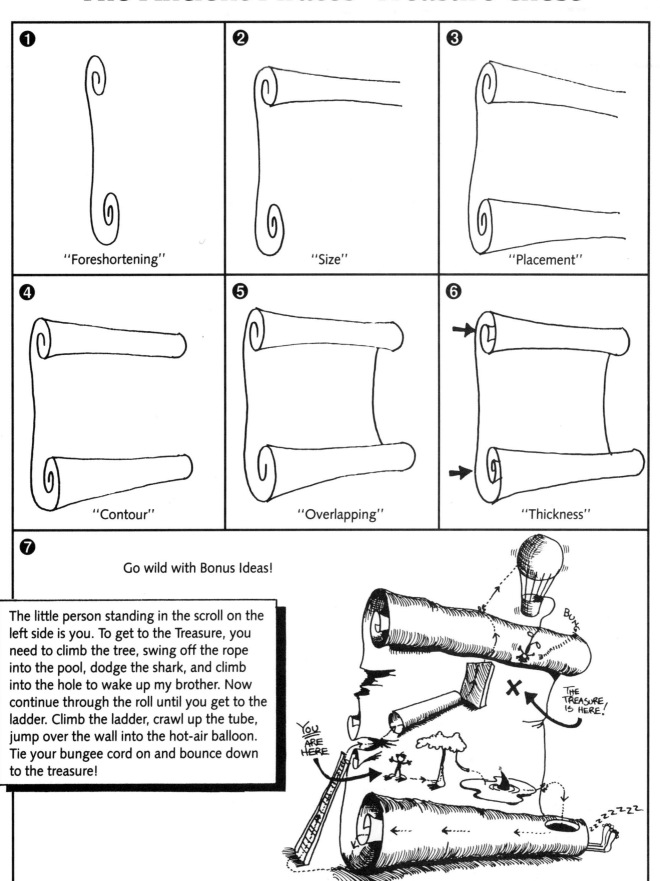

Pondering Pencil Possibilities Practice Page

PRACTICE, PRACTICE, PRACTICE!

Draw your own Treasure Map below. Think of the story you could write about it! I've left the bottom balloon empty for you to write your ''Ultimate Treasure Hunt Adventure''! Good Luck! Mail me a copy of your picture and your story. I'd love to use it on one of my television lessons or my next book. My address is on page 262.

Every time you pick up your pencil, imagine that you are embarking on the treasure hunt of the century. Each dash of your pencil reveals amazing three-dimensional treasure never before seen by human eyes! Share these treasures with your friends! Why? Because you're such a cool person!

"Draw Squad Moon"
Terry's Mother Melissa
Age: 21+
City: Houston, Texas

Terry's mother had fun drawing this amazing 3-D scroll at my weeklong summer art school in Houston, Texas. Each evening I give the students and their parents a take-home three-hour drawing "home fun" assignment. Homework should all be this fun! List the Renaissance Words she has used in her drawing below:

1. _____ 2. _____ 3. _____

4. _____ 5. _____ 6. _____

7. _____ 8. _____ 9. _____

EPISODE 15 The Great Adventure Down Under Cool King Koala!

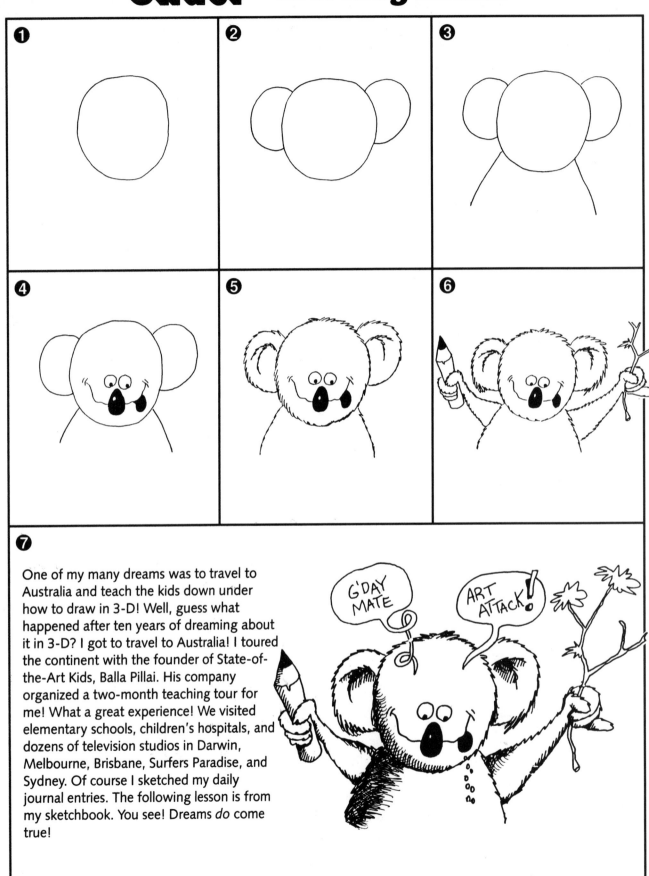

One of my many dreams was to travel to Australia and teach the kids down under how to draw in 3-D! Well, guess what happened after ten years of dreaming about it in 3-D? I got to travel to Australia! I toured the continent with the founder of State-of-the-Art Kids, Balla Pillai. His company organized a two-month teaching tour for me! What a great experience! We visited elementary schools, children's hospitals, and dozens of television studios in Darwin, Melbourne, Brisbane, Surfers Paradise, and Sydney. Of course I sketched my daily journal entries. The following lesson is from my sketchbook. You see! Dreams *do* come true!

G'DAY MATE

ART ATTACK!

Pondering Pencil Possibilities Practice Page

PRACTICE, PRACTICE, PRACTICE!

Draw a tree with an entire family of koalas in it. Yum!
Eucalyptus leaves for lunch!

Every day I sketch in my daily drawing journal. Why don't you
start a sketch journal too? It is a great way to keep track of your
improvement in drawing in 3-D. You will also use your daily
sketchbook as a memory photo album of all the neat places you
have visited and all the neat adventures you have done with
your friends. Buy a sketchbook with a spiral binding today! In
fact, have your parents buy you fifteen sketchbooks. You are
going to need them!

AMBIANCE: The distinct atmosphere of an environment or setting. When you draw, you are creating a
unique *ambiance* in your picture.

Kangaroo the Kid!

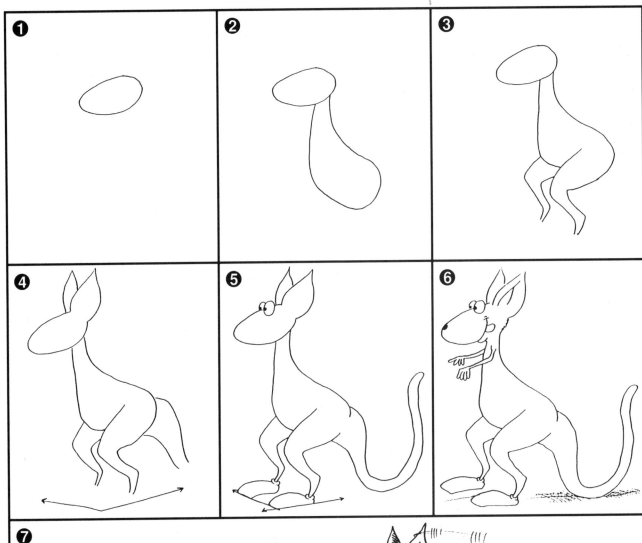

⓪

⓪ This is one of my favorite memory photos from my Australian teaching tour sketchbook. A lot of the kids in northern Australia would arrive at my drawing workshops with baby wallabies and kangaroos in their backpacks! The kids would draw with me while the baby kangaroos would peer out of the backpacks and watch! I sure like the way the people talk in Australia. Be sure to use *overlapping* on the ears and the legs of the Kangaroo Mama. This will create the 3-D look. I added the *horizon* line to make the kangaroo stand on the ground.

Pondering Pencil Possibilities Practice Page

PRACTICE, PRACTICE, PRACTICE!

Draw thirty-five kangaroos jumping across the plains in Australia. If you add *action* lines you will make the kangaroos look like they are really moving!

SUPER STORY STARTER:

''Faster, Mama, faster!'' the Kangaroo Kids giggled as their mom jumped across the grass field. The kids were holding on to the inside of Mama's pouch with their noses sticking out into the rushing wind. Their giggles and squeals were filled with delight as Mama Kangaroo picked up speed.

You finish the story!

Super-Splendid Student Sketches

Sean
Age: 6
City: Albany, New York

Sean was in first grade when he drew this Koala Forest. Look how he used very dark *undershadows* to pull the eucalyptus leaves away from the tree trunk. He went wild with *bonus* ideas, adding koalas drawing on top of the trees and koalas swinging from the branches. Fantastic drawing, Sean!

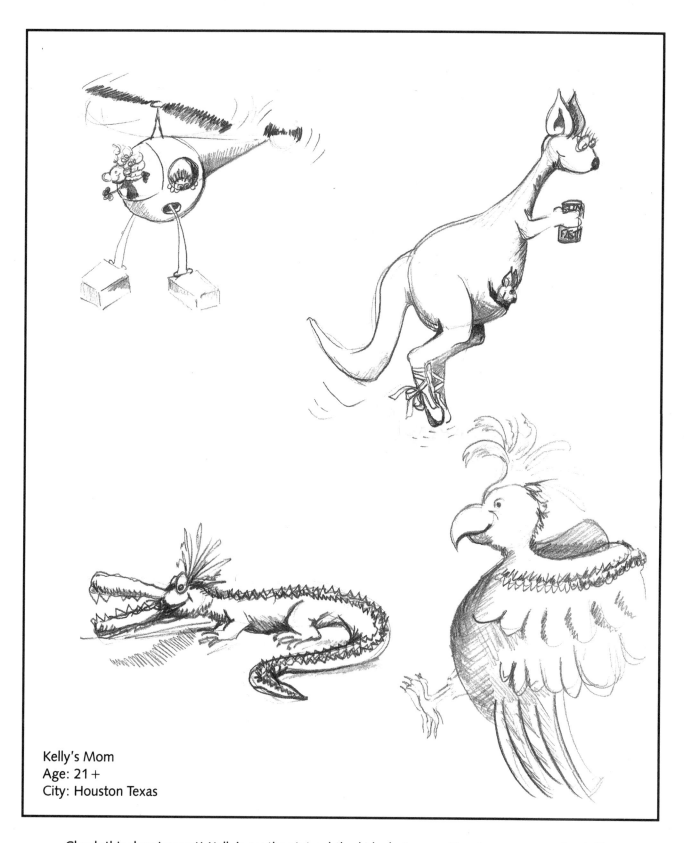

Kelly's Mom
Age: 21+
City: Houston Texas

Check this drawing out! Kelly's mother joined the kids during our Houston summer school. She drew all four of these drawings in less than an hour! I showed this drawing on my public television series *Mark Kistler's Imagination Station*, episode 15. I wanted the TV viewers to see how even moms and dads could learn how to draw in 3-D! If parents learn how to draw in 3-D with their kids, it will give them something wonderful to do together instead of watching so much mindless television in the evening. Drawing in 3-D is cool!

Awesome Australian Animals
The Charismatically Caring Cockatiel!

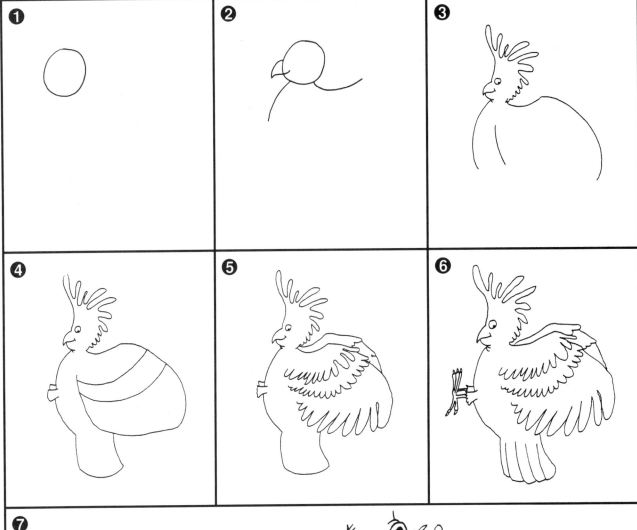

❼

Here's another page from my daily drawing journal during my Australian teaching tour. One day when we were driving between cities outside of Brisbane, I looked up and saw an entire flock of hundreds of wild cockatiels fluttering overhead. What an amazing sight! Yellow-feathered blurs streaking over my head, I grabbed my sketchbook. I didn't want to forget this inspiring sight! Use darkness on the back wing to tuck it behind the near wing. What Renaissance Word of 3-D drawing is used to tuck?

Pondering Pencil Possibilities Practice Page

PRACTICE, PRACTICE, PRACTICE!

Draw a beautiful flock of 3-D cockatiels in the space below. Go to your library and look for a book with colored photographs of a cockatiel. Use the photo as a guide to add color to your drawing. Color will really make your 3-D rendering look awesome!

Draw thirty-one cockatiels on separate sheets of a sticky notepad. Now stick your cockatiels all over the house as a wonderful art-attack surprise for your parents! Stick them on each mirror, on all the doors, and even on light switches! You might need to draw more to fill up your house.

VIRTUOSO: One with outstanding talent in any field, especially in the arts. This accurately describes someone I know—YOU! Your are a drawing-in-3-D creative artistic-genius virtuoso!

The Carnivorous Crocodile

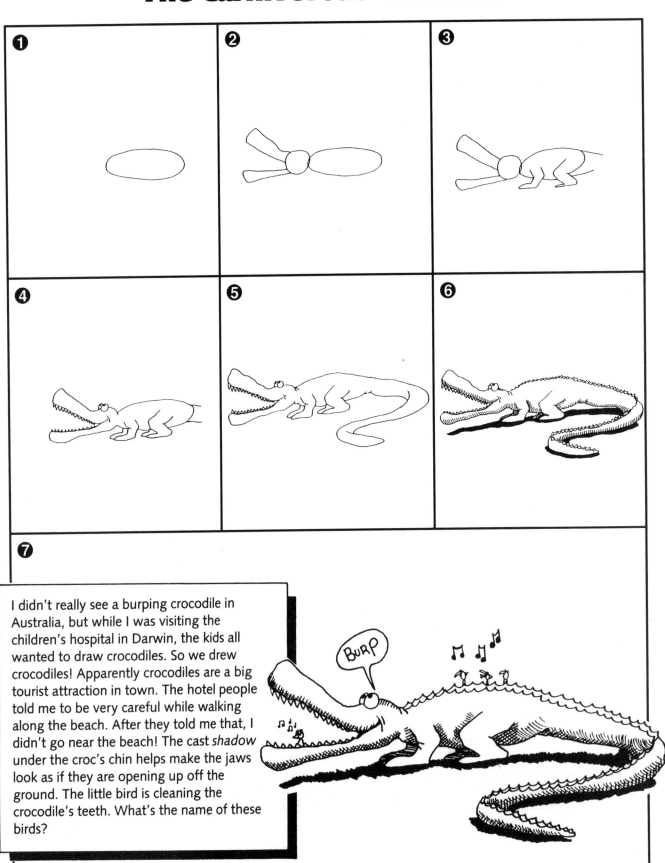

I didn't really see a burping crocodile in Australia, but while I was visiting the children's hospital in Darwin, the kids all wanted to draw crocodiles. So we drew crocodiles! Apparently crocodiles are a big tourist attraction in town. The hotel people told me to be very careful while walking along the beach. After they told me that, I didn't go near the beach! The cast *shadow* under the croc's chin helps make the jaws look as if they are opening up off the ground. The little bird is cleaning the crocodile's teeth. What's the name of these birds?

Pondering Pencil Possibilities Practice Page

PRACTICE, PRACTICE, PRACTICE!

Draw a couple of crocodiles swimming with their periscope eyes sticking out above the surface of the water. Use a jagged texture on the back to make the crocodiles' skin look very rough and tough.

Let's go on a Research Quest! Go to your library and find out the name of the little birds that ride on crocodiles' backs and clean crocodiles' teeth. These birds are like flying dentists! Do you think that the crocodile would ever decide to have a snack while the little birds are cleaning their teeth? Find out! Libraries are like giant information warehouses! Go to it, you researching, drawing, scientific student, you!

Super-Splendid Student Sketches

Mike Horton
Age: 10
City: Montana

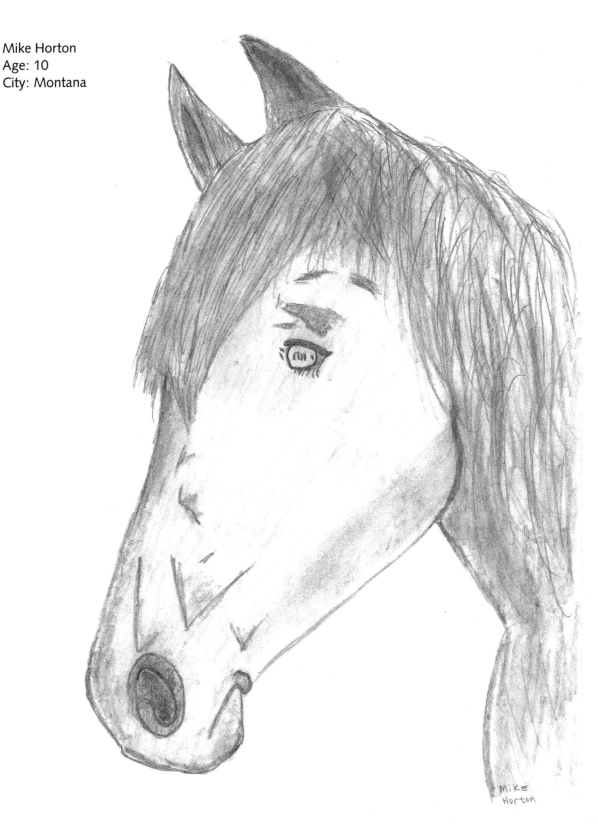

Mike loves horses, so Mike draws horses! Drawing in 3-D is a wonderful way to express yourself! Draw things that you love. Draw things that interest you! Draw 3-D things all day long! Mike used a nice texture to give the horses' hair a nice flowing look. Can you spot where she used *foreshortening*? Mail me a drawing of something you love. I'll hang it up in my drawing studio! Thanks!

Radical Renderings by Students

"Can Can Crocodiles"
Alicia
Age: 9
City: Kentucky

Alicia decided to draw her crocodiles dancing in a Broadway chorus line! What a totally unique idea! What will you draw? To make the crocodiles look as if they are kicking up their right feet, Alicia used *overlapping*. Count how many check marks you have put next to each Renaissance Word on pages 36–39. Which Renaissance Word have we used the most so far?

Earth Patrol HQ
The 3-D Earth Patrol HQ Building

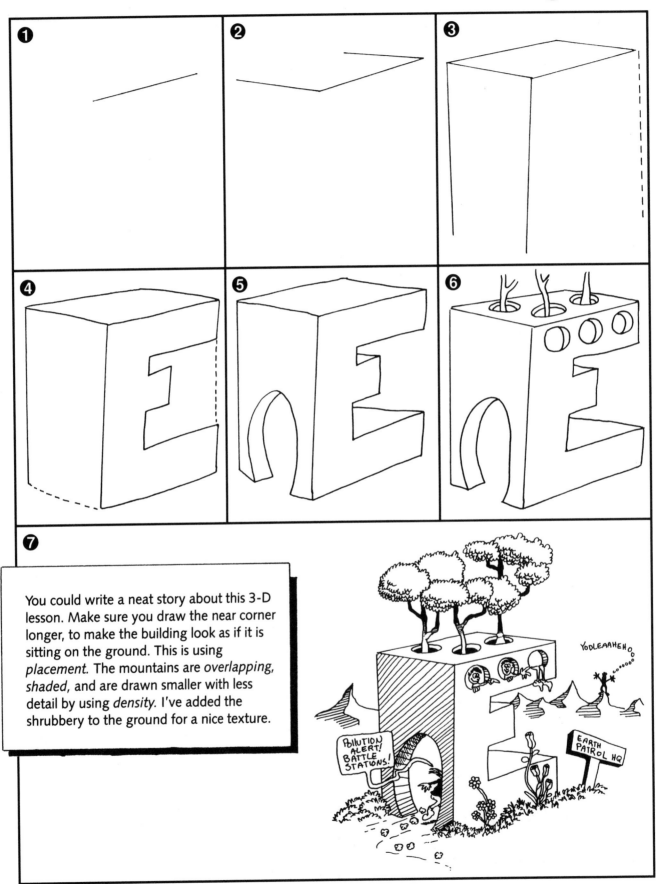

❼

You could write a neat story about this 3-D lesson. Make sure you draw the near corner longer, to make the building look as if it is sitting on the ground. This is using *placement*. The mountains are *overlapping*, *shaded*, and are drawn smaller with less detail by using *density*. I've added the shrubbery to the ground for a nice texture.

Pondering Pencil Possibilities Practice Page

PRACTICE, PRACTICE, PRACTICE!

Draw an entire Earth-Patrol City with dozens of 3-D buildings *overlapping.* Add trees growing out of the roofs, windows, and doorways.

SUPER STORY STARTER:

"Pollution alert! Battle stations! We've got to save the planet from the Pollution Monster!" the Earth Patrol speaker blared. "Call in all the kids of the planet Earth!" Thousands of Pollution Patrollers were running out of the building to jump into their Cereal-Powered Pollution-Cleanup Vehicles.

You finish the story!

MAESTRO: A master in an art; a famous conductor or composer. When you draw, you are conducting a visual symphony in 3-D! You are the *maestro* of your drawing paper!

3-D Shadow Lettering

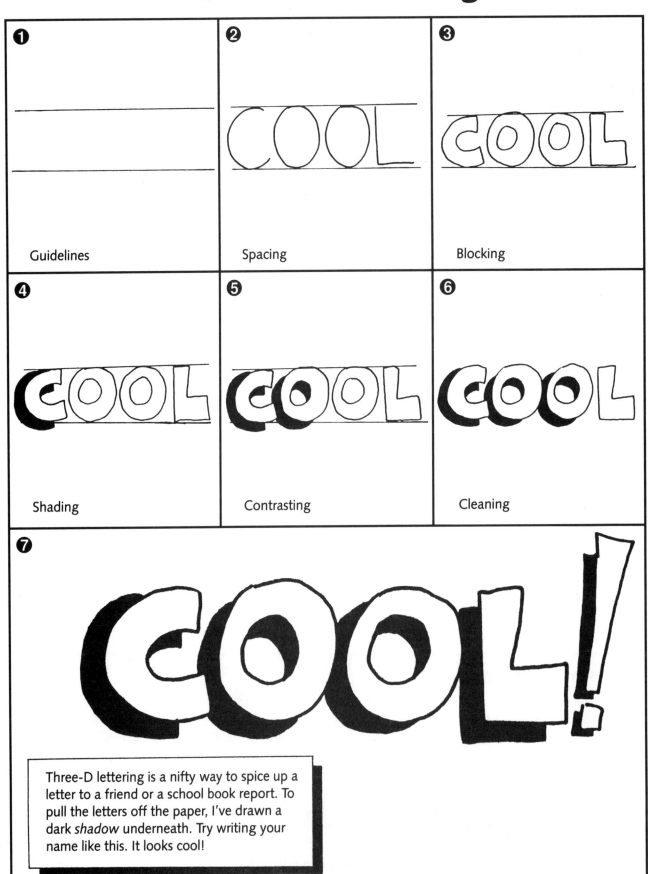

❶ Guidelines

❷ Spacing

❸ Blocking

❹ Shading

❺ Contrasting

❻ Cleaning

❼

Three-D lettering is a nifty way to spice up a letter to a friend or a school book report. To pull the letters off the paper, I've drawn a dark *shadow* underneath. Try writing your name like this. It looks cool!

Pondering Pencil Possibilities Practice Page

PRACTICE, PRACTICE, PRACTICE!

Write all the names in your family with shadow lettering below.

Draw everyone in your family a dinner-table name tag with shadow lettering. When you are setting the table for dinner tonight, set the name tags up around the table. What a cool surprise for your family. You are such a cool person!

COOL!

Super-Splendid Student Sketches

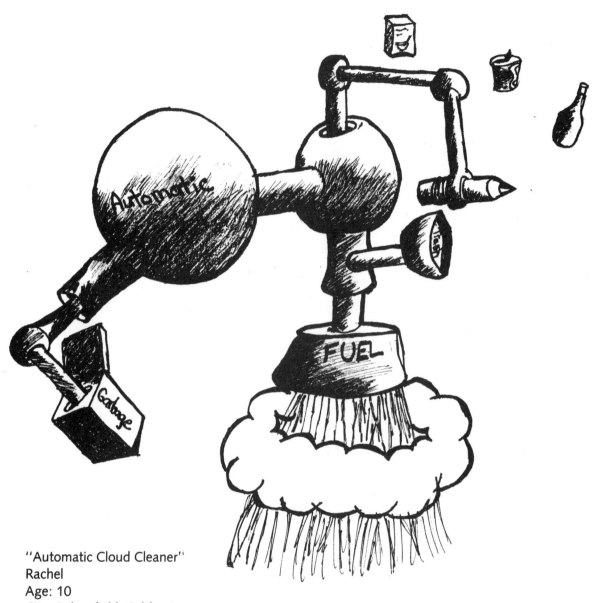

"Automatic Cloud Cleaner"
Rachel
Age: 10
City: Bakersfield, California

After my assembly drawing lesson at Rachel's elementary school, she drew this High-Tech Automatic Cloud Cleaner. This is steam pouring out of the bottom, not toxic waste! Great *shading*, Rachel!

Tim Winkelman
Age: 12
City: Utah

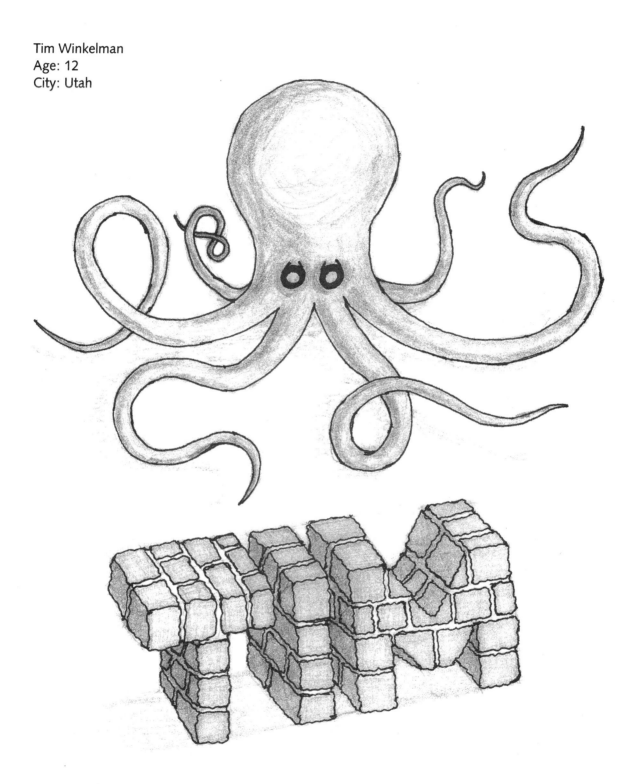

Tim figured out another way to draw his name in 3-D. He created the texture of bricks with *shading.* Is the squid's name Tim? Brilliant drawing, buddy!

Mammoth Moon Metropolis
The Mammoth Moon Metropolis

❶

❷

❸

❹

❺

❻

❼

Let's journey to the Moon for our next drawing adventure! Isn't it amazing how we can travel from Dino Land to Australia and then to the Moon in less than a microsecond? Drawing in 3-D is the best way to travel the galaxy! Be sure to draw the near craters on the moon surface first. As you move away, tuck the other craters behind the near ones, using the Renaissance Word *overlapping.* I've added the buildings for the Moon Dudes to live in. How about some Moonmobiles?

Pondering Pencil Possibilities Practice Page

PRACTICE, PRACTICE, PRACTICE!

Draw an Extraordinary Mega Moon Metropolis below! Not just an ordinary Moon City, but an Extraordinary Mega Moon Metropolis!

SUPER STORY STARTER:

Many men made Moon mansions towering terrifically above the Moon craters. Mark, a Moon Murble, ran rather riskily toward the nearest tower.

Finish the story with as many *alliterations* as you can. Don't forget to mail me copies of your Genius Work!

ALLITERATION: The writing of two or more words having the same initial sound. I use alliterations often in my drawing lessons. Try writing some of your own. I've started one for you in the Super Story Starter below.

The Mighty Moon Dude

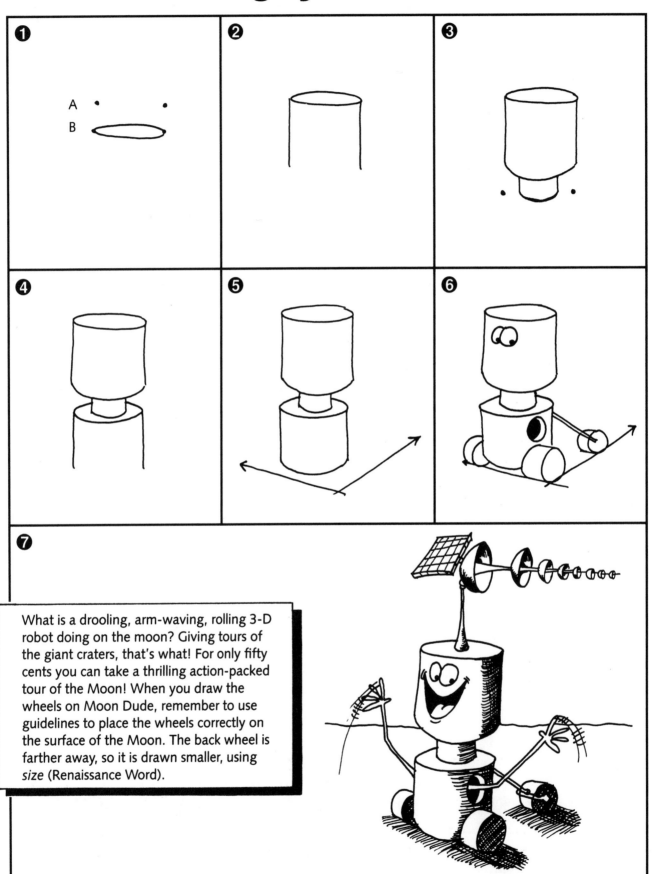

What is a drooling, arm-waving, rolling 3-D robot doing on the moon? Giving tours of the giant craters, that's what! For only fifty cents you can take a thrilling action-packed tour of the Moon! When you draw the wheels on Moon Dude, remember to use guidelines to place the wheels correctly on the surface of the Moon. The back wheel is farther away, so it is drawn smaller, using *size* (Renaissance Word).

Pondering Pencil Possibilities Practice Page

PRACTICE, PRACTICE, PRACTICE!

Draw four Moon Dudes below. Draw one round, one square, one spherical, and one triangular. Be sure to use a lot of *foreshortening* in each of the drawings.

Today's Creative Challenge is to do something *extraordinary*. When you do the dishes, do them *really* well. When you sweep the room, do it with *extraordinary* flair. Sing while you take out the trash. And, of course, smile at the world. Show everyone what an extraordinary human "bean" you are!

Super-Splendid Student Sketches

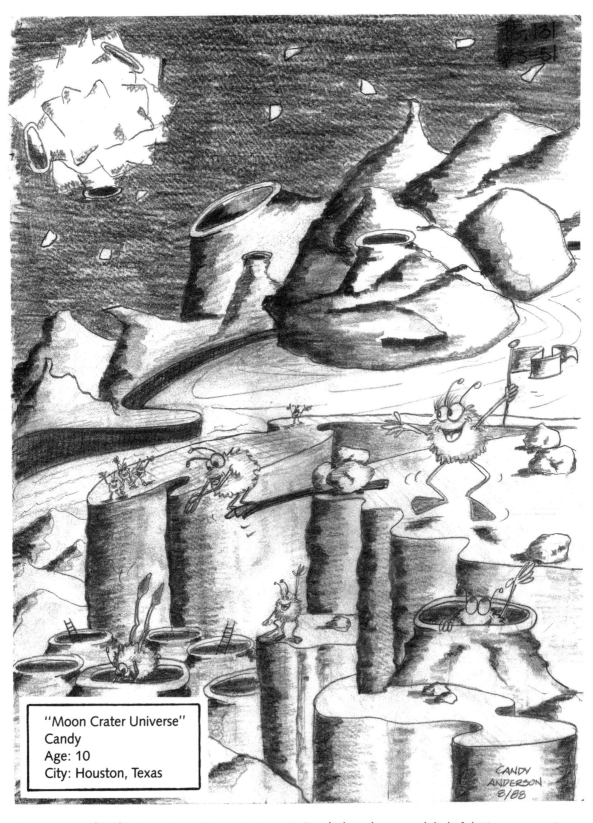

"Moon Crater Universe"
Candy
Age: 10
City: Houston, Texas

Wooooooooooh! This is a Moon-Crater Universe! Candy has drawn a delightful Moon scene in 3-D with lots of the twelve Renaissance Words. She used *foreshortening* on the edge of the canyon, *shading* on the side of the mountains, and lots of *overlapping* on the craters. By filling the background in with black, she created deep space! The floating asteroid in the distance is smaller, looking farther away, through use of *size* (Renaissance Word). What Renaissance Word has she used on the little Moon Critters in her drawing?

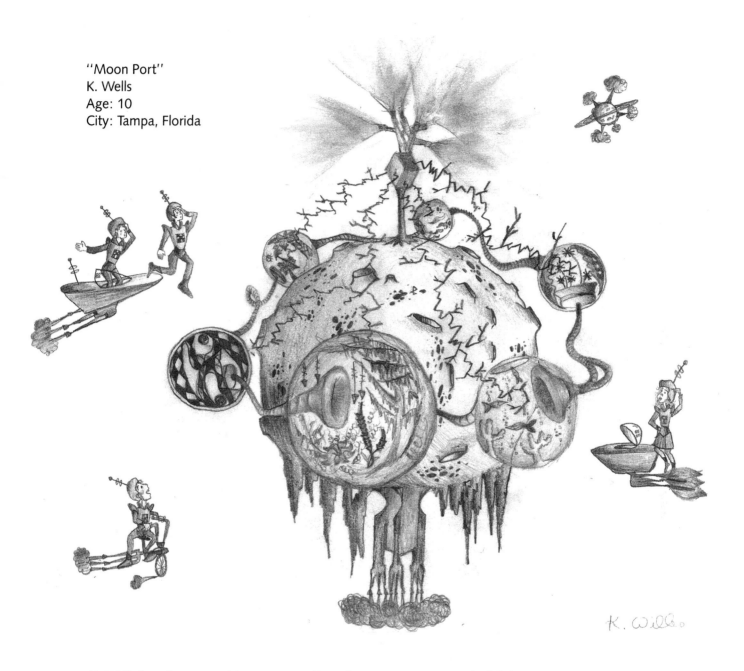

"Moon Port"
K. Wells
Age: 10
City: Tampa, Florida

K. Wells has drawn a wild 3-D Moonville. What Renaissance Words did she use in her drawing?
I like all the people flying around in their nifty little space bikes. Neat idea, dudette!

The Cool Clam Family
The Cool Clam Family

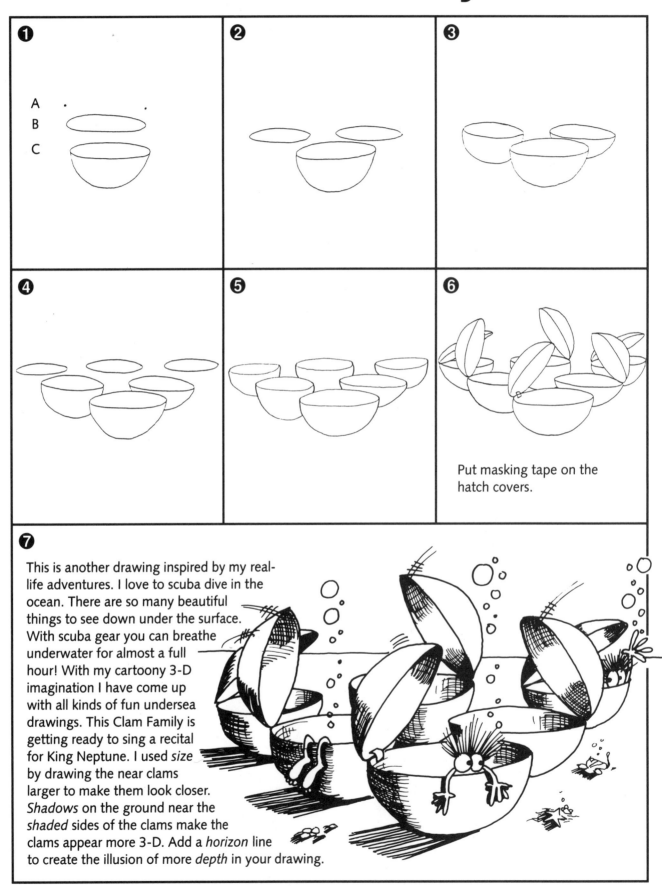

❶

A
B
C

❷

❸

❹

❺

❻

Put masking tape on the hatch covers.

❼

This is another drawing inspired by my real-life adventures. I love to scuba dive in the ocean. There are so many beautiful things to see down under the surface. With scuba gear you can breathe underwater for almost a full hour! With my cartoony 3-D imagination I have come up with all kinds of fun undersea drawings. This Clam Family is getting ready to sing a recital for King Neptune. I used *size* by drawing the near clams larger to make them look closer. *Shadows* on the ground near the *shaded* sides of the clams make the clams appear more 3-D. Add a *horizon* line to create the illusion of more *depth* in your drawing.

Pondering Pencil Possibilities Practice Page

PRACTICE, PRACTICE, PRACTICE!

Draw 127 clams singing in the blank space below. To make them look more 3-D, be sure to use lots of *overlapping*, *size*, and *shading*.

TODAY'S GENIUS WORD:
RENAISSANCE

Here's a cool acronym for you to remember: P.A.P.E.R. You are a <u>P</u>ositive-<u>A</u>ttitude <u>P</u>owerful <u>E</u>nthusiastic <u>R</u>ascal! An acronym is a word formed from the first letters of words in a phrase. S.M.A.R.T. means you are a <u>S</u>uper-<u>M</u>agnificent <u>A</u>rtistically <u>R</u>adical <u>T</u>alent! Make up acronyms for D.R.A.W., P.E.N.C.I.L., and I.M.A.G.I.N.A.T.I.O.N.! Mail me your acronyms today! My address is on page 262. Give yourself an A + + + + + + + on your drawing for a job well done!

RENAISSANCE: A revival; the revival of classical art, literature, and learning in Europe during the fourteenth to sixteenth centuries. Every time you pick up your pencil you are creating a *renaissance* on your piece of paper. The twelve words I use to teach 3-D drawing were refined during this time period.

The 3-D Papa Seahorse

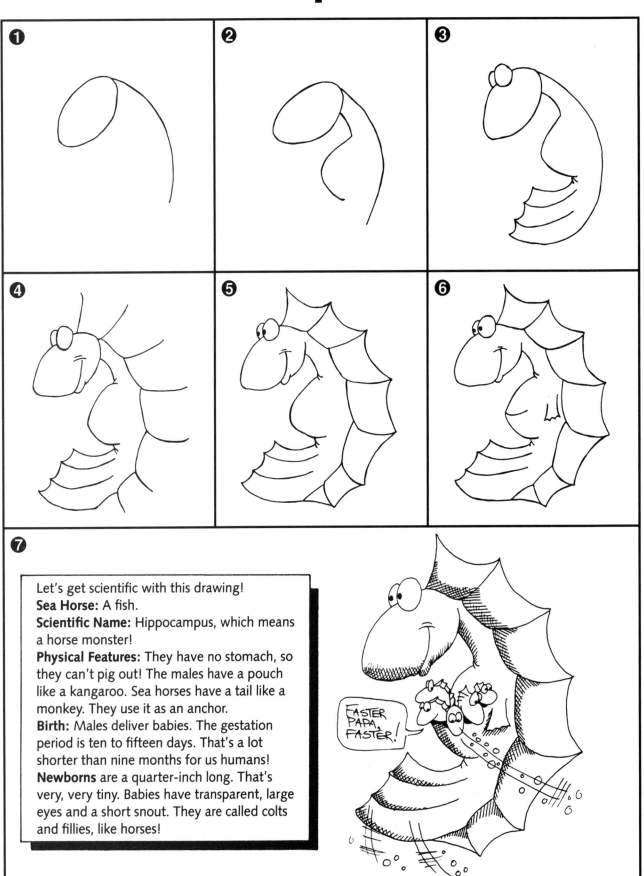

① **②** **③** **④** **⑤** **⑥**

⑦

Let's get scientific with this drawing!

Sea Horse: A fish.

Scientific Name: Hippocampus, which means a horse monster!

Physical Features: They have no stomach, so they can't pig out! The males have a pouch like a kangaroo. Sea horses have a tail like a monkey. They use it as an anchor.

Birth: Males deliver babies. The gestation period is ten to fifteen days. That's a lot shorter than nine months for us humans!

Newborns are a quarter-inch long. That's very, very tiny. Babies have transparent, large eyes and a short snout. They are called colts and fillies, like horses!

FASTER PAPA, FASTER!

Pondering Pencil Possibilities Practice Page

PRACTICE, PRACTICE, PRACTICE!

Draw a large herd of sea horses swimming through the ocean below.

Today's Creative Challenge is to go to your library and look at a book entitled *Wonders of Sea Horses* by Ann Brown. I sure love doing artistic scientific research at libraries. Can you tell?

Super-Splendid Student Sketches

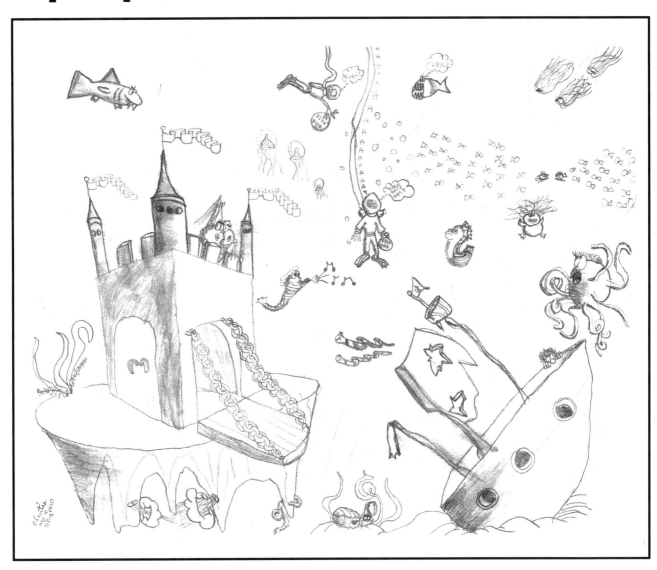

"Sea Castle"
Chris
Age: 8
City: Orlando, Florida

Now this is an undersea scene packed full of *bonus* ideas! Chris let his imagination soar, or should I say dive, with this awesome 3-D picture. I hope my sailboat doesn't end up like the one in this drawing! I like the detail on the chain on the castle gate. It uses a lot of *overlapping*!

Jeff learned a lot from our shark lesson. He used *shading* to make his friend look 3-D.

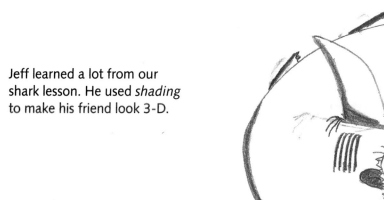

Jeff
Age: 7
City: Sydney, Australia

Eric Hartman
Age: 10½
City: New York

Eric had a good time drawing his 3-D undersea adventure, complete with turtles and sunken treasure chests! When I visited Eric's school in New York, I challenged the students to fill an entire page with an undersea scene. Eric sure filled up his page, eh!

Professional Pollution Patrollers
The 3-D Satellite Space Sweeper!

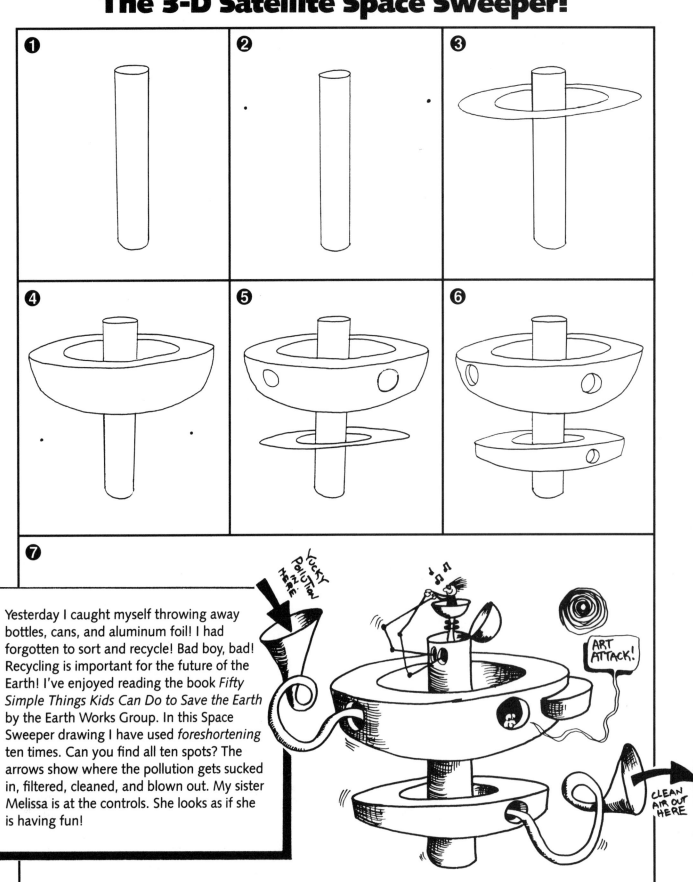

❶ **❷** **❸**

❹ **❺** **❻**

❼

YUCKY POLLUTION IN HERE

ART ATTACK!

CLEAN AIR OUT HERE

Yesterday I caught myself throwing away bottles, cans, and aluminum foil! I had forgotten to sort and recycle! Bad boy, bad! Recycling is important for the future of the Earth! I've enjoyed reading the book *Fifty Simple Things Kids Can Do to Save the Earth* by the Earth Works Group. In this Space Sweeper drawing I have used *foreshortening* ten times. Can you find all ten spots? The arrows show where the pollution gets sucked in, filtered, cleaned, and blown out. My sister Melissa is at the controls. She looks as if she is having fun!

Pondering Pencil Possibilities Practice Page

PRACTICE, PRACTICE, PRACTICE!

Create your own 3-D Cloud Cleaner below, then try to build a module of it out of disposable objects from around your house. Trash turned into an artistic sculpture. Cool!

TODAY'S GENIUS WORD: **ENVIRONMENTALIST**

Mail me a home video of your family recycling the trash. This will make a great insert into my public television series!

ENVIRONMENTALIST: One working to solve environmental problems, such as air and water pollution. Be an *environmentalist* artist!

The Pollution-Pounding Trash Masher

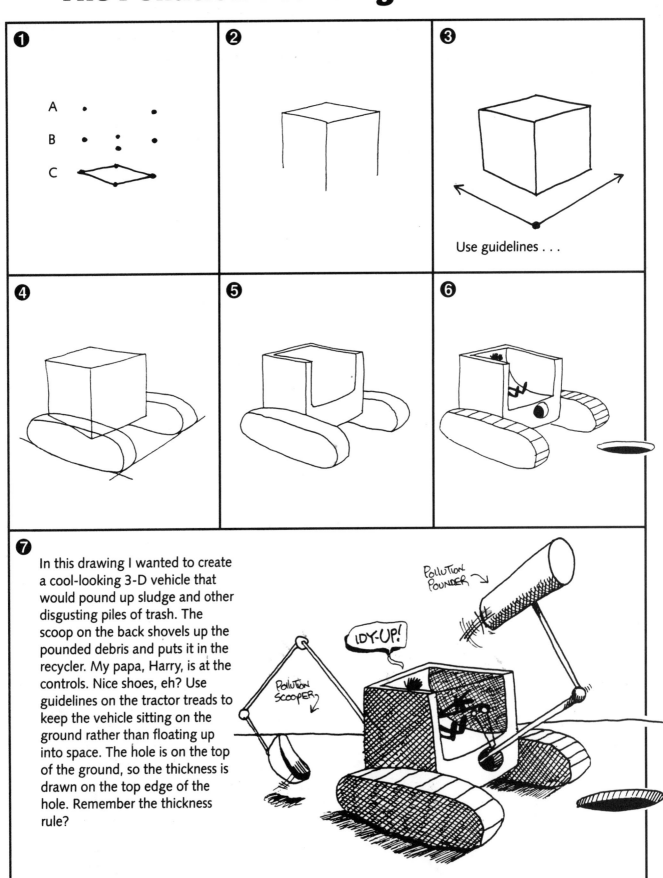

1 A • •
B • • •
C

2

3 Use guidelines . . .

4

5

6

7 In this drawing I wanted to create a cool-looking 3-D vehicle that would pound up sludge and other disgusting piles of trash. The scoop on the back shovels up the pounded debris and puts it in the recycler. My papa, Harry, is at the controls. Nice shoes, eh? Use guidelines on the tractor treads to keep the vehicle sitting on the ground rather than floating up into space. The hole is on the top of the ground, so the thickness is drawn on the top edge of the hole. Remember the thickness rule?

POLLUTION POUNDER

IDY-UP!

POLLUTION SCOOPER

Pondering Pencil Possibilities Practice Page

PRACTICE, PRACTICE, PRACTICE!

In the blank space below, draw an entire planet with Pollution Patrollers in the sky, on the land, and in the sea. This would make a great mural project in your room. Ask your parents to tape a giant piece of paper on your wall to draw on!

SUPER STORY STARTER:

"Wham!" The hammer pounder slammed into the pile of sludge. "One more ought to finish this pile of slime," Jenny thought to herself as she scooped up the debris by pushing back on the scoop-handle toggle. Jenny reached up to push the hammer pounder one last time when suddenly . . .

You finish the story!

Super-Splendid Student Sketches

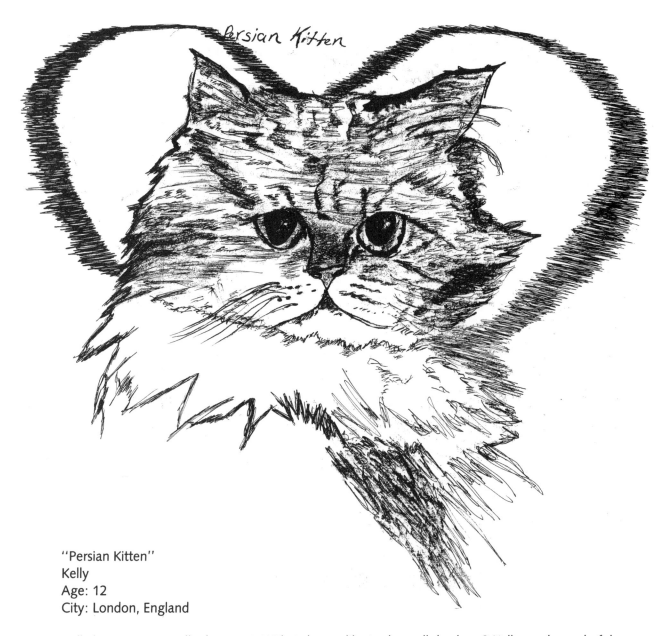

Persian Kitten

"Persian Kitten"
Kelly
Age: 12
City: London, England

Kelly loves cats, so Kelly draws cats! What do you like to draw all day long? Kelly used wonderful texture to make the cats' fur look very soft and cuddly. What other Renaissance Words has she used to make her drawing look 3-D?

"Mr. Humpback"
Michelle
Age: 8
City: Michigan

Duke Ellington was a very famous musician. He once said that if it sounds like good music, it is good music! The same principle applies to your drawing. If it looks like a good drawing, then it is a good drawing. Michelle's drawing of a 3-D humpback whale is so good, I'd love to see this on a T-shirt. I'd buy a dozen! Why don't you draw an endangered animal and have it transferred to a T-shirt at your local copy store. Wearable art! Cool!

The Adventures of Genius Pickle Genius Pickle

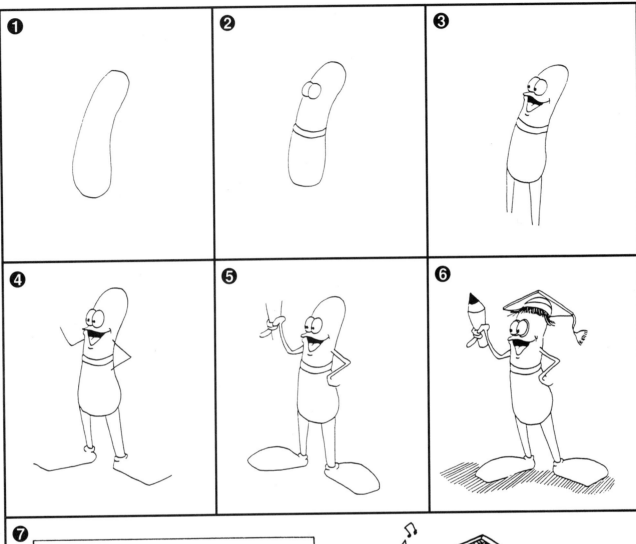

❶ **❷** **❸** **❹** **❺** **❻**

❼

Let's turn on our scientific-research brains. Here's what the library computer says about pickles.

Definition: A fruit or vegetable preserved in flavored vinegars (nope, they are not just cucumbers).

Examples: crab apples, green beans, beets, okra, peaches, tomatoes, and watermelon rinds.

Kinds: Sweet, sour, mustard, dill, and bread and butter.

I bet you never knew that pickles would make such a fascinating research project! Pick any ordinary object and look it up in your library's computer catalog. Chances are there has been a book written about it! Books are wonderful!

A PENCIL FOR YOU!

Pondering Pencil Possibilities Practice Page

PRACTICE, PRACTICE, PRACTICE!

Draw Genius Pickle flying over your house in the blank space below. Add *contour* lines to make Genius Pickle look 3-D.

Today's Creative Challenge is to create your own superhero. You can take any normal everyday object and turn it into a super-3-D-drawing hero! I decided to use a pickle as my theme and created Genius Pickle and Pickleville City. Why don't you try this with a shoe, a banana, and a lasagna noodle!

ACHIEVER: A person who accomplishes tasks successfully through applied effort. When you draw nine hours each day, you prove what an artistic *achiever* you are! Go get 'em!

One-Point-Perspective Pickleville City

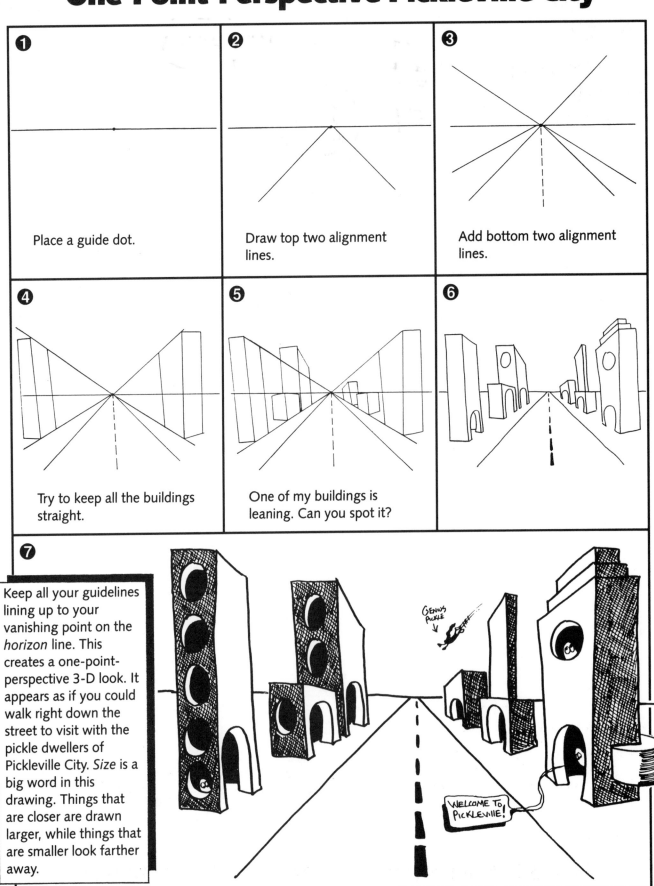

❶ Place a guide dot.

❷ Draw top two alignment lines.

❸ Add bottom two alignment lines.

❹ Try to keep all the buildings straight.

❺ One of my buildings is leaning. Can you spot it?

❻

❼ Keep all your guidelines lining up to your vanishing point on the *horizon* line. This creates a one-point-perspective 3-D look. It appears as if you could walk right down the street to visit with the pickle dwellers of Pickleville City. *Size* is a big word in this drawing. Things that are closer are drawn larger, while things that are smaller look farther away.

GENIUS PICKLE

WELCOME TO PICKLEVILLE!

Pondering Pencil Possibilities Practice Page

> **PRACTICE, PRACTICE, PRACTICE!**

Here's an idea! Teach your brothers and sisters how to draw in 3-D and really surprise your parents! Be a family T.E.A.M.! <u>T</u>ogether <u>E</u>veryone <u>A</u>chieves <u>M</u>ore! Make a one-point-perspective drawing of the street you live on, complete with trees, houses, and mailboxes! Mail in your drawings. Look on page 262 for my address.

SUPER STORY STARTER:

"Yes the rumors you've been hearing are true." Mayor Pickle's voice cracked a bit as he spoke to the citizens of Pickleville. "We are all out of pencils!" The crowd erupted into pandemonium. "Oooooh nooooo! Out of pencils! What will we draw with! Oooooh Noooo!" Suddenly a hush fell over the gathering as a speeding flying pickle, almost a blur, zoomed over the city.

You finish the story.

Super-Splendid Student Sketches

"The New Twinkies on the Block"
Sharon Dowell
Age: 9
City: Houston, Texas

Shannon decided to draw her favorite music group posed as Twinkies! What a novel idea! Notice how all the hairstyles are different? I wonder how close these cartoon characters look to their real-life counterparts. It's too bad I couldn't reproduce the great color she used in her drawing. This is a black-and-white book. Sorry, Shannon! When you add color to your drawing, you really make it look wonderful! Look how she used *overlapping* to make the Twinkies in the audience look as if they are sitting in the chairs! Great 3-D drawing. Just great!

Super-Splendid Student Sketches

"Welcome to Twinkie Town"
Eric Hartman
Age: 7
City: San Diego, California

Eric placed his vanishing point just above the center of his page. Notice how all the guidelines converge to that point. I really enjoy his dark-line style. When you draw your lines really dark, you make the objects really stand out from the background. This is called creating *contrast*. Eric used *size* (Renaissance Word) on the buildings, doorways, and lane markers. Look! There's Genius Pickle waving from the top of the near building!

The 3-D Expression of *Exasperation*

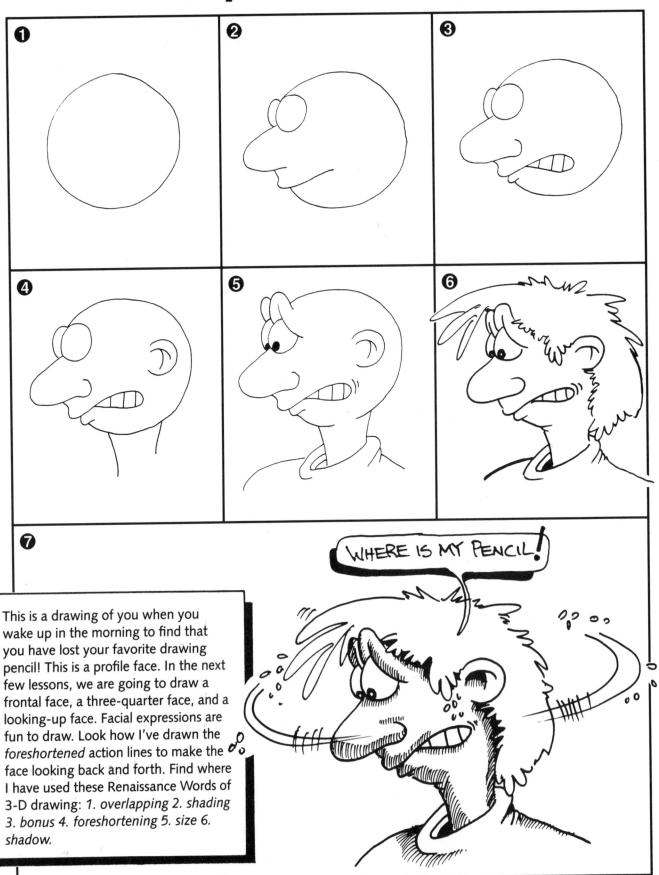

WHERE IS MY PENCIL!

This is a drawing of you when you wake up in the morning to find that you have lost your favorite drawing pencil! This is a profile face. In the next few lessons, we are going to draw a frontal face, a three-quarter face, and a looking-up face. Facial expressions are fun to draw. Look how I've drawn the *foreshortened* action lines to make the face looking back and forth. Find where I have used these Renaissance Words of 3-D drawing: *1. overlapping 2. shading 3. bonus 4. foreshortening 5. size 6. shadow.*

Pondering Pencil Possibilities Practice Page

PRACTICE, PRACTICE, PRACTICE!

You are saving the world with your artistic intellect! Quick! Grab a pencil and draw fifteen profile expressions in 3-D below!

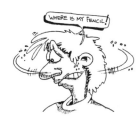

WHERE IS MY PENCIL!

SUPER STORY STARTER:

The early morning light had just begun to seep through my window curtains when I awoke with a start. "Where did I put my pencil?" I shrieked with a terrible premonition. Had I lost my most important Genius Drawing Device? Swiftly I jumped out of bed and . . .

You finish the story!

ASTONISHING: Causing sudden amazement. This is the expression your parents have each time they look at your amazing 3-D sketches in your always handy cool-drawing daily journal sketchbook!

The 3-D Expression of *Enlightenment*

Aha! You have recalled where you last put down your favorite drawing pencil! Eureka! You will soon be able to draw in 3-D again! This is a frontal view of your happy face. I use guidelines to place the eyes, nose, and mouth. The smile is a *contour* line. Of course, I have added the all-important drool to my drawing. Drool is COOL!

AHAA

Pondering Pencil Possibilities Practice Page

PRACTICE, PRACTICE, PRACTICE!

Draw four frontal face views below. After you finish that, take your sketchbook and look at your face in the mirror. Draw your self-portrait with different facial expressions. Use guidelines. They really help! Mail me your self-portraits. I'd love to put them on my public television show! You're going to be a famous artist!

Today's Creative Challenge is to energize your drawings with *astonishing* ideas! Now mail your drawing with a Story Starter to one of your friends in another state. When they get your drawings, ask them to add to the story and add another picture. Now they can mail your drawing and Story Starter with their drawing and story continuation to one of their friends in a different state. Then their friend can do the same and mail it to their friend. Then your friend's friend's friend can do the same and mail it to their friend! Get the idea? A totally cool chain letter of artistic friendship!

The 3-D Stacked Pyramid

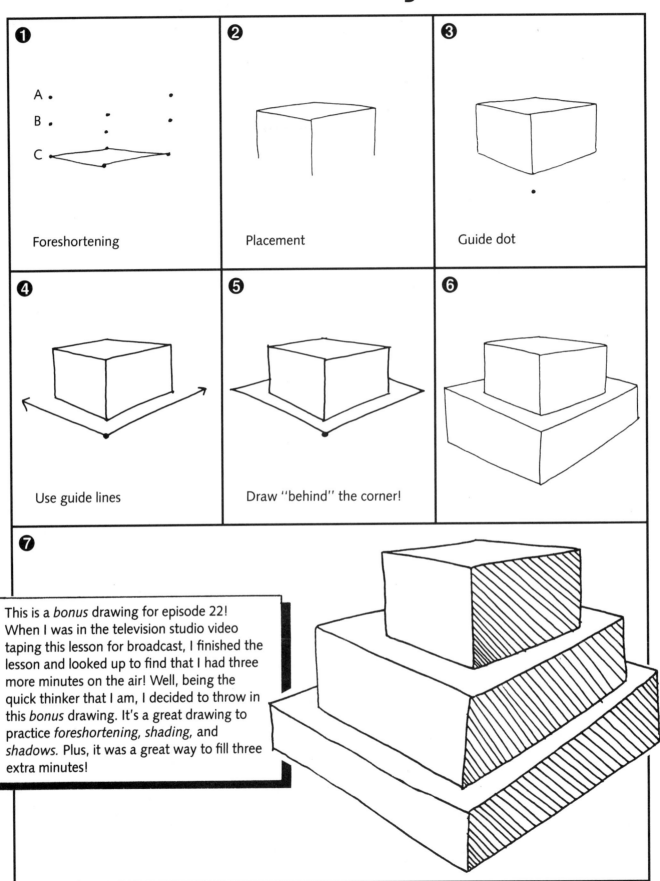

❶ A • • • • B • • • • C •

Foreshortening

❷

Placement

❸

Guide dot

❹

Use guide lines

❺

Draw "behind" the corner!

❻

❼

This is a *bonus* drawing for episode 22! When I was in the television studio video taping this lesson for broadcast, I finished the lesson and looked up to find that I had three more minutes on the air! Well, being the quick thinker that I am, I decided to throw in this *bonus* drawing. It's a great drawing to practice *foreshortening*, *shading*, and *shadows*. Plus, it was a great way to fill three extra minutes!

Pondering Pencil Possibilities Practice Page

PRACTICE, PRACTICE, PRACTICE!

Draw a 3-D stacked pyramid forty-two-layers high! Be sure to place your guide dots below the near corner of each layer. This will help you draw the next layer in a *foreshortened* shape. Each guide dot also helps you draw in 3-D by using *placement* (Renaissance Word).

My class had a contest once to see who could draw the most layers in a stacked 3-D pyramid. Everyone in the class drew more than a hundred, with the winner drawing over a thousand on a long sheet of computer paper. When she ran out of room, she slanted the sides in to a new starting point. Ingenious!

Super-Splendid Student Sketches

"Four 3-D Expressions"
Kimberly's Mother
Age: 21+
City: Houston, Texas

I am constantly delighted to find so many parents mailing in their drawings with their kids'! This is a copy of Kimberly's mother's drawing of the assembly lesson I taught at her school. We had seven hundred kids drawing four expressions each. How many expressions does that total? (*A.* 1200 *B.* 2800 *C.* lots.)

Self-Portrait
Kenny
Age: 11
City: Hamburg, Germany

Mike Haveman
Age: 8
City: Langlar, BC

Kenny has drawn a nicely detailed self-portrait above. Below Kenny's cool self-portrait is Mike's computer drawing of ''Dino-Baby''. Computers have opened up a whole new media for you to explore! Here's an idea, how about drawing a self-portrait on a computer? Mail me your self-portrait today!

More Expressions of Drawing
The Three-Quarter View of the Expression of *Intent*

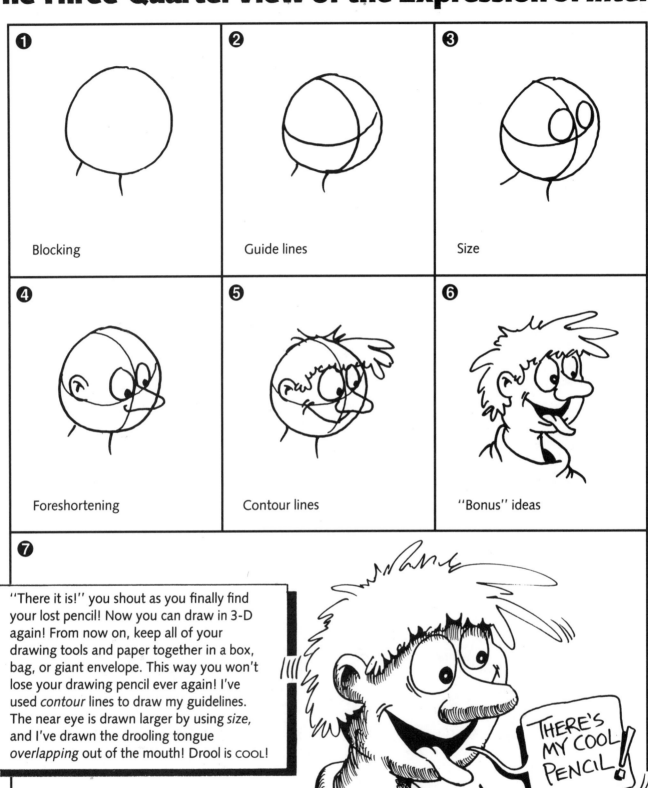

❶ Blocking

❷ Guide lines

❸ Size

❹ Foreshortening

❺ Contour lines

❻ "Bonus" ideas

❼

"There it is!" you shout as you finally find your lost pencil! Now you can draw in 3-D again! From now on, keep all of your drawing tools and paper together in a box, bag, or giant envelope. This way you won't lose your drawing pencil ever again! I've used *contour* lines to draw my guidelines. The near eye is drawn larger by using *size*, and I've drawn the drooling tongue *overlapping* out of the mouth! Drool is COOL!

THERE'S MY COOL PENCIL!

Pondering Pencil Possibilities Practice Page

PRACTICE, PRACTICE, PRACTICE!

Draw six three-quarter-view faces below. Use *contour* lines to draw the guidelines.

Today's Creative Challenge is to make a drawing bag to keep all your drawing supplies and paper in one place. Instead of leaving your art tools scattered all over the house, design a grocery bag to tote them around in! Now you are ready to carry your drawing stuff with you anywhere at a moment's notice.
"Honey, come with me to run some errands."
"Just a sec, Mumsie! Let me grab my drawing bag!"

MARVELOUS: Causing wonder; extraordinary; splendid. This is what your teachers say about your drawings as long as you don't draw during their lessons!

The 3-D Expression of *Elation*

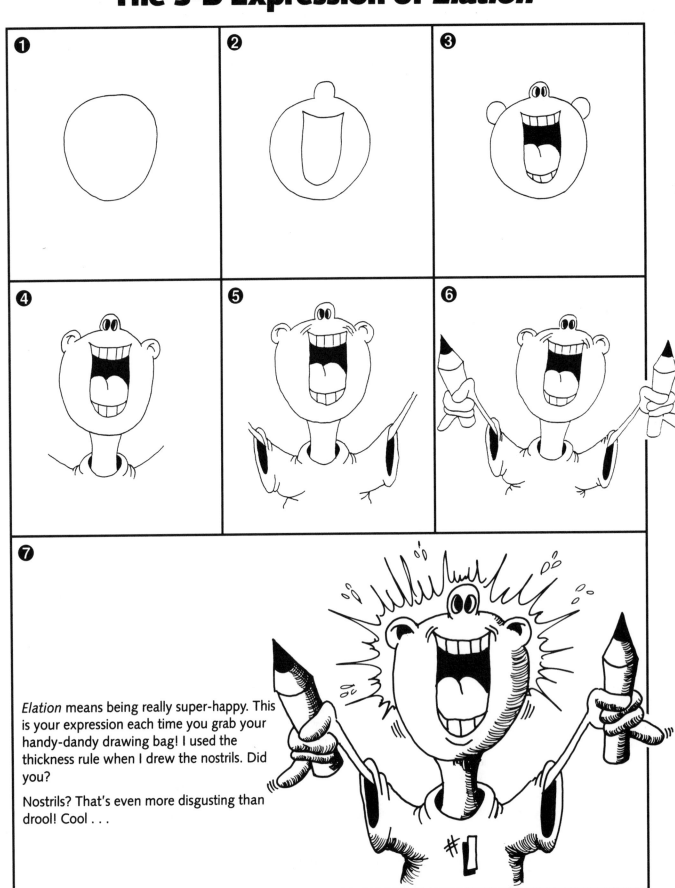

Elation means being really super-happy. This is your expression each time you grab your handy-dandy drawing bag! I used the thickness rule when I drew the nostrils. Did you?

Nostrils? That's even more disgusting than drool! Cool . . .

Pondering Pencil Possibilities Practice Page

PRACTICE, PRACTICE, PRACTICE!

I noticed how nice and clean your teeth were in this drawing. You must brush three hundred times every day! You tooth-brushing, clean-teeth animal!

Today's Creative Challenge: Ask your family to sit around the kitchen table. Give them all a piece of paper and a pencil. Now ask your family to draw portraits of the others while you draw theirs! Ahhh, a nice family drawing evening! Hey! Set up your home video camera and record this for your family memoirs. Mail me a copy of this video. I'd like to broadcast it on my TV show.

Imagination Station HQ

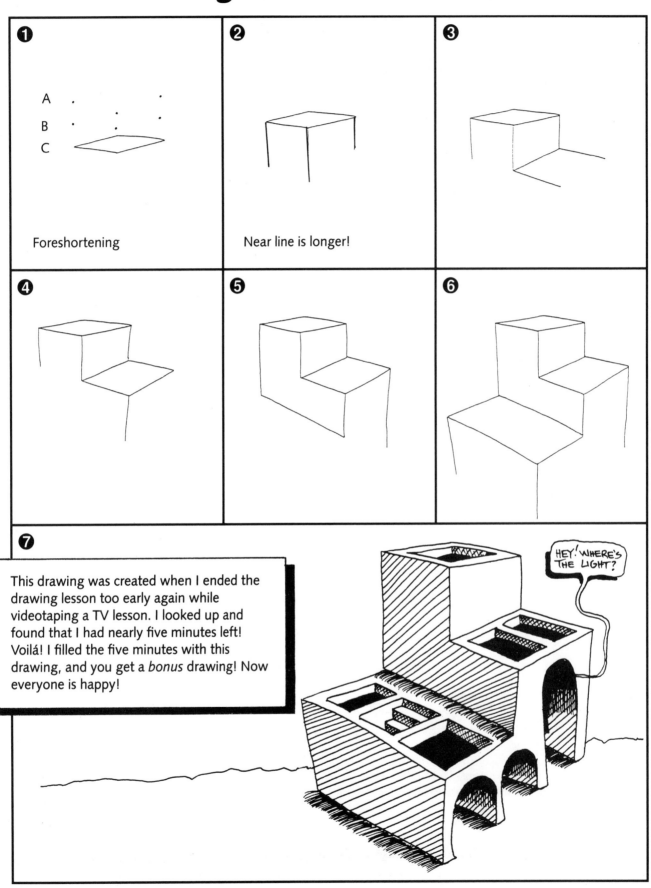

❶ A · · ·
B · · ·
C [diagram of foreshortened square]

Foreshortening

❷ Near line is longer!

❸

❹

❺

❻

❼ This drawing was created when I ended the drawing lesson too early again while videotaping a TV lesson. I looked up and found that I had nearly five minutes left! Voilá! I filled the five minutes with this drawing, and you get a *bonus* drawing! Now everyone is happy!

HEY! WHERE'S THE LIGHT?

Pondering Pencil Possibilities Practice Page

PRACTICE, PRACTICE, PRACTICE!

Draw an Imagination Station 3-D building seventeen layers high! Use guidelines off the *foreshortened* squares to keep your drawing lined up correctly.

SUPER STORY STARTER:

My memory clicked on like a computer screen. Suddenly, I remembered where I had left my drawing bag full of pencils! The night before, I had been drawing in the Great Hall of Ideas at Imagination Station Headquarters when an idea zapped me!

You finish the story!

Super-Splendid Student Sketches

"Twenty Cool Expressions of Drawing in 3-D!"
Destre
Age: 9
City: Indianapolis

Which is your favorite expression in Destre's picture of faces? Mine is the one with the Scottish hat! Let's have a contest and see who can draw the most facial expressions on one piece of paper!

Super-Splendid Student Sketches

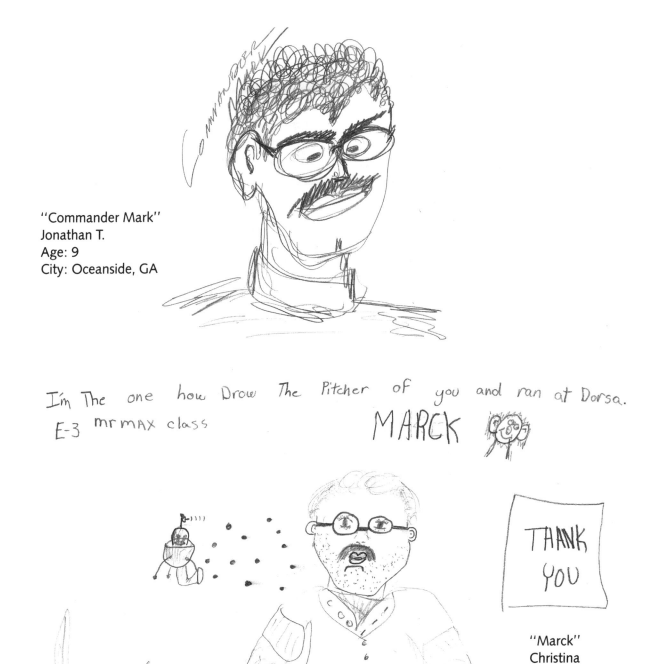

"Commander Mark"
Jonathan T.
Age: 9
City: Oceanside, GA

I'm The one how Drow The Pitcher of you and ran at Dorsa.
E-3 mr mAX class
MARCK

THANK YOU

"Marck"
Christina
Age: 10
City: Tennessee

I seem to receive several pictures a week from kids who have drawn my portrait. I love getting these in the mail. Some make me look really skinny and some, really humongous! Some make me look like a scientist, and some make me look like a professional wrestler. Why don't you draw a picture of your art teacher?

Dino-Lizards
Texas Rex

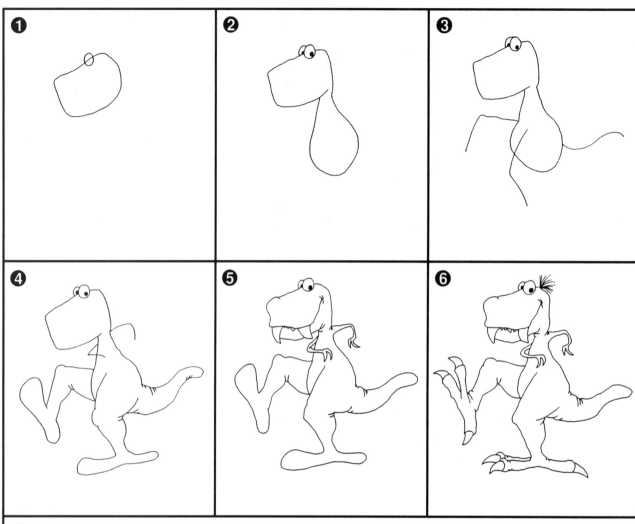

7

When you start this drawing, try *blocking* it in as I did. Professional artists block in their drawings lightly before they ink them. Usually, professional illustrators use a nonreproducing blue pencil first, then they draw it in ink. This nonrepro blue pencil does not come out on copying machines. This saves the artist lots of time spent erasing lines. Why don't you try it? Get a nonreproducing blue pencil from your local art store, draw a picture, and ink it with a black pen. Now take it to a copy store and watch what happens. The blue lines disappear on your copies!

Pondering Pencil Possibilities Practice Page

PRACTICE, PRACTICE, PRACTICE!

Draw three Texas Rexes sitting around a campfire roasting delicious hot dogs. Yum! Use *size* to make the back leg look farther away and *shadow* to make the Dino Dudes stand on the planet surface.

TODAY'S GENIUS WORD:
CHARACTER

Today's Creative Challenge is to make neato personalized memo pads for Grandma, Mom, and your teachers. Get a blank piece of paper, a nonreproducing blue pencil, and a black ink pen. Using the nonreproducing blue pencil, draw a very cool 3-D picture around the edge of the paper. Leave a lot of white space in the middle for messages. Take your black ink pen and draw the final picture over the blue lines. Now you are ready for the copy shop! Have your parents take you to the copy shop and ask the technician to reduce your art to fit the memo-pad size you want. After they reduce (shrink) your drawing, take a look at it. It looks great, doesn't it? (I love looking at reduced copies of my art. Reducing it really tightens up the lines and cleans up the drawing.) Once you have the art reduced, place a copy order for ten memo pads! Don't forget to mail me one! Thanks . . .

CHARACTER: Moral strength; a distinctive trait; reputation; behavior typical of a person. You have a lot of *character* because you help people, apply yourself at school, and draw twelve hours every day!

The 3-D Laughing Dino-Lizard

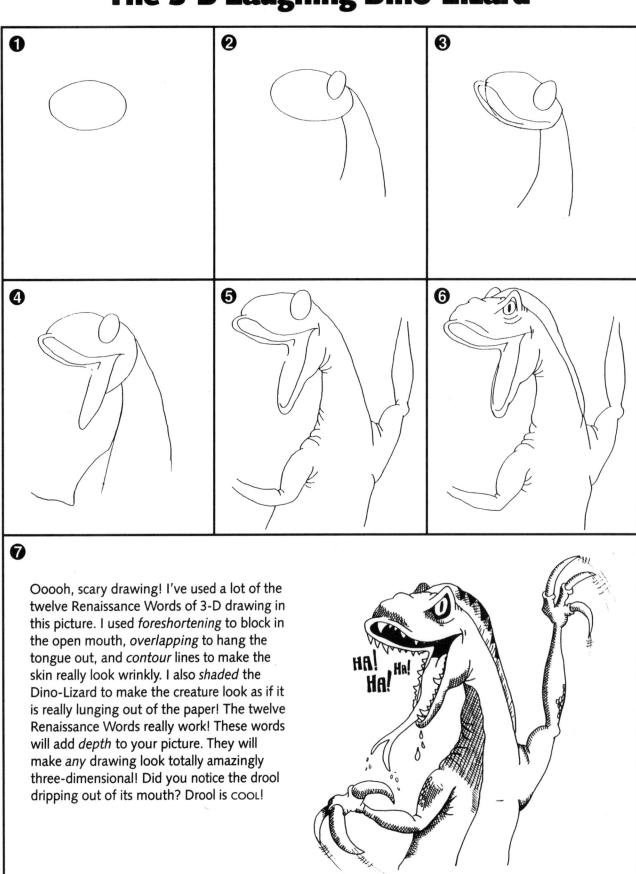

❼ Ooooh, scary drawing! I've used a lot of the twelve Renaissance Words of 3-D drawing in this picture. I used *foreshortening* to block in the open mouth, *overlapping* to hang the tongue out, and *contour* lines to make the skin really look wrinkly. I also *shaded* the Dino-Lizard to make the creature look as if it is really lunging out of the paper! The twelve Renaissance Words really work! These words will add *depth* to your picture. They will make *any* drawing look totally amazingly three-dimensional! Did you notice the drool dripping out of its mouth? Drool is COOL!

HA! HA! HA!

Pondering Pencil Possibilities Practice Page

PRACTICE, PRACTICE, PRACTICE!

In the blank space below, draw a big fat lumpy scaly wrinkled hairy drooling Dino-Lizard with bad breath! Yeah! Nice and disgusting!

SUPER STORY STARTER:

''Wow! Cool shoes!'' Laughing Lizard exclaimed as he wiggled his big claws deeper inside the soft padding of his new shoes. ''I bet I could run a billion miles an hour with these puppies on!'' At that, he took off running toward the giant forest on the edge of Dino Town. The red blinking lights in the heel of each shoe glowed wildly as he dashed away.

You finish the story!

Super-Splendid Student Sketches

"Dragon"
Kelly's Mother
Age: 21+
City: Spokane, Washington
Wellington Elementary School

Kelly's mom created this happy 3-D drawing while attending my evening drawing program with her daughter at Carver elementary school. We sure had a great time! Four hundred family members having a wild creative art attack in 3-D together! Cool . . .

"Ice Creamasaurus"
Chris Eckhardt
Age: 9
City: Anchorage, Alaska

The assignment was to take the dinosaur-lesson drawing home and create a unique dino-creature. Chris went home and drew for five hours! He drew fifty dino-critters! Here is my favorite. What a neat idea! What a creative genius he is! I like the wild hair, the *shading,* the *horizon,* and the tree popping out of the *foreshortened* hole in the ground!

"Pencil Troll"
Mark
Age: 31
City: Carlsbad, California

I was sorting through about thirty thousand student drawings, attempting to pick some to use in this book. Really, thirty thousand! At least thirty thousand! You kids sure can draw! Anyway, I'm sitting in my office buried up to my waist in cool drawings, trying to decide on how to decide on which to decide to use in the book. A very difficult task indeed! They all look so good! I had almost finished choosing when I found this old sketch that I had drawn ten years ago! Save your original drawings to build your portfolio! Give signed copies away to friends and family, not the originals! In this drawing I used a scribble *shading* technique. Try this on some of your drawings. It's really fun! It feels as if you are painting with your pencil.

Polar Party
Interesting Ice Cubes

❶ A . . .
B

Guide dots

❷

Foreshortening

❸

Placement

❹

Guide lines

❺

Alignment

❻

Size

❼ This is a great drawing to warm up with before you begin your daily-drawing nine-hour session. Practice this pile of cubes until you can draw it without thinking in thirty seconds flat! I'd like you to get to the point where drawing a *shaded, foreshortened* cube is like second nature to you. When this happens, you will be able to draw just about anything in 3-D with very little effort.

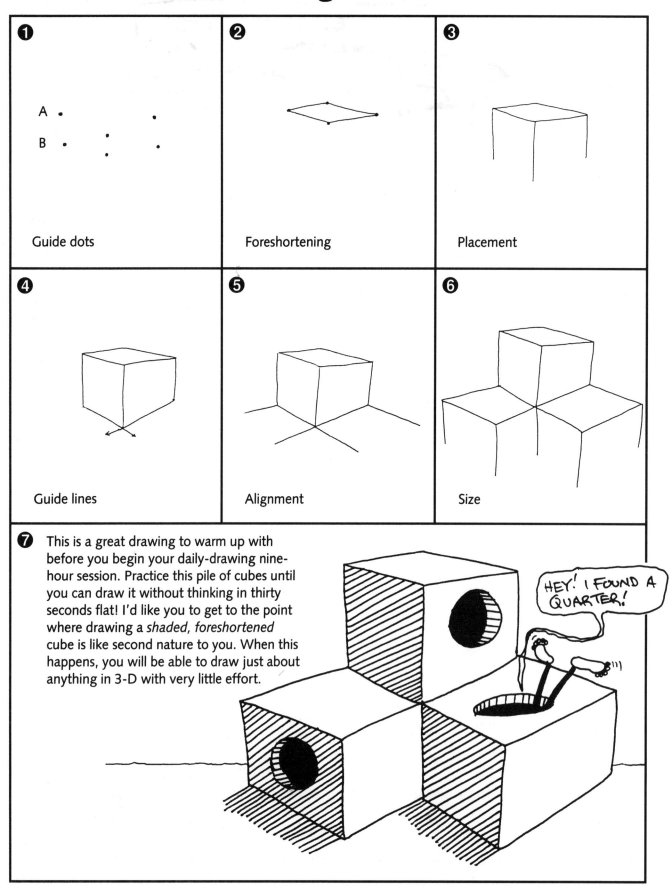

HEY! I FOUND A QUARTER!

Pondering Pencil Possibilities Practice Page

PRACTICE, PRACTICE, PRACTICE!

In the blank space below, draw a stack of 3-D ice cubes, fifteen layers high! Use guidelines to keep the ice cubes from *drooping* off the page.

Today's Creative Challenge is to create your own 3-D drawn gift-wrap paper. Use old paper bags, the back of old wrapping paper, or the back of old posters. You'll be recycling, saving trees, and enhancing the present with the gift of your *magnificent* talent!

MAGNIFICENT: Splendid, stately, and exalted. Something often said of your ideas! A very common word used to describe your artwork.

The Cool 3-D Polar Ice Dome

❶

❷

❸

❹

❺

Use size by drawing the near end of the doors LARGE!

❻

❼

Brrr, it's cold in Connecticut in the winter! I was visiting some elementary schools up there last January and nearly turned into an ice man! All the kids and teachers didn't think much of the 30-below temperature, but I panicked! They are truly adaptable people. I got off the airplane (having just arrived from my 70-degree weather back home in San Diego) and yelled, "Whoooooooooooooooooooo!" They had to push me out of the airport terminal to get me in the car. It took me a month to thaw after that week! The kids in Connecticut laughed when I called them Eskimos, so I drew them a cool ice house! Use texture in this drawing to create the look of stacked ice cubes.

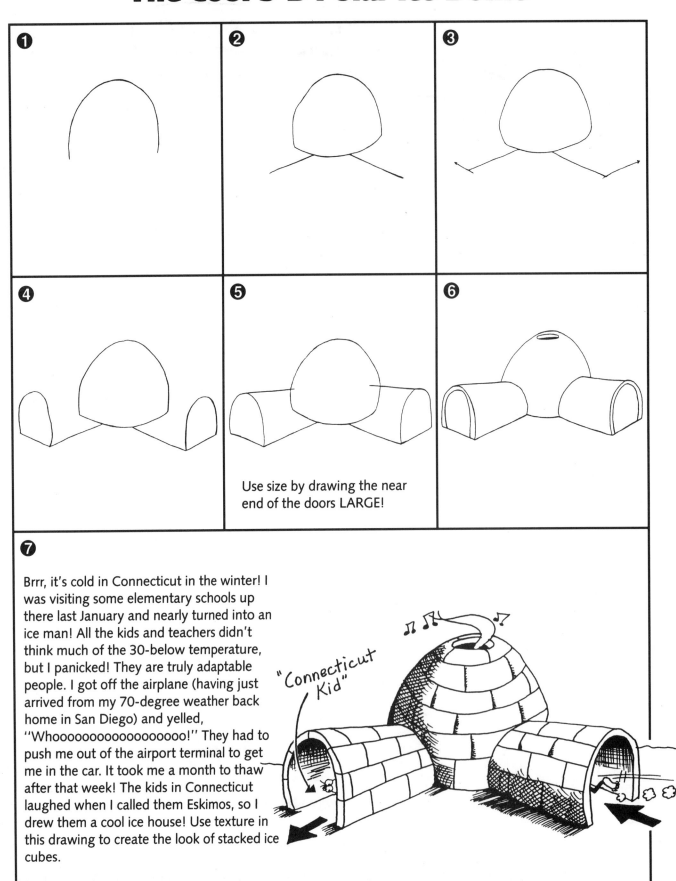

"Connecticut Kid"

Pondering Pencil Possibilities Practice Page

PRACTICE, PRACTICE, PRACTICE!

Draw an entire 3-D Polar Ice-Dome City in the blank space below. Connect the separate ice domes with long, winding 3-D ice tunnels. Use *size* and *overlapping* a lot.

SUPER STORY STARTER:

"Wooooooo, it's cold!" Mark shrieked out loud as he peeked his head out of the polar ice dome door. "We'll need some extra parkas if we're going to cross that glacial bridge today."

You finish the story!

Popular Polar Dude

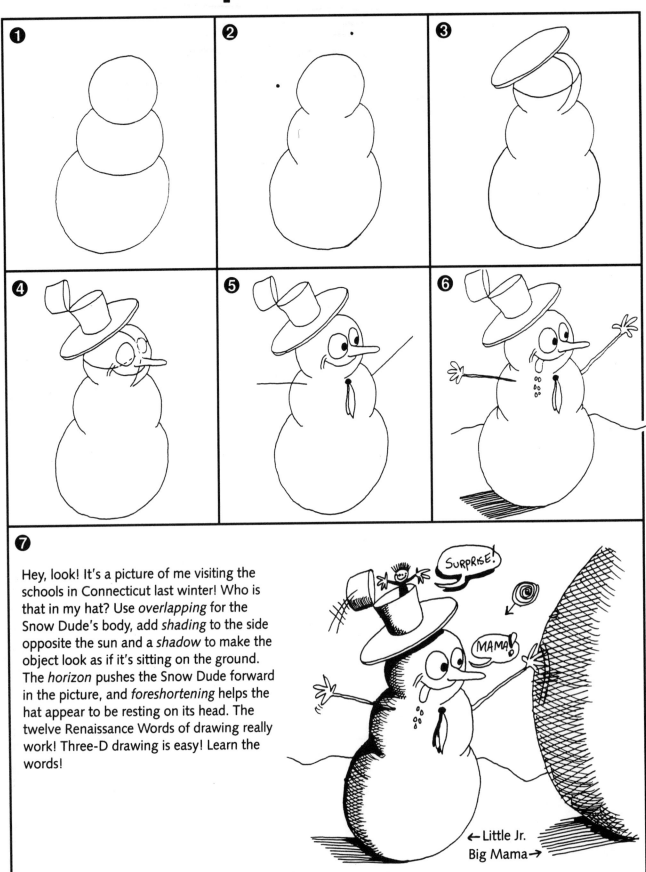

7

Hey, look! It's a picture of me visiting the schools in Connecticut last winter! Who is that in my hat? Use *overlapping* for the Snow Dude's body, add *shading* to the side opposite the sun and a *shadow* to make the object look as if it's sitting on the ground. The *horizon* pushes the Snow Dude forward in the picture, and *foreshortening* helps the hat appear to be resting on its head. The twelve Renaissance Words of drawing really work! Three-D drawing is easy! Learn the words!

SURPRISE!

MAMA!

← Little Jr.
Big Mama →

Pondering Pencil Possibilities Practice Page

PRACTICE, PRACTICE, PRACTICE!

In the space below, draw a giant 3-D Snow Dude that is twenty-three layers high. Add lots of *bonus* ideas to make your drawing look even more brilliant!

SUPER STORY STARTER:

"Hey, Mom! Look at me!" I shouted, waving my skinny tree-branch arms. "See! I told you it was cold enough to turn me into Frosty's brother!" I shifted my button eyes to look down at my giant round snow body. A few melted water drops trickled down my side. "I can start a new diet fad!" I mumbled to myself. "Frosty's melting weight-loss program!"

Suddenly I heard squealing voices, dozens of them, coming from somewhere behind me. I tried to turn around, but movement is difficult when you're a frozen clump of snow with a piece of smelly coal stuck to your nose. The next thing I knew, a crowd of kids had encircled me, dancing around and singing the most obnoxious songs! One of them decided a carrot would look better for my nose than a piece of smelly coal, so off came the coal and in went the carrot.

"I feel so ridiculous!" I muttered to myself, wondering how in the world I was going to get out of this predicament.

You finish the story!

Super-Splendid Student Sketches

''Stacks of Cubes''
Matt Murray
Age: 8
City: Oroville, California

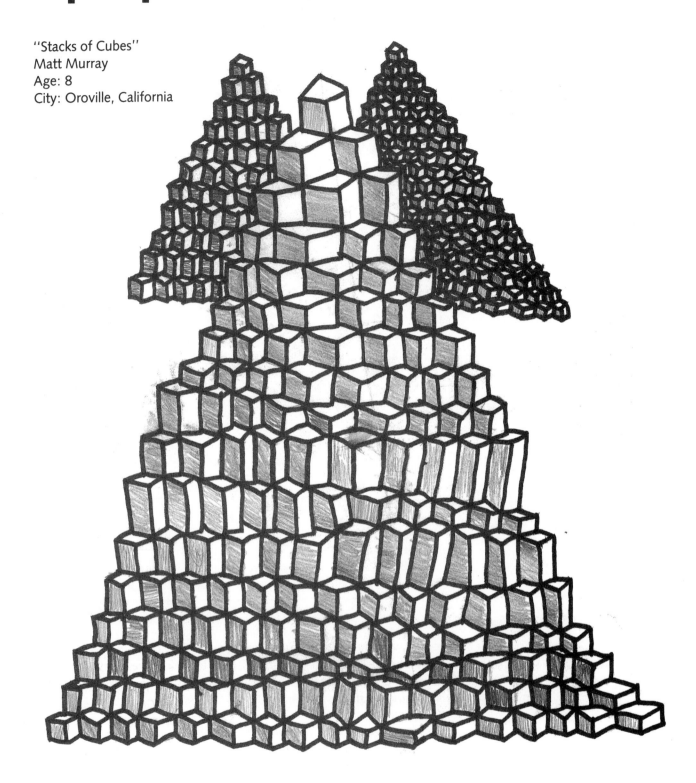

Matt is now an official *Foreshortening* Expert after stacking so many 3-D ice cubes! Nice *over-lapping* on the back cubes! Great *shading* on the entire stack! Why don't you mail me a stack of 2,006!

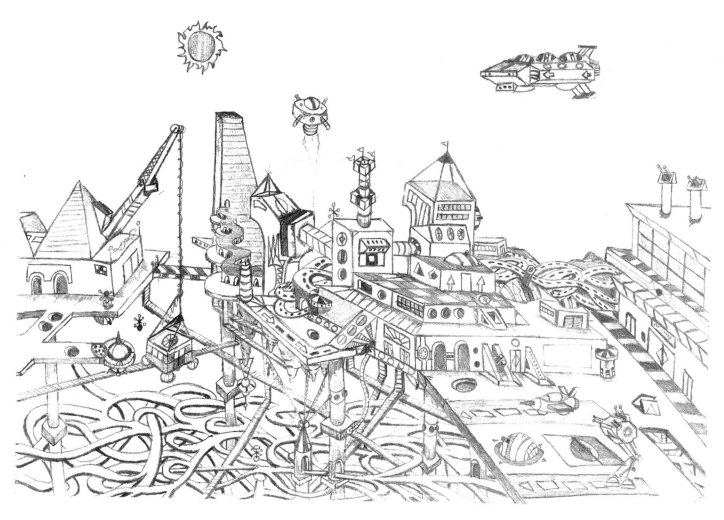

"Cool Super City"
Steve
Age: 14
City: Baltimore, Maryland

Steve used to watch me every day on my old public television children's series *The Secret City.*
Now he's drawing with me on my new series, *Mark Kistler's Imagination Station.* He combined
the theme of my old series with ideas from the new show to draw this cool Super City. I love the
detail and all the *bonus* ideas he has used. Find where he has used the following Renaissance
Words in his masterpiece: *1. foreshortening 2. shading 3. shadow 4. overlapping 5. contour 6.
placement 7. bonus 8. horizon 9. attitude 10. daily 11. bonus 12. density.* Yup! He has used all
of the twelve Renaissance Words of 3-D drawing.

EPISODE 26 Flying High With Your Imagination
The 3-D Giant Jumbo Jet

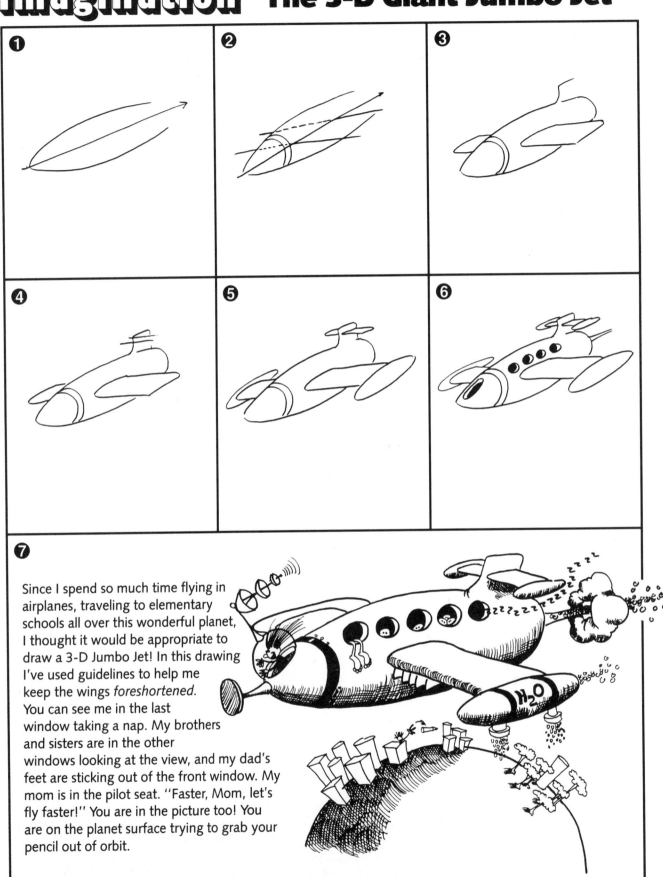

①

②

③

④

⑤

⑥

⑦

Since I spend so much time flying in airplanes, traveling to elementary schools all over this wonderful planet, I thought it would be appropriate to draw a 3-D Jumbo Jet! In this drawing I've used guidelines to help me keep the wings *foreshortened*. You can see me in the last window taking a nap. My brothers and sisters are in the other windows looking at the view, and my dad's feet are sticking out of the front window. My mom is in the pilot seat. "Faster, Mom, let's fly faster!" You are in the picture too! You are on the planet surface trying to grab your pencil out of orbit.

Pondering Pencil Possibilities Practice Page

PRACTICE, PRACTICE, PRACTICE!

Draw five 3-D Jumbo Jets below. Add lots of windows and action lines! Use the thickness rule on the windows and add *bonus* ideas everywhere!

SUPER STORY STARTER:

"All set!" Amy hollered as she tightened the harness of her solar-powered paraglider. The captain of the fuel-conserving airline dipped the wing of the plane to make Sara's jump safer. Many airlines are now paradropping passengers rather than making extra, fuel-wasting stops at airports.

"Thanks for flying with Ecology Airline!" the captain said, waving good-bye to Sara as she glided down toward her house.

You finish the story!

MOTIVATION: Incentive or drive. You are filled with *motivation* to draw twelve hours every day!

The High-Tech Hovering Helicopter

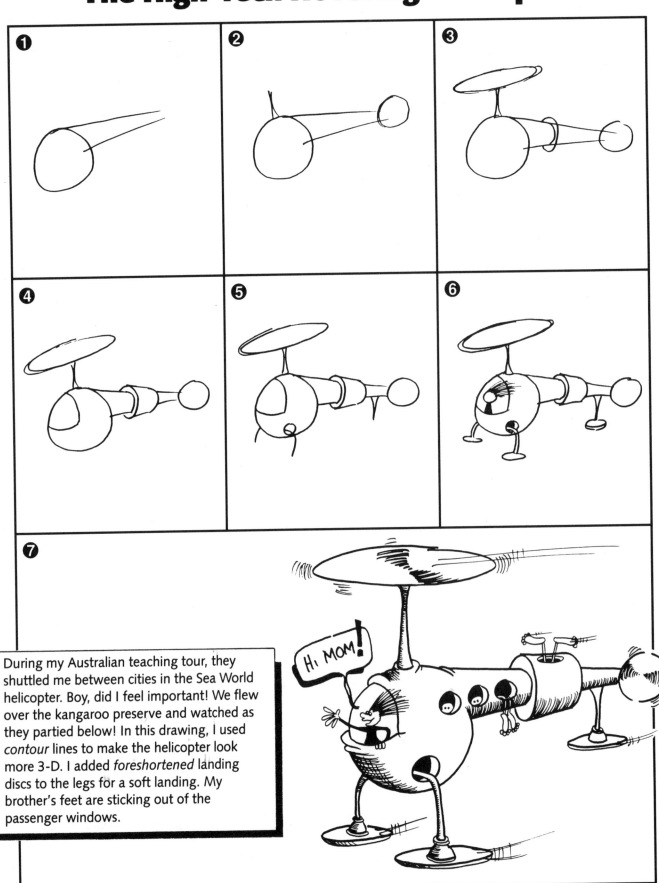

❶

❷

❸

❹

❺

❻

❼

During my Australian teaching tour, they shuttled me between cities in the Sea World helicopter. Boy, did I feel important! We flew over the kangaroo preserve and watched as they partied below! In this drawing, I used *contour* lines to make the helicopter look more 3-D. I added *foreshortened* landing discs to the legs for a soft landing. My brother's feet are sticking out of the passenger windows.

HI, MOM!

Pondering Pencil Possibilities Practice Page

PRACTICE, PRACTICE, PRACTICE!

In the blank space below, design your own flying vehicle. Maybe a heliplane or a winged car. Let your imagination really *soar* with this one.

Today's Creative Challenge is to have your parents drive you to the airport. Go into the terminal with your sketch pad and find a seat at a window overlooking the jets. Draw a few of them below. After you finish drawing the parked jets, ask your parents to drive you near the runway. Not *on* the runway! Find a street where you can get a decent view of the runway. Now draw the planes taking off and landing. I have this great spot at the San Diego airport where I can park my car near the takeoff end of the runway! What a spectacular view to draw from!

Super-Splendid Student Sketches

"Rocket Book"
Mary J.
Librarian
City: Bakersfield, California

Look at how many cool helivehicles Eric has drawn in the sky. He used blended *shading* to make the port windows on the round buildings look hollow.

Eric
Age: 13
City: Los Angeles, California

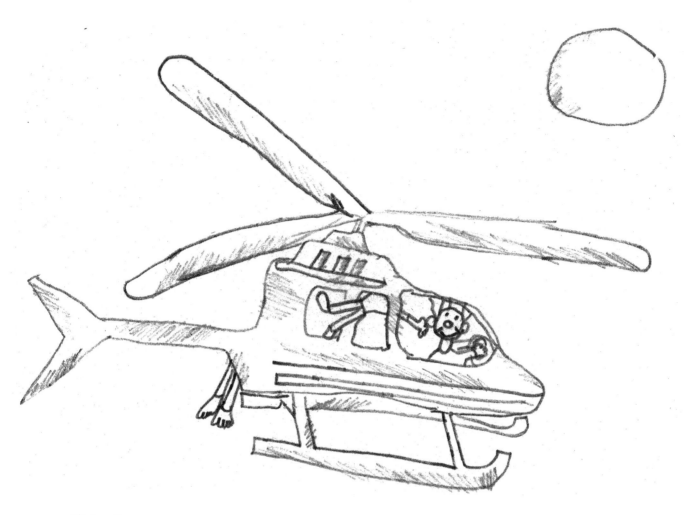

Clinton P.
Age: 9
City: Houston, Texas

Clinton has drawn a lot of people catching a ride in his helicopter. Good use of *bonus* (Renaissance Word)! What kind of helivehicles are you going to draw? Use action lines to make the rotor blades appear moving.

Knights of the Drawing Table Return The Two-Point-Perspective Castle

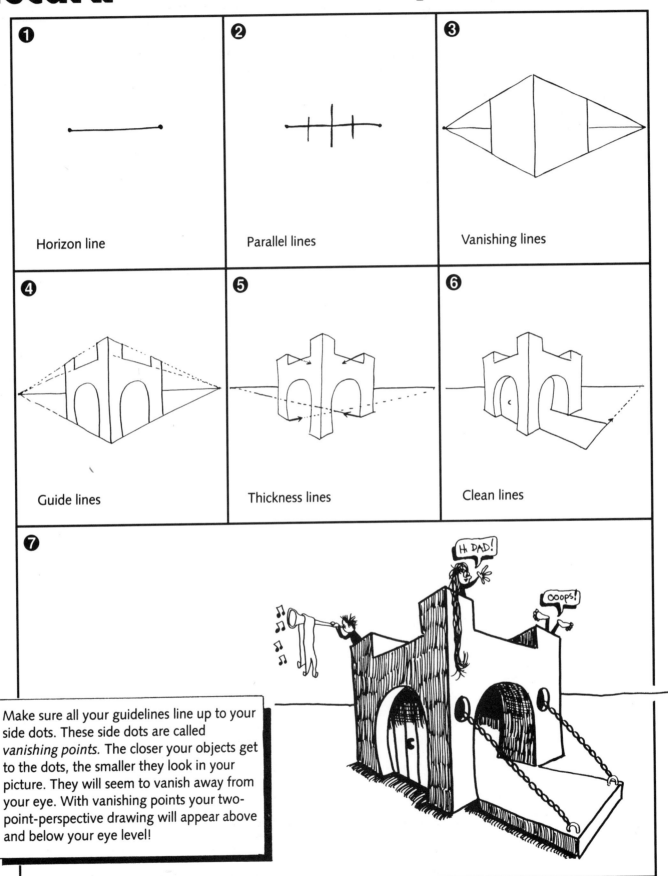

① Horizon line

② Parallel lines

③ Vanishing lines

④ Guide lines

⑤ Thickness lines

⑥ Clean lines

⑦

HI DAD!

OOOPS!

Make sure all your guidelines line up to your side dots. These side dots are called *vanishing points.* The closer your objects get to the dots, the smaller they look in your picture. They will seem to vanish away from your eye. With vanishing points your two-point-perspective drawing will appear above and below your eye level!

Pondering Pencil Possibilities Practice Page

PRACTICE, PRACTICE, PRACTICE!

Draw your own two-point-perspective castle below. Start with the *horizon* line. This will help you place your vanishing dots correctly before you start to draw the guidelines.

Today's Creative Challenge is to draw a two-point-perspective city on a large piece of paper. Here's a cool tip. Whenever I draw a two-point-perspective picture, I start with the horizon line and draw the two dots. Then I push pins into the dots. Next I stretch a rubber band between the pinned dots. This rubber band will act as your movable guideline! Just draw a vertical line anywhere on the piece of paper. Now stretch the rubber band to the top of the vertical line. Presto! You have both sides of the top of the building already lined up for you. You can do the same to the bottom of the line to create the bottom of the building!

PURPOSE: Determination; an intended or desired result; a goal. Each time you pick up your pencil to draw you are filled with *purpose* to create awesome masterpieces!

Knights Around the Really Very Round Table!

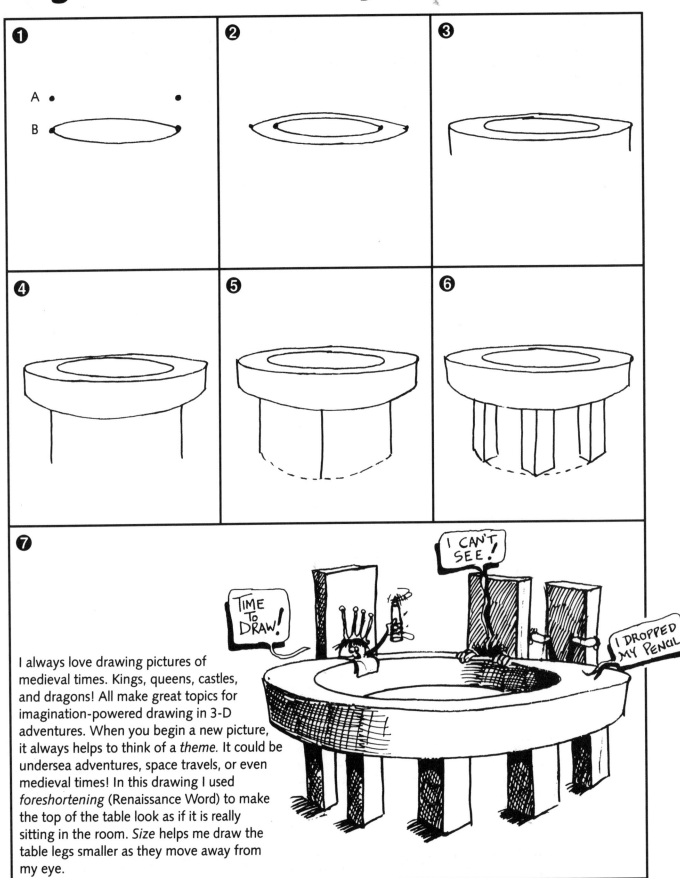

I always love drawing pictures of medieval times. Kings, queens, castles, and dragons! All make great topics for imagination-powered drawing in 3-D adventures. When you begin a new picture, it always helps to think of a *theme.* It could be undersea adventures, space travels, or even medieval times! In this drawing I used *foreshortening* (Renaissance Word) to make the top of the table look as if it is really sitting in the room. *Size* helps me draw the table legs smaller as they move away from my eye.

PRACTICE, PRACTICE, PRACTICE!

In the blank space below, have fun drawing a really *square* table for the knights of King Arthur's court. The *round* table was sent to the carpenter's shop for repairs. This is their rental table. Use your *foreshortened* guide dots just as you do when drawing a round table.

SUPER STORY STARTER:

''More cereal!'' the king ordered loudly as he stared into his empty bowl. ''The second-graders must have been in here this morning!'' he mumbled in a growling tone. The second-graders of the castle's elementary school had a mischievous habit of sneaking into the king's kitchen and gobbling up all his delicious nutritious royal breakfast cereal.

You finish the story!

Super-Splendid Student Sketches

"A Garage"
Emily
Age: 6
City: Carlsbad, California

Emily has really learned this one-point-perspective idea. All her guidelines converge to the vanishing point. How is this different from two-point perspective? I like her cars. They look like vintage 1920 cars.

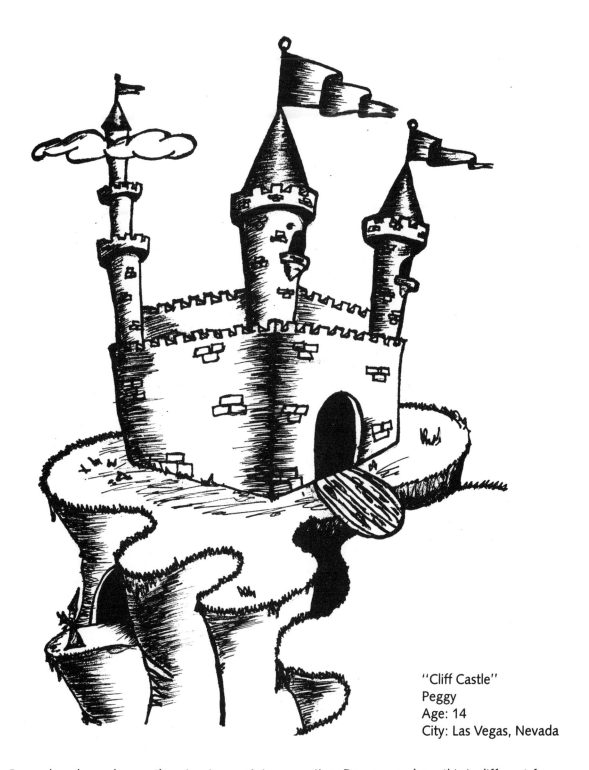

"Cliff Castle"
Peggy
Age: 14
City: Las Vegas, Nevada

Peggy has drawn her castle using two-point perspective. Do you see how this is different from Emily's one-point-perspective drawing? I love the way Peggy has added the cliffs and canyons in her sketch. The gate is *foreshortened.* This makes it appear to be stretching across the moat. The banners add a nice touch to the medieval theme. Just one tiny teeny mistake in the drawing. The flags need to be drawn from a below view rather than from an above view. Unless, of course, she wanted to create an optical illusion!

EPISODE 28 Super Solar System
The Imagination Launch

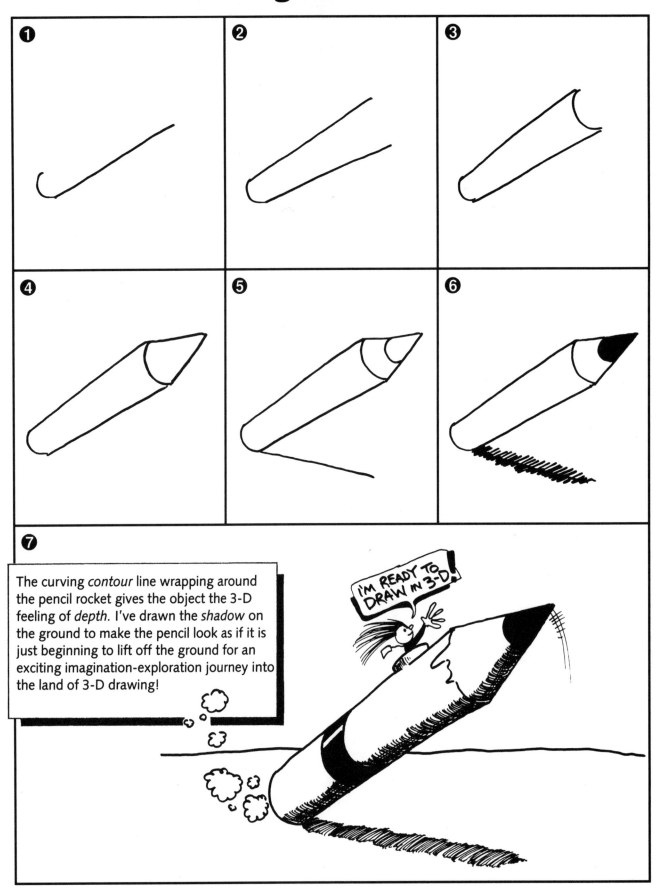

❼

The curving *contour* line wrapping around the pencil rocket gives the object the 3-D feeling of *depth.* I've drawn the *shadow* on the ground to make the pencil look as if it is just beginning to lift off the ground for an exciting imagination-exploration journey into the land of 3-D drawing!

I'M READY TO DRAW IN 3-D!

PRACTICE, PRACTICE, PRACTICE!

Draw Imagination-Powered Pencil Rockets launching from different positions. Draw some launching toward you and some launching away. The *shadows* are really important in this exercise. Fill up the blank space below. Have fun!

TODAY'S GENIUS WORD:
INTELLECTUAL

Today's Creative Challenge is to have your parents help you tape a lot of your artwork on the wall. Now aim your video camera at each piece and tell me about your masterpiece. Mail me your home video. Maybe I can broadcast it on my show! We will show the world your amazing *intellectual* talent!

INTELLECTUAL: Inclined toward rational or creative thought; showing high intelligence. Sounds like a person describing you! You are an *intellectual* artistic genius!

The Space-Quest Explorer

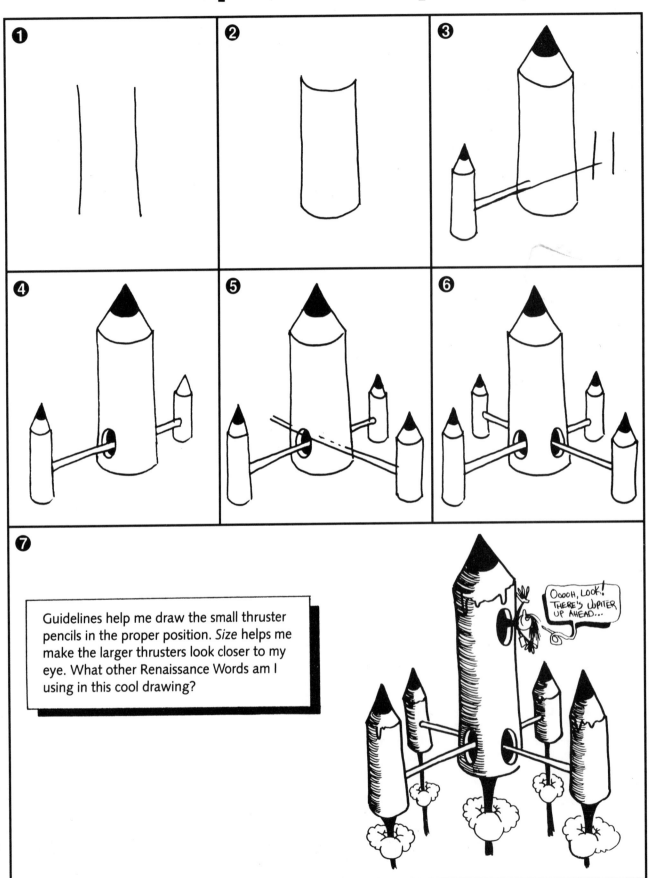

❶

❷

❸

❹

❺

❻

❼

Guidelines help me draw the small thruster pencils in the proper position. *Size* helps me make the larger thrusters look closer to my eye. What other Renaissance Words am I using in this cool drawing?

Ooooh, look! There's Jupiter up ahead...

Pondering Pencil Possibilities Practice Page

PRACTICE, PRACTICE, PRACTICE!

Draw a Space Quest Pencil Rocket with eight booster pencil thrusters below. You will have to use a lot of guidelines and *size* on this one!

SUPER STORY STARTER:

The Space-Quest Rocket seemed to stretch as it broke through the Earth's outer atmosphere. Jennifer laughed with delight while watching the planet below shrink away from her view in the port window.

Now you finish the story.

The Solar System in 3-D

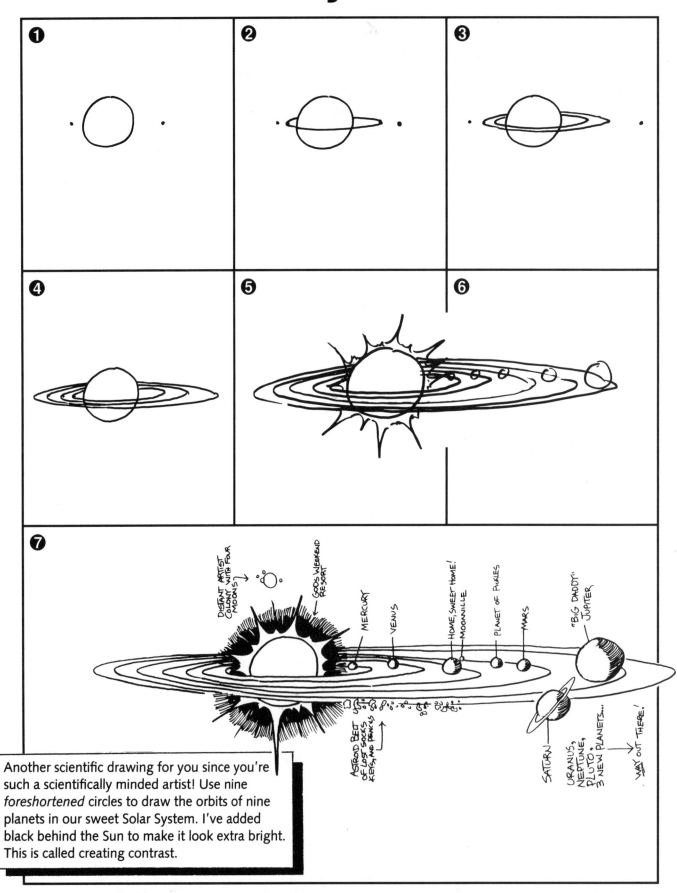

Another scientific drawing for you since you're such a scientifically minded artist! Use nine *foreshortened* circles to draw the orbits of nine planets in our sweet Solar System. I've added black behind the Sun to make it look extra bright. This is called creating contrast.

Pondering Pencil Possibilities Practice Page

PRACTICE, PRACTICE, PRACTICE!

Create a cool galaxy with seven solar systems in it. Use lots of *foreshortened* orbit rings to make your drawing look super-duper 3-D.

Here's some scientific data about our Solar System. Libraries are full of neat information like this!

Planet, in Order from the Sun	Distance from the Sun	Size
1. Mercury	58 million kilometers	⅓ the Earth
2. Venus	108 million kilometers	9/10 the Earth
3. Earth	150 million kilometers	
4. Mars	228 million kilometers	½ the Earth
5. Jupiter	7783 million kilometers	11 Earths
6. Saturn	1429 million kilometers	9½ Earths
7. Uranus	2875 million kilometers	4 Earths
8. Neptune	4504 million kilometers	4 Earths
9. Pluto	5900 million kilometers	⅕ Earth

I love looking up information like this! I feel so scientific. Which planets have moons? Visit your library to find out! You can feel scientific too!

Super-Splendid Student Sketches!

"Space-Bubble City"
Alistar Willis
Age: 15
City: Pincourt, Quebec

Alistar has drawn an entire galaxy of Space-Bubble Cities. I like the *shading* and the *foreshortening*. Look at the little human floating out of the shuttle. Looks like my sister!

"Space Place"
Mark
Age: 10
City: Alabama

Mark created an erupting volcano on a barren planet! I wonder what it would be like living in a big city inside a bubble floating through deep space for centuries! Mark curved the *horizon* of the planet to make the ship appear to hover in orbit.

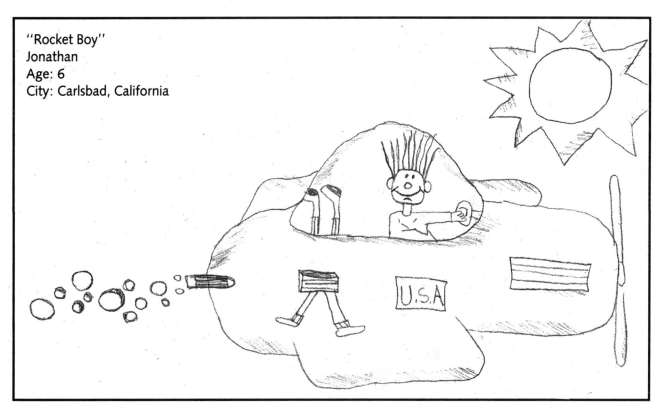

"Rocket Boy"
Jonathan
Age: 6
City: Carlsbad, California

"Space City"
Edwin Alvarenga
Age: 10
City: London, England

Flying space things was the lesson assembly theme when I visited these students' schools. We had a good time! Four hundred kids drawing 3-D flying space vehicles and cities at one time. How many of the twelve Renaissance Words of 3-D drawing have these students used in their brilliant masterpieces?

Thumbs-Up For Thinkers
The 3-D Thumbs-Up Tower!

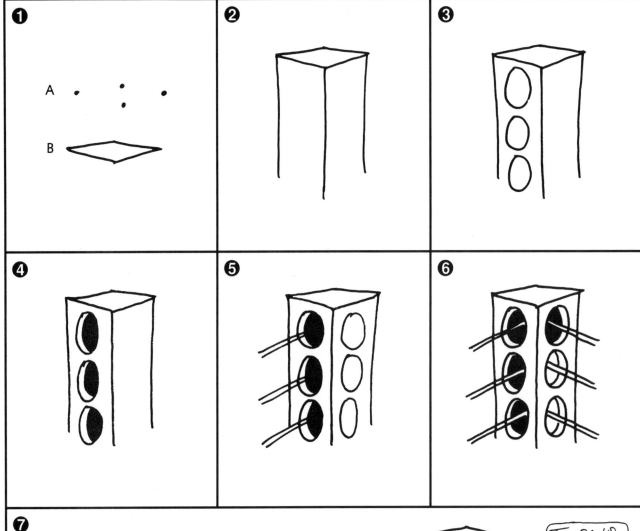

❼

I love reading positive-attitude and goal-setting books. I love reading biographies of people I admire, people I consider my personal heroes of positive attitude. People like Benjamin Franklin, Earl Nightingale, Dr. Norman Vincent Peale, Doctor Dobson, Helen Keller, Christa McAuliffe, and of course my mother, Joyce Kistler! When I'm feeling low, grumpy, irritated, or depressed, I pick up a good inspirational book! Thumbs-up for having a super-positive mental attitude!

Use the thickness rule in this drawing. When you draw the arms, use guidelines to keep all the arms lined up.

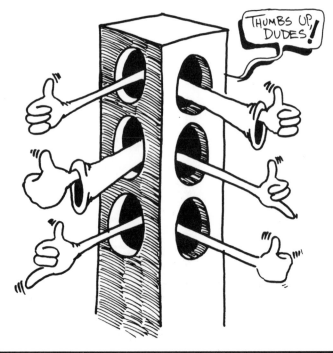

THUMBS UP DUDES!

Pondering Pencil Possibilities Practice Page

PRACTICE, PRACTICE, PRACTICE!

Draw twelve Thumbs-Up Towers with twenty-four arms each! Keep all the windows *foreshortened* and remember to use the thickness rule.

SUPER STORY STARTER:

"Good morning, thinkers!" Steve hollered loudly as he stuck his arm out the small window. The crowd below cheered as he gave his famous thumbs-up position!

Now you finish the story.

AMBITIOUS: Having a strong desire for success. You are an extremely *ambitious* person because you draw ten thousand hours a day.

Ballooning Beyond the Biosphere

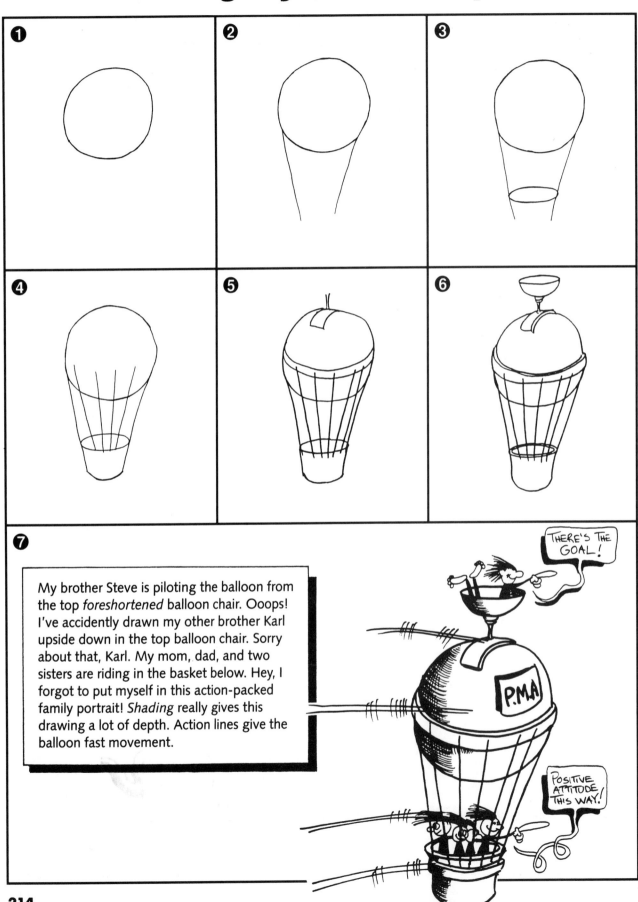

My brother Steve is piloting the balloon from the top *foreshortened* balloon chair. Ooops! I've accidently drawn my other brother Karl upside down in the top balloon chair. Sorry about that, Karl. My mom, dad, and two sisters are riding in the basket below. Hey, I forgot to put myself in this action-packed family portrait! *Shading* really gives this drawing a lot of depth. Action lines give the balloon fast movement.

THERE'S THE GOAL!

P.M.A

POSITIVE ATTITUDE THIS WAY!

Pondering Pencil Possibilities Practice Page

PRACTICE, PRACTICE, PRACTICE!

Draw a whole fleet of hot-air balloons in the blank space below. Use *overlapping* to make the balloons look 3-D.

Today's Creative Challenge is to draw a portrait of your family in a hot-air balloon flying over the Swiss Alps. Mail in your family portraits to me! I would really like to see the family of such a brilliant *prodigy*!

Super-Splendid Student Sketches

"My Kitchen"
Scott
Age: 11
City: Plattsburg, New York

You don't always have to draw in a cartoon style as I do. You can draw realistic pictures the way Scott has done. He has drawn a very detailed picture of his family's kitchen. I bet he spends six hours a day drawing at the kitchen table! It seems the kitchen table is usually where I end up drawing, even though I have a huge drawing desk. I listened to a National Public Radio report that said the kitchen is the most common meeting room in homes all over the world. Interesting little fact, eh? I really like the tile texture Scott has drawn on the kitchen floor. How many *bonus* ideas can you find in Scott's drawing?

Super-Splendid Student Sketches

"Mr. Mark"
Rena
Age: 8
City: Bangor, Maine

I love this drawing! Rena has drawn a picture of me preparing to beam aboard the U.S.S. *Enterprise*! Cool! *Star Trek* is my favorite television show of all time. I must have read over a hundred *Star Trek* books. The artwork on the covers really inspires me to learn how to paint with color in 3-D! One of my dream goals is to beam aboard the *Star Trek* set and teach Data how to draw in 3-D. Thanks for the great drawing, Rena!

Cool Creative Creatures
The Laith Bug

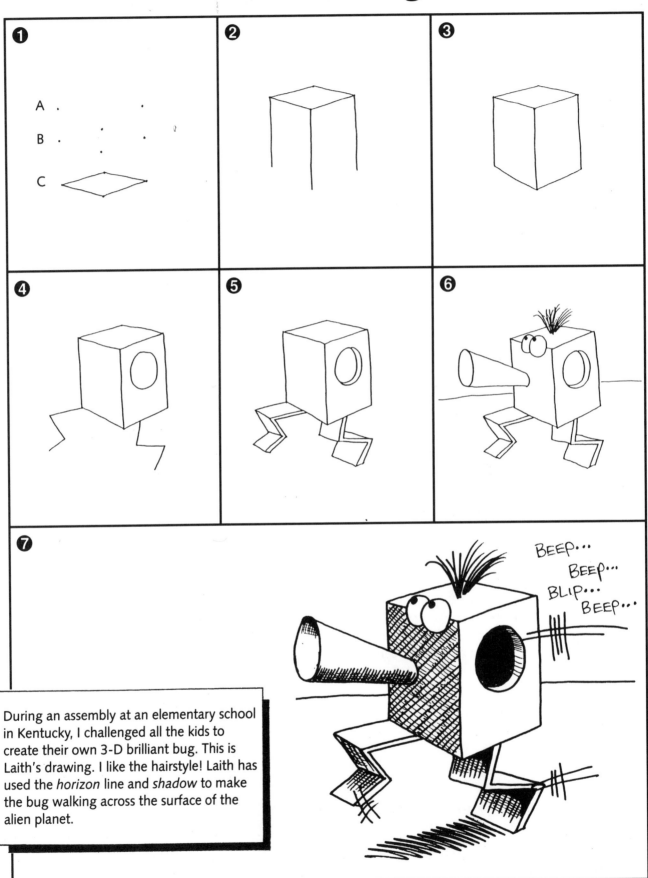

During an assembly at an elementary school in Kentucky, I challenged all the kids to create their own 3-D brilliant bug. This is Laith's drawing. I like the hairstyle! Laith has used the *horizon* line and *shadow* to make the bug walking across the surface of the alien planet.

BEEP...
BEEP...
BLIP...
BEEP...

Pondering Pencil Possibilities Practice Page

PRACTICE, PRACTICE, PRACTICE!

Draw a line of Laith Bugs marching across the surface of Saturn. Use *density* to make the line move away toward the *horizon*.

Today's Creative Challenge is to listen to National Public Radio while you draw. You will learn about what is happening in the world, hear some neat feature stories about new books and movies coming out, and find out interesting facts about cultures from different countries—all while you are drawing in 3-D! This is called using your whole creative brain all at once! Each school year I spend hundreds of hours driving between elementary schools all over the United States. When I rent cars from the different airports, the first thing I check is the radio's reception of National Public Radio. I'd go nuts driving all those hours without my pals Bob Edwards, Carl Castle, Marla Lyison, Scott Simon, Garrison Keillor, Terry Gross, and Cokie Roberts at NPR!

GRACIOUS: Having or showing kindness, courtesy, and charm; compassionate and polite. People use this word when they describe you!

The Andrea Bug

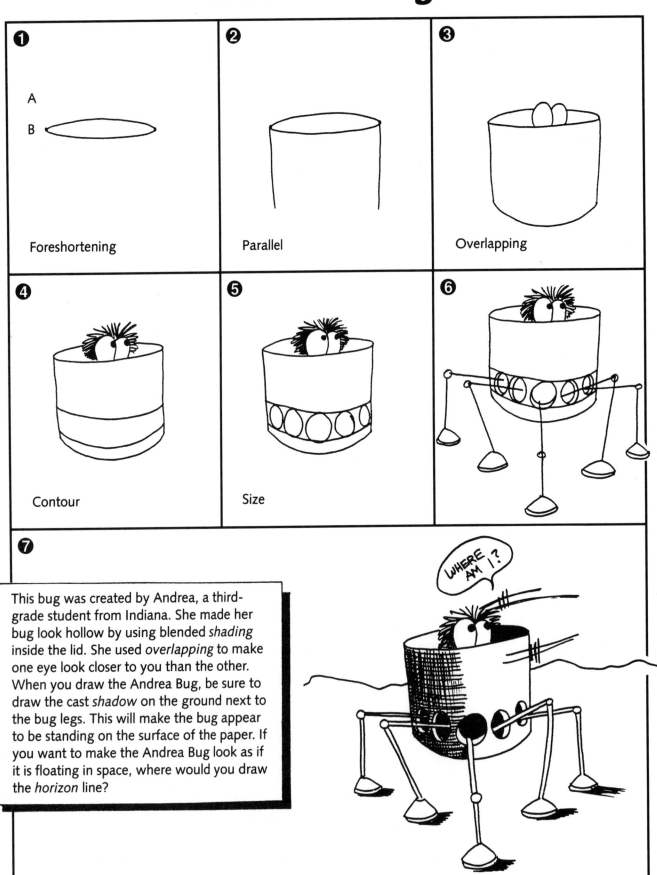

❶ A
B

Foreshortening

❷ Parallel

❸ Overlapping

❹ Contour

❺ Size

❻

❼

This bug was created by Andrea, a third-grade student from Indiana. She made her bug look hollow by using blended *shading* inside the lid. She used *overlapping* to make one eye look closer to you than the other. When you draw the Andrea Bug, be sure to draw the cast *shadow* on the ground next to the bug legs. This will make the bug appear to be standing on the surface of the paper. If you want to make the Andrea Bug look as if it is floating in space, where would you draw the *horizon* line?

WHERE AM I?

Pondering Pencil Possibilities Practice Page

PRACTICE, PRACTICE, PRACTICE!

Albert Einstein once said that imagination is more important than knowledge. Use your awesome *prodigious* imagination to draw a thousand Buoyant Bouncing Bugs below! (Look up the meaning of *prodigious* in your dictionary).

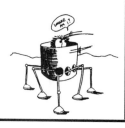

SUPER STORY STARTER:

Start your own story about your brilliant bug drawing above. Send a copy of your drawing and your Story Starter to a friend to continue! Ask them to send their story continuation to one of their friends, who can add to it and send it to one of their friends, who can add even more to it and send it to one of their friends, who can publish it and make a million dollars!

The Matt Bug

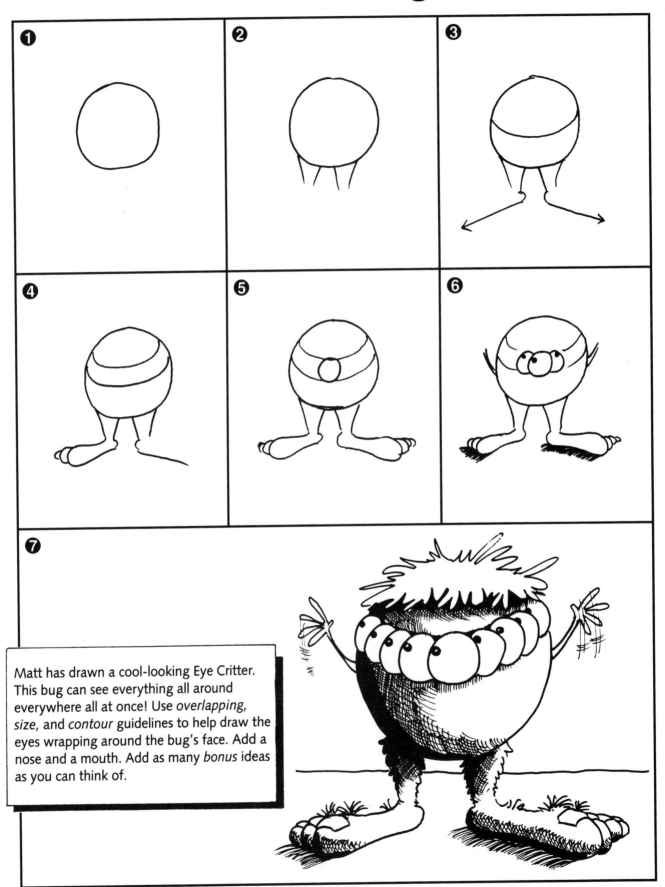

❶

❷

❸

❹

❺

❻

❼

Matt has drawn a cool-looking Eye Critter. This bug can see everything all around everywhere all at once! Use *overlapping*, *size*, and *contour* guidelines to help draw the eyes wrapping around the bug's face. Add a nose and a mouth. Add as many *bonus* ideas as you can think of.

Pondering Pencil Possibilities Practice Page

PRACTICE, PRACTICE, PRACTICE!

A very famous sculptor, Henry Moore, said in an interview after his eightieth birthday, "The secret of life is to have a task that you completely love so much that you devote every waking minute of every hour of every day pursuing it." He went on to say, "the most important thing about this task is that it should be something that you can't possibly achieve." He explained that he wanted to be as great a sculptor as Donatello or Michelangelo. He believed that he could never attain that status (although some artists think he did!) but that it was the quest for his goal that was important.

Can you take a wild guess where I listened to the radio interview? National Public Radio! Of course, this story made me think about my personal *task,* my career *dream.* My goal is to be the positive-attitude artistic Mr. Rogers of your generation. I don't know if that is really possible, but I sure am having fun traveling around the world teaching you kids how to draw in 3-D. What is your *task?* What is your *dream?* What do you want to do with this fantastic brilliant life of yours? Today's Creative Challenge is to draw a 3-D picture of your lifelong dream in your daily drawing sketchbook. A hero of mine, science fiction author Ray Bradbury, once said, "Chasing your wild and wonderful dreams is what makes life so much fun!"

Super-Splendid Student Sketches

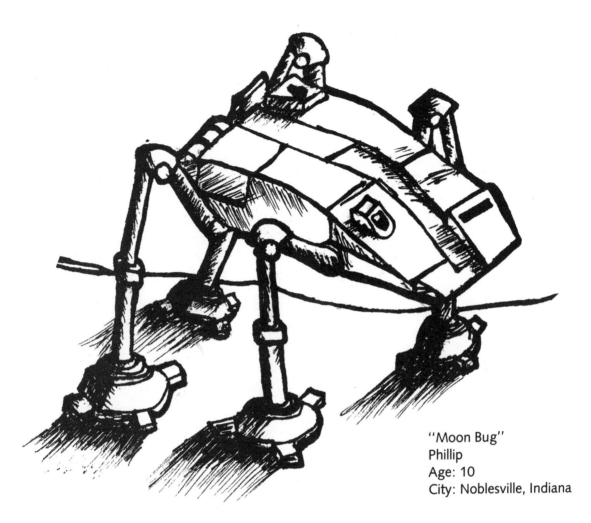

"Moon Bug"
Phillip
Age: 10
City: Noblesville, Indiana

Phillip created this Moon Bug in 3-D by really using a lot of the twelve Renaissance Words! Draw Phillip's Moon Bug in your sketchbook. Copying other people's drawings is a great way to learn new ideas and styles! Even Michelangelo copied drawings to learn how to draw!

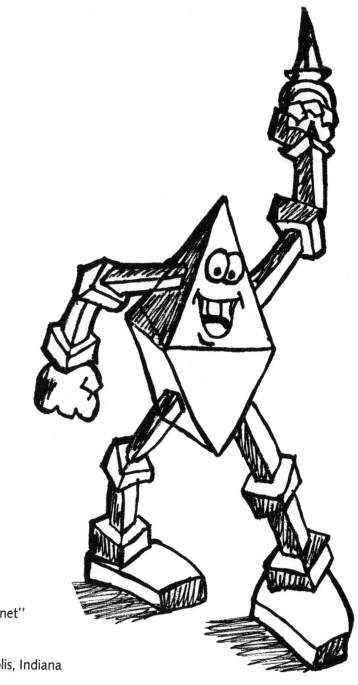

"Monster Magnet"
Ryan
Age: 9
City: Indianapolis, Indiana

This is the drawing that started this whole bug madness! Ryan gave it to me after I visited his school on one of my teaching tours through Indiana. His drawing has sparked the imagination of over twenty million kids! When I get terrific ideas from you, I pass them on to all the kids watching my television show and who are reading my books! Mail me your drawings. Maybe I can show your ideas to millions of kids. My address is on page 262.

Melf Magic
Meet Mr. Melf

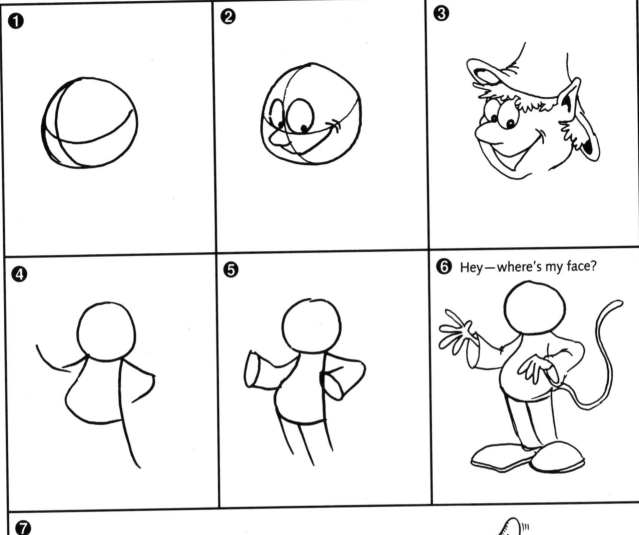

① ② ③

④ ⑤ ⑥ Hey—where's my face?

⑦

Mr. Melf has been a friend of mine since I was in fifth grade. You could say we sort of grew up together. Over the years he has changed a bit. He has grown a tail, sports a new nifty hat, and has put on a few pounds (like me!). I've never included him in a drawing lesson before. I thought maybe you would enjoy drawing him as much as I have for the last twenty years. He is a good, loyal pal. I know you are going to enjoy his company for many hours of 3-D drawing fun! How many of the twelve Renaissance Words have I used to draw Mr. Melf?

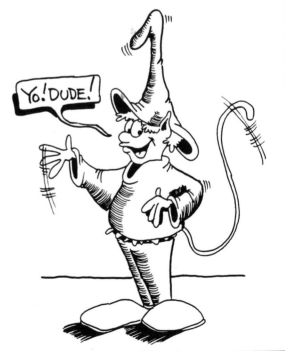

YO! DUDE!

Pondering Pencil Possibilities Practice Page

PRACTICE, PRACTICE, PRACTICE!

In the blank space below, draw the Melf Family, complete with tails, hats, and shoes. Use *placement* on the shoes to make the lower one look closer to your eye.

TODAY'S GENIUS WORD:
FANTASY

SUPER STORY STARTER:

Mr. Melf climbed out of the knothole in the tree trunk. This knothole had served as his front door for over ten years. He wrapped his tail around the lowest branch and swung to the ground.

You finish the story.

FANTASY: An illusion or reverie; fiction portraying highly imaginative characters or settings. Your 3-D drawings are filled with fantasy.

The 3-D Bubble-Blowing Macromonster

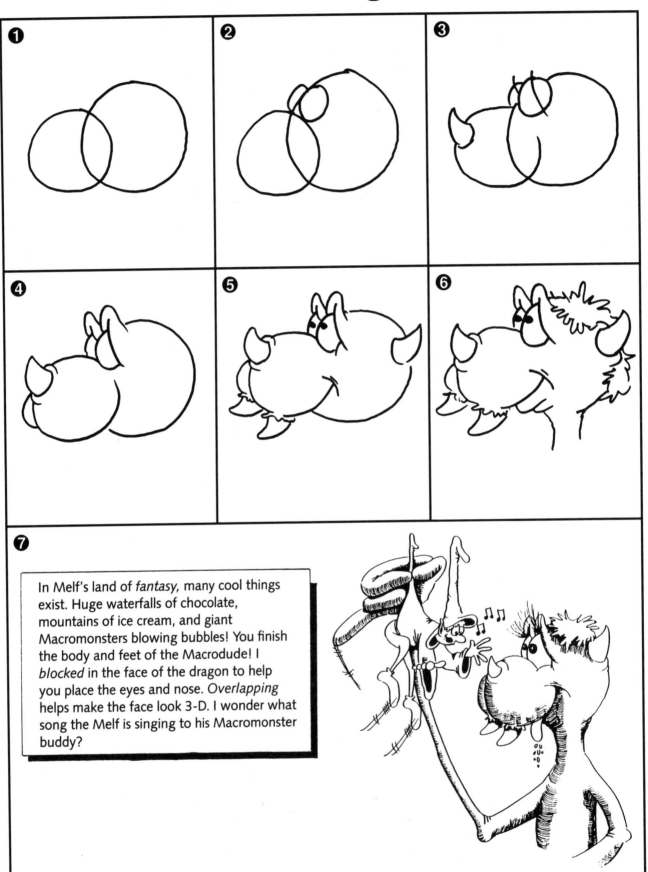

❶ ❷ ❸ ❹ ❺ ❻

❼

In Melf's land of *fantasy*, many cool things exist. Huge waterfalls of chocolate, mountains of ice cream, and giant Macromonsters blowing bubbles! You finish the body and feet of the Macrodude! I *blocked* in the face of the dragon to help you place the eyes and nose. *Overlapping* helps make the face look 3-D. I wonder what song the Melf is singing to his Macromonster buddy?

Pondering Pencil Possibilities Practice Page

PRACTICE, PRACTICE, PRACTICE!

In the blank space below, draw a Macromonster blowing bubbles, complete with feet, tail, and really long arms! Use *shading* to create a nice furry texture on your dragon!

One of my heros, Earl Nightingale, once said, "You are what you think about all day long!" This means if you think about drawing all day long, you're a magnificent artist! If you think about playing the piano all day long, you're an awesome musician! If you think, "Yes, I can!" all day long, you're an incredible achiever! Your Creative Challenge today is to draw an entire Melf scene with Macrodragon Dude on a piece of cardboard. Cut the cardboard up into a jigsaw puzzle. Now mail your jigsaw puzzle to a friend to put back together again.

Plumbing Puzzler
Contour Tubes

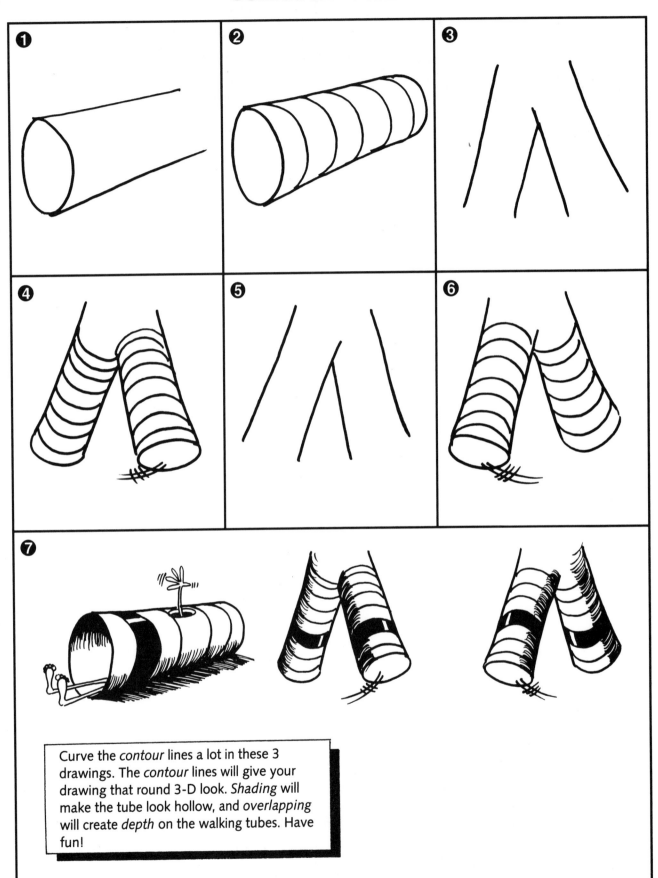

Curve the *contour* lines a lot in these 3 drawings. The *contour* lines will give your drawing that round 3-D look. *Shading* will make the tube look hollow, and *overlapping* will create *depth* on the walking tubes. Have fun!

Pondering Pencil Possibilities Practice Page

PRACTICE, PRACTICE, PRACTICE!

In the blank space below, go wild drawing tubes in every direction! Make some hollow, some long, some short. Use a lot of *contour* lines to create that round 3-D look!

Did you know that everything that is manufactured is drawn by an artist first? Look around the room. The telephone, the television, the doorknob, even the pencil in your hand was drawn by an artist *first* before it could be made! In other words, artists design the future! Have fun designing your future Tube City in the next lesson!

VOYAGE: A long journey by water, by aircraft, by spacecraft, or by your *imagination*! Each time you pick up your pencil, you are departing on an amazing *voyage* of creative discovery!

Pondering Plumbing Possibilities

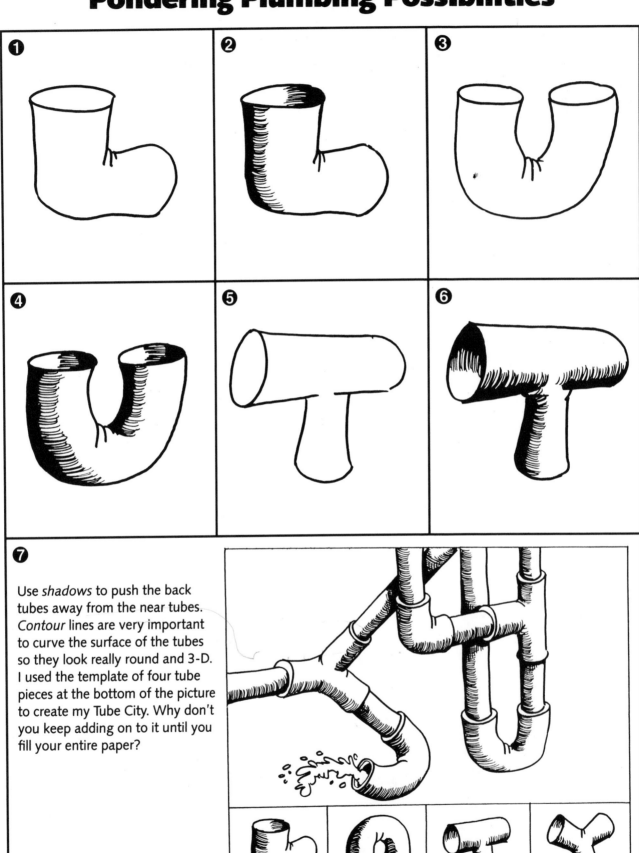

7

Use *shadows* to push the back tubes away from the near tubes. *Contour* lines are very important to curve the surface of the tubes so they look really round and 3-D. I used the template of four tube pieces at the bottom of the picture to create my Tube City. Why don't you keep adding on to it until you fill your entire paper?

Pondering Pencil Possibilities Practice Page

PRACTICE, PRACTICE, PRACTICE!

Another blank practice space just for you! Are you ready to fill it up? Draw a tube network using the tube connector pieces "L," "U," "T," and "Y." Use *shadow, contour, overlapping, size, density, shading,* and *placement* to make it look really 3-D!

SUPER STORY STARTER:

"Take a left at the next tube intersection!" Tammy called out as she studied the underground waterway-tube highway map. Tammy and Leitha had been traveling most of the day, bouncing along at unbelievable speeds through this amazing maze of water road tubes.

"I think I hear the spout ejection doorway just ahead!" Leitha replied while pushing the tiller steering bar away from herself!

You finish the story on a giant piece of paper. Now illustrate your story by drawing a huge maze of tube networks. See if your friends can find a way for Tammy and Leitha to flow out!

Super-Splendid Student Sketches

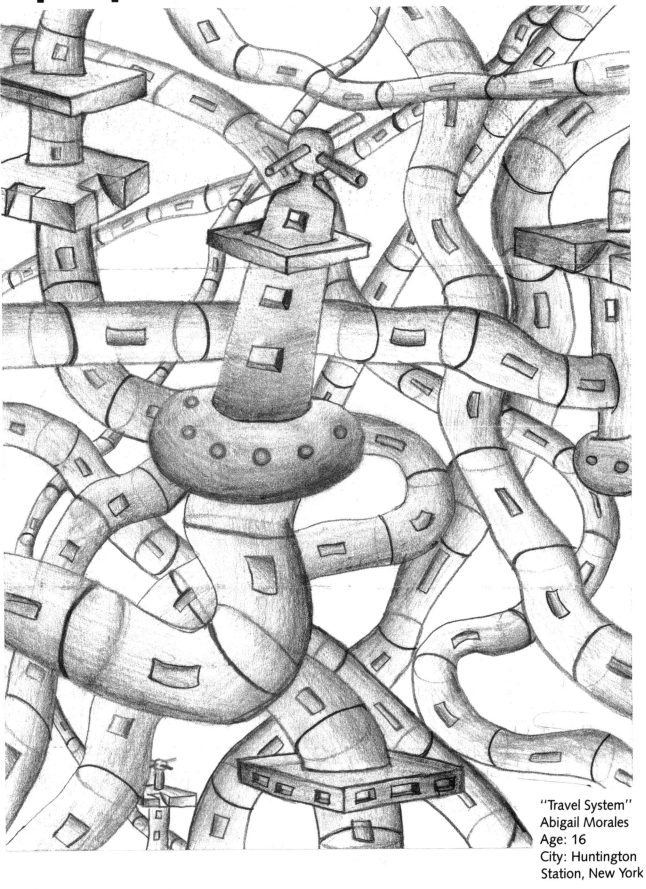

"Travel System"
Abigail Morales
Age: 16
City: Huntington
Station, New York

Abigail has drawn an amazing maze of 3-D tubes using *shading, contour,* and *overlapping.* What would it be like roller-blading through this tubular city? Cool drawing, Abigail. Thanks!

"Chute!"
Christina
Age: 8
City: Jacksonville, Florida

"Tube Town"
Greg
Age: 10
City: Houston, Texas

Look at the two distinctly different *styles* Christina and Greg used in their 3-D masterpieces. Christina uses a *blended*-shading soft style with very neat exact lines. I really liked my brother's feet sticking out from the top and the cereal collecting at the bottom. Neat idea. Greg uses a wonderful dark, *sketchy*, loose style. He uses *contour* lines in his *shading*. I like the dolphin jumping out of the tube. I wonder why the top dude has scissors in his hand? Fun drawing, Greg! Thanks for mailing it in!

The Forest of Ideas
Rooted with Integrity

❶ **Sketch**

❷ **Block**

❸ **Foreshorten**

❹ **Overlap**

❺ **Placement**

❻ **Size**

❼

I made the roots gnarled and spread out over the ground with *foreshortening* and *overlapping*. *Shading* adds a lot of wonderful texture to trees. If you want to, you can try using *scribble* shading rather than my *cross-hatch* shading. Try using your finger to blend your scribble shading across the surface of your tree roots from dark to light. This will give your tree a sharp, professional look!

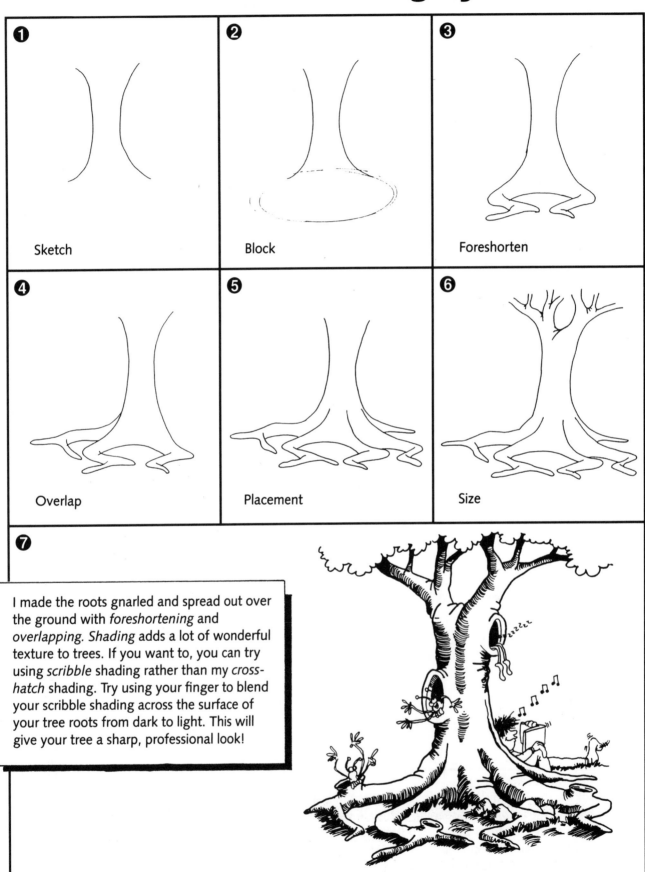

Pondering Pencil Possibilities Practice Page

PRACTICE, PRACTICE, PRACTICE!

In the blank space below, draw one large tree with Roots of Integrity wrapping all over the ground. Think of interlocking *foreshortened* circles to make the roots appear to be lying flat on the ground. Add tufts of grass in between the roots and scatter some rocks around. Knotholes are pretty cool to add, too!

TODAY'S GENIUS WORD:
INTEGRITY

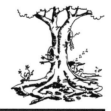

SUPER STORY STARTER:

Valerie put her book down in the soft grass. Settling deeper into the nook of the tree, she sighed, ''What a perfect way to spend my afternoon.'' She gazed up at the cool cloud formations floating by while . . .

You finish the story.

INTEGRITY: Wholeness, honesty, sincerity, character. You draw with a lot of *integrity*. Your parents have raised you with tremendous *integrity*!

The Forest of Ideas

❼ I've used *size* to make the *foreshortened* walking path wind back into the forest. The near part of the trail is drawn larger, while the path gets smaller as it curves away. Tufts of grass *overlapping* the trail give it that grassy, forest look. Drawing is a great way to walk with your imagination through the Forest of Ideas.

Pondering Pencil Possibilities Practice Page

PRACTICE, PRACTICE, PRACTICE!

In the blank space below, draw a forest of thirty-eight trees complete with knotholes, squirrel tails sticking out, roots *overlapping,* and a *foreshortening* trail winding through it.

This drawing is very symbolic of your life. You need to set your goals, dream your dreams, and walk your path of life. You'll have to wind your way through life's twists and turns, over rocks and ditches. You'll have to scale huge cliffs and slide down grassy hills. The important thing is always to keep your dream in sight and keep trudging on. *Always, always* keep your dreams on the tip of your nose! Write down your dream on a sticky note pad and stick it on your nose. When somebody asks you what that is, stuck to your nose, you tell them, "I always keep my dreams at the tip of my nose so I'll stay on my adventure path of life!" A great book to read at your library is Dr. Seuss's *Oh, the Places You'll Go.* The story is A+ and the drawings are even better!

EPISODE 34 Stalactite City

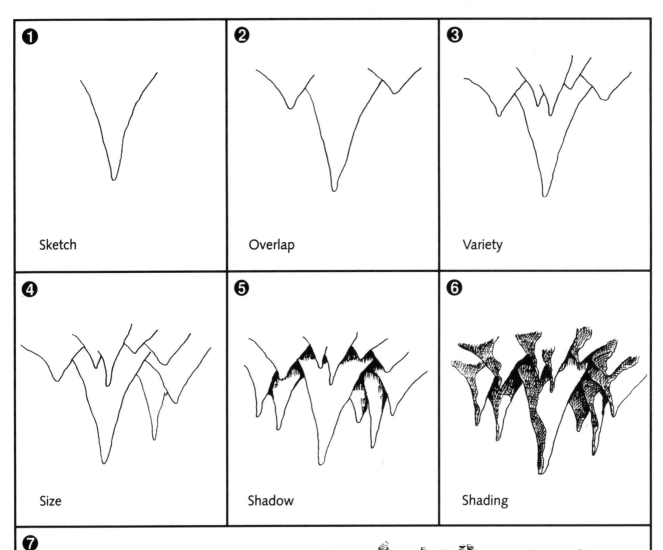

❶ Sketch

❷ Overlap

❸ Variety

❹ Size

❺ Shadow

❻ Shading

❼

In this drawing we have combined everything we have learned in the last thirty-three 3-D drawing lessons. We have castles, mountains, craters, dragons, elfs, cylinders, spheres, windows, doors, and cool-looking feet sticking out! How many Renaissance Words have I used to create this Stalactite City? *Stalactite* means a formation of rock hanging from the ceiling. Stalactites drip minerals down upon a cave floor and create the rock formations called *stalagmites.* Another bit of scientific information for your scientific computer mind to store!

Pondering Pencil Possibilities Practice Page

PRACTICE, PRACTICE, PRACTICE!

In the space below, create your own cool deep cave dwelling. Add waterfalls, tube transportation bridges, and maybe even a few flying bubble-blowing dragons!

Last year I was touring some elementary schools in Kentucky, teaching lots of little geniuses like yourself how to drawn in 3-D. On the weekend, I decided to be adventuresome and explore. I took out the Kentucky state map and looked for something *exceptional* to grab my attention. I found a green shaded area in Central Kentucky with a notation, "Mammoth Caves National Park." Earlier that week, the Kentucky kids and I had been drawing stalactite cites and caves, so I thought, "Hmmm, this should be interesting." I jumped in my handy rental car with my sketchbook and took a road trip, listening to National Public Radio for a few hours. Later I discovered Mammoth Caves National Park. It was spectacular! Think of the wildest, coolest 3-D cave you could draw and multiply it by a thousand! God is one *exceptional* artist!

SUPER STORY STARTER:

"You look thirsty, Fundar," David said as he maneuvered the high-tech mechanical stretch-arm water retriever. "Here, this should wet your whistle," he chuckled, lowering the water bucket to his pet dragon's cave entrance.

You finish the story!

EXCEPTIONAL: Unusual, especially unusually good; amazingly brilliant. This sure does sound like the definition of *you*. You are an *exceptional* human being!

Earth Art

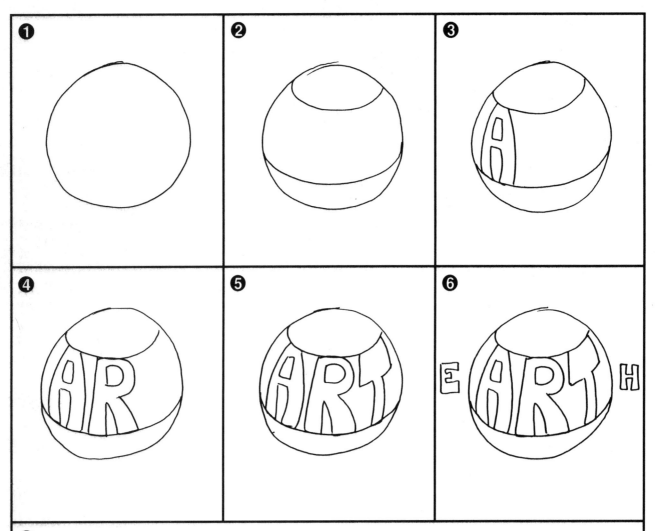

❶ ❷ ❸ ❹ ❺ ❻

❼ How do you spell our planet's name? EARTH! Art makes the world go round. Art makes people happy, sad, thoughtful, and creative. Art makes people think! Art can bring together people from all over the world through a single drawing or sculpture. Art is how we understand how people lived long before history books were written. Art is how we imagine, create, and build for the future. Surround your friends and family with your cool, creative art, because your art is helping our planet EARTH go round! I used *shading* behind the balloon lettering to make the lettering pop out of the paper in 3-D! This drawing was inspired by an amazing art teacher I met in the Ohio elementary schools. Thanks, Becky Laabs, for this wonderful idea! She believes WORLD PEACE THROUGH ART IS POSSIBLE. I do too!

PRACTICE, PRACTICE, PRACTICE!

In the space below, draw a planet of ART. Include lots of art museums, painting studios, artists' lofts, and research libraries. Draw lots of artists sketching landscapes, sculpting statues, coloring sunsets, and drawing oceans. Try to use all the twelve Renaissance Words of 3-D drawing!

"BE A POSSIBILITY THINKER!"
Dr. Norman Vincent Peale

Super-Splendid Student Sketches

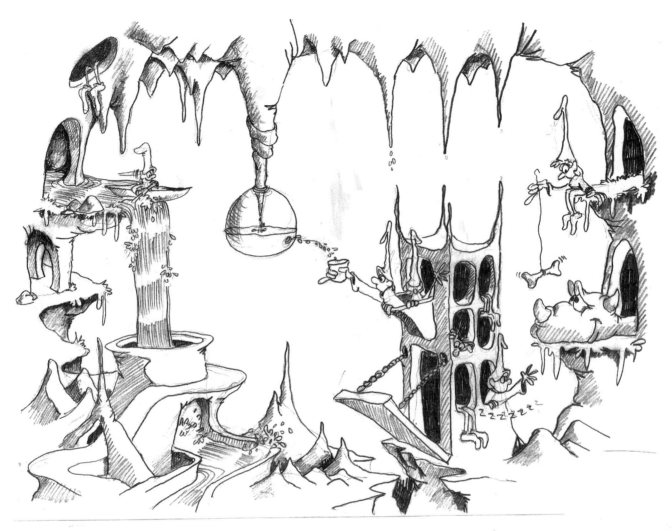

Mark (me)
Age: 31 big ones
City: Carlsbad, California

This was the rough sketch for my television episode 34, Stalactite City. As you can see from our book episode 34, I did not have enough broadcast time to finish the cave city with as much detail as I did in this sketch. In each television episode I only had twenty-six minutes to draw. That's not much time to draw a complex cave city! You can use my drawing above to add *bonus* ideas to your stalactite cave town!

"Find Robin Hood"
Mark (me)
Age: 31
City: Carlsbad, California

In 1980 I was going through a major castle-drawing mania. Here I hid a little Robin Hood in the picture. These pen and ink drawings took me over forty hours each to draw! Ten years later, when I saw Martin Handford's first *Find Waldo* book, I nearly fell over. It must have taken him over a thousand hours per book to draw, not to mention the coloring! Wow! Martin Handford is a *true* drawing hero to me! How many of the Renaissance Words have I used in this drawing?

Sprinting Spinach Superstars
Speedy Spinach!

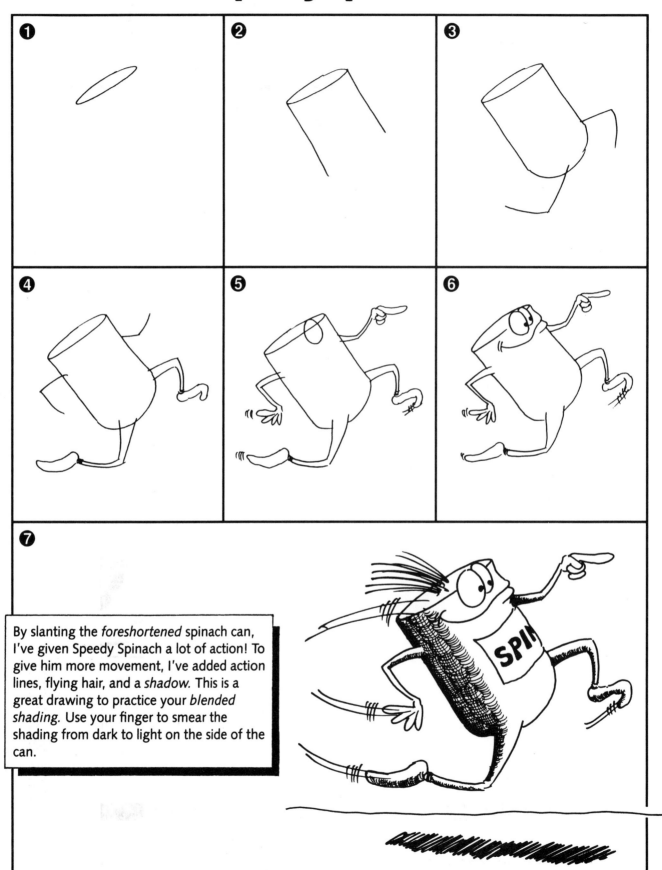

❶ ❷ ❸ ❹ ❺ ❻

❼

By slanting the *foreshortened* spinach can, I've given Speedy Spinach a lot of action! To give him more movement, I've added action lines, flying hair, and a *shadow*. This is a great drawing to practice your *blended shading*. Use your finger to smear the shading from dark to light on the side of the can.

Pondering Pencil Possibilities Practice Page

PRACTICE, PRACTICE, PRACTICE!

Can you believe it! Another cool blank space for you to practice in! What a coincidence! Just in time to draw a whole *marathon* of speeding spinach runners! Use *foreshortening*, *blended shading*, *shadows*, and a horizon line!

SUPER STORY STARTER:

"Faster" Speedy Spinach panted to himself as he sprinted toward the finish line. "Just a little bit faster!" Speedy Spinach tilted his body back even further, reaching his long legs toward the finish line.

You finish the story!

IMAGINATION: Resourcefulness, the act or power of forming mental images of what is not present. In other words, awesome brain power! You have the most powerful imagination in the galaxy!

Serenity in Spinachville

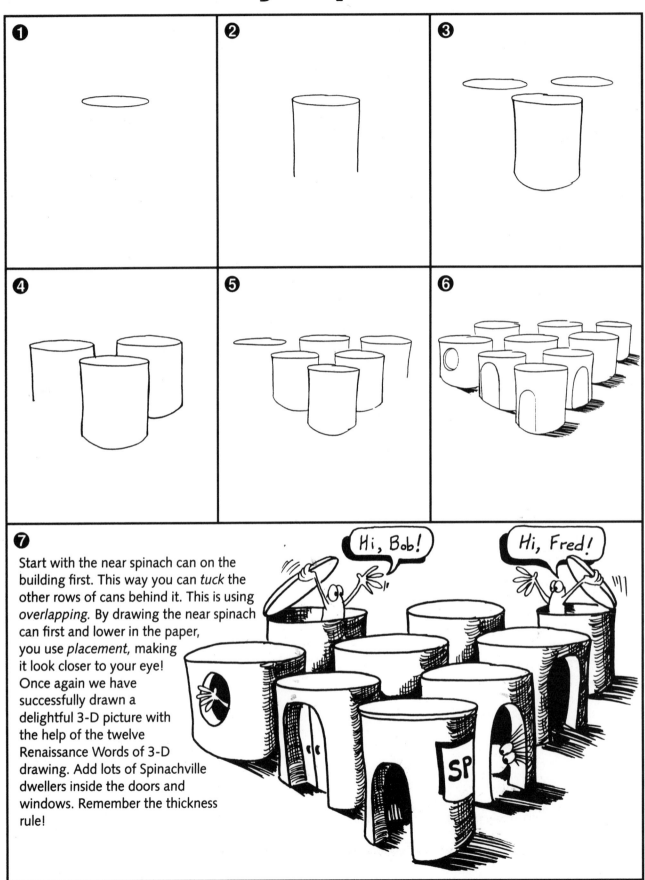

❼ Start with the near spinach can on the building first. This way you can *tuck* the other rows of cans behind it. This is using *overlapping.* By drawing the near spinach can first and lower in the paper, you use *placement,* making it look closer to your eye! Once again we have successfully drawn a delightful 3-D picture with the help of the twelve Renaissance Words of 3-D drawing. Add lots of Spinachville dwellers inside the doors and windows. Remember the thickness rule!

Pondering Pencil Possibilities Practice Page

> ## PRACTICE, PRACTICE, PRACTICE!

In the blank space below, draw a Spinach Can City complete with roadways, bridges, and stacked skyscraper spinach cans! Use lots of *foreshortening* on the tops of each can and *shadows* on the ground next to each can. Have fun!

Today's Creative Challenge is to gather twenty or thirty cans, bottles, and containers from your kitchen cupboards. Build a cool-looking container community on the kitchen table. You can use salt and pepper shakers as supports holding up the fork bridge. Add the ketchup skyscraper and the loaf-of-bread library. How about a banana arch spanning the river of sugar trailing through your city? Use your powerful imagination to build a magnificent metropolis! *Now*, grab your sketchbook and draw your creation in 3-D. Draw your city from three different points of view.

Hurry up! Your family will need the kitchen table for dinner in less than two hours! Be sure to put everything away *where* you found it, or I'll be in *big trouble!* I'll get thousands of letters from irritated parents suggesting that I'm a macadamia nut for telling you to do this!

Super-Splendid Student Sketches

"Spinach Castle"
Jason Winner
Age: 9½
City: Indianapolis, Indiana

What a cool last name, Jason! You are a winner! Jason has taken the idea of a Spinach City all the way! Look at the tops of each can. Nice *foreshortening*, eh? Jason has also used excellent curving *contour* lines to make the stacked cans look round. You can tell he used his finger to *blend* the *shading* to create *depth* in his picture. I love the texture of the castle gate, and other people climbing everywhere! The one can falling over under the middle climber is a good use of *bonus!*

Here's an idea for you to try. Draw your own Spinach Castle. When you *shade* it, switch the sun to the opposite side of your drawing. See what happens? I have developed a habit over the last twenty years of always shading the left side. For some reason, it's always morning time in my pictures. Do you do this too? Try shading from different sides. It adds a lot of variety and increases your own unique drawing *style.*

"The Pencil Tribe"
Mark B.
Age: 8
City: New York

When I visited Mark's school to teach them how to draw 3-D, they were studying the history of the American Indians. During our drawing assembly, Mark learned how to draw a 3-D pencil rocket. He took that idea and created his Pencil Tribe Village based on his American Indian lessons. What a clever idea! Really like all the *overlapping* and the loooooooong *foreshortened* flag! Magnificent masterpiece, Mark. Marvelous!

Be a Dream Beam
The 3-D High-Tech Dream-Beam Helmet

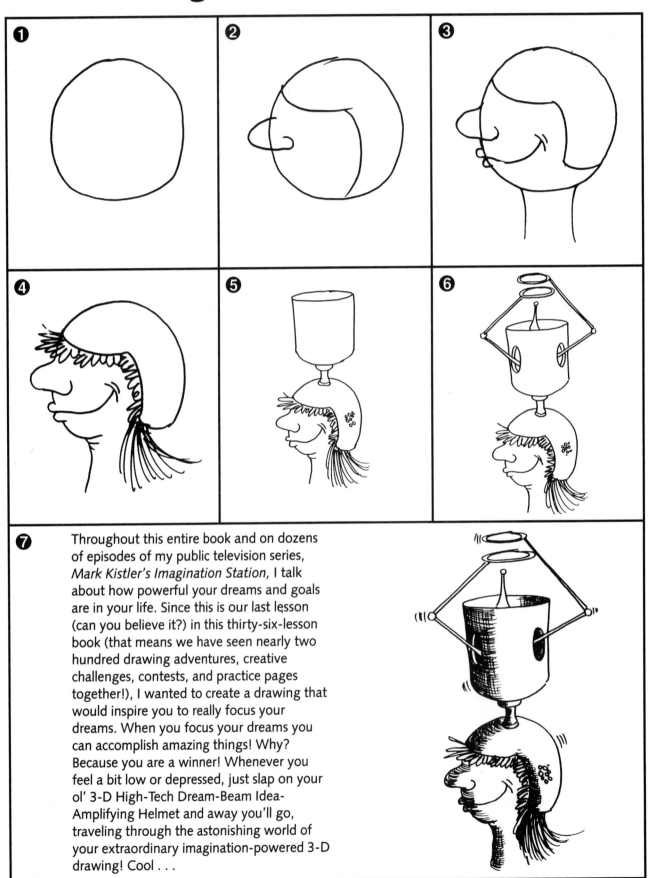

❼ Throughout this entire book and on dozens of episodes of my public television series, *Mark Kistler's Imagination Station*, I talk about how powerful your dreams and goals are in your life. Since this is our last lesson (can you believe it?) in this thirty-six-lesson book (that means we have seen nearly two hundred drawing adventures, creative challenges, contests, and practice pages together!), I wanted to create a drawing that would inspire you to really focus your dreams. When you focus your dreams you can accomplish amazing things! Why? Because you are a winner! Whenever you feel a bit low or depressed, just slap on your ol' 3-D High-Tech Dream-Beam Idea-Amplifying Helmet and away you'll go, traveling through the astonishing world of your extraordinary imagination-powered 3-D drawing! Cool . . .

PRACTICE, PRACTICE, PRACTICE!

In the blank space below, draw your own 3-D High-Tech Dream-Beam Idea-Amplifying Helmet! Use all of the twelve Renaissance Words to make your drawing look 3-D with that cool feeling of *depth*.

SUPER STORY STARTER:

"NASA control," Mari spoke into her voice-relay microphone, "Dream-Beam Idea-Amplifying Helmet is attached and ready for power!" Mari flicked the ignition toggle on the arm of her virtual-reality cockpit chair. Automatically the thickly padded chair began to recline. Mari settled in for another imagination journey to the land of . . .

You finish the story!

JOURNEY: Traveling from one place to another across land, over water, or through space. Each time you begin to draw a picture, you embark on an exhilarating *journey* in your mind's imagination. You can journey across land, over and under water, through space *and* time with just a few quick 3-D strokes of your pencil!

The Dreamer

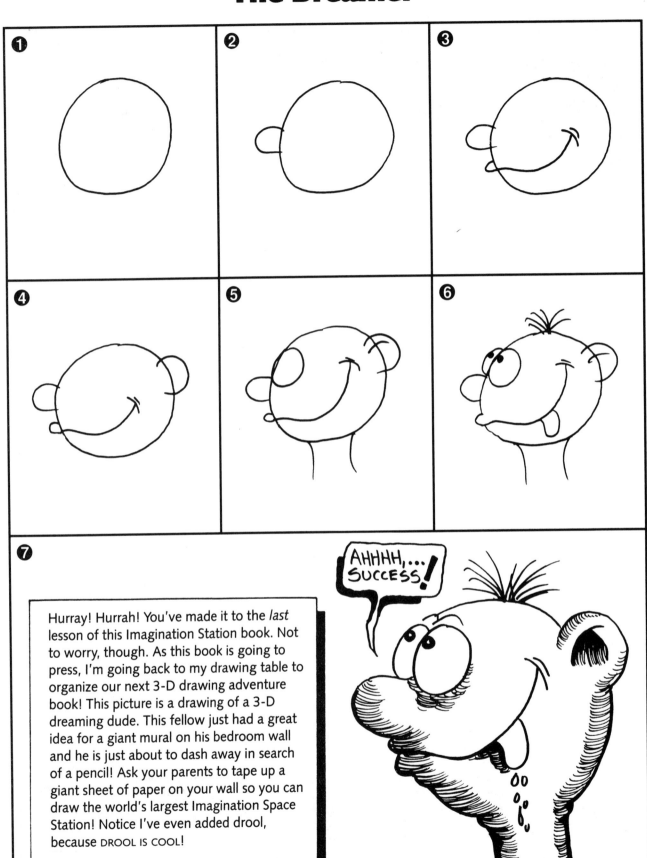

①

②

③

④

⑤

⑥

⑦

Hurray! Hurrah! You've made it to the *last* lesson of this Imagination Station book. Not to worry, though. As this book is going to press, I'm going back to my drawing table to organize our next 3-D drawing adventure book! This picture is a drawing of a 3-D dreaming dude. This fellow just had a great idea for a giant mural on his bedroom wall and he is just about to dash away in search of a pencil! Ask your parents to tape up a giant sheet of paper on your wall so you can draw the world's largest Imagination Space Station! Notice I've even added drool, because DROOL IS COOL!

AHHHH,... SUCCESS!

Pondering Pencil Possibilities Practice Page

PRACTICE, PRACTICE, PRACTICE!

In the blank space below, draw twenty-three dreamers in 3-D! Add different hairstyles, noses, and smiles. Draw thought balloons showing what each dreamer is dreaming about. On each face, use your finger to blend the *shading* for that ultimately cool 3-D look! Don't forget the drool! Why? Because drool is cool!

Today's Creative Challenge is to gather all the Super Story endings that you wrote in the thirty-six lessons in this book. Have your parents take these stories with your illustrations to a local copy shop. Copy off a few sets and have them bound with a spiral binder. Now you are published! Send a copy to your grandparents, send one to your relatives in Europe, and of course, send one to me! I'd like to show it on my television show to inspire millions of other kids to do the same thing.

The Dream-Beam Achiever Award!

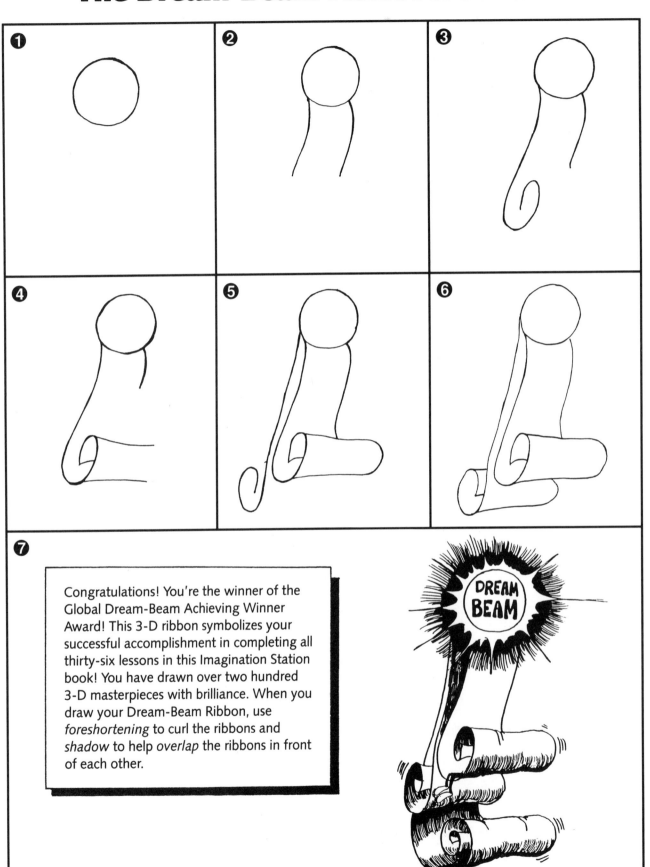

❶

❷

❸

❹

❺

❻

❼

Congratulations! You're the winner of the Global Dream-Beam Achieving Winner Award! This 3-D ribbon symbolizes your successful accomplishment in completing all thirty-six lessons in this Imagination Station book! You have drawn over two hundred 3-D masterpieces with brilliance. When you draw your Dream-Beam Ribbon, use *foreshortening* to curl the ribbons and *shadow* to help *overlap* the ribbons in front of each other.

DREAM BEAM

PRACTICE, PRACTICE, PRACTICE!

In the blank space below, draw a giant Dream-Beam Achiever Award Ribbon. Add twelve 3-D curling ribbons to the button. Label each ribbon with one of the twelve Renaissance Words of 3-D drawing. Add color and action lines to your dream-beam button!

A few times a year I visit my local video rental store to rent one of my favorite movies, *Rudy*. This movie always inspires me to stick to my dreams. *Rudy* is about a dreamer named Rudy who chases his dream for his whole life, even when it seems totally impossible for him to make the dream come true. This movie reminds me that no matter *what,* no matter how *long* it takes, and no matter what anyone tells you, dreams CAN and WILL come true! Today's Creative Challenge is to draw twenty Dream-Beam Achiever Buttons on cardboard. Cut them out, add color, and tape safety pins to the backs. Now hang one on your door to remind you every morning what a cool person you are! Hang one on the front of your school desk to remind everyone that you're a Dream Beamer! Give the rest away to your friends and family to award them for being such creative thinkers on this planet Earth. The world needs more dream-beam winners!

If you are feeling really industrious, you can check out a book from your local library titled *The Writer's Market*. Have your parents help you pick out a few publishers of children's books. Mail your book of stories to them for global publication! My motto is, "The sooner you get your first five hundred rejection letters, the sooner you'll be a published author and illustrator!" I've received over a thousand rejections from dozens of book and television proposals. Rejection letters are good! They are badges of effort! Hang each one up with *pride* in your room! I want to see your wall covered with them! Promise me one thing—that when you *do* get your book published, you will include in it a photo of all your rejection letters to inspire others to stick to their dreams!

S.M.I.L.E.S.

*S*uper-*M*agnificent *I*maginative *L*ovable *E*xtraordinary *S*tudents! Mail your brilliant drawings, stories, and photographs to me at the address below! I can't wait to see how well you're learning and applying the twelve Renaissance Words! All of the Story Starters in the lessons are left unfinished. I've just got to find out how you decided to finish the stories! Be sure to include a photograph of yourself with your letter. This way millions of kids watching Mark Kistler's Imagination Station can see the face behind your artwork!

Mark Kistler's Imagination Station
P.O. Box 3046
Carlsbad, CA 92009

THE TEST

Oooooh! Nooooo! Not a Test! Don't fret. This is a fun test. I want to see how much you remember from the thirty-six lessons in this encyclopedia of ideas! If you can't remember the answers, just turn back to the page number listed next to the questions and voila! you will experience instant recall and strengthen your marvelously creative 3-D imagination-powered memory!

1. How many times in this book did I mention each of the twelve Renaissance Words of 3-D combined? Add up all the checks you made on pages 36 through 39 and write the total here _____ .

2. Draw lines connecting each of the Renaissance Words with its proper definition. (See pages 35 to 39).

1. Foreshortening	a. Drawing objects *lower* on the paper to make them appear closer
2. Shading	b. Adding neat ideas to your drawing to make it more exciting
3. Shadow	c. Drawing objects *behind* other objects to push them away from your eye
4. Size	d. Squishing a shape to make part of it look closer to your eye
5. Placement	e. A positive state of mind that helps you learn faster
6. Overlapping	f. Adding darkness to the side of an object that faces away from the light source in your picture
7. Contour	g. Drawing in 3-D every day to make your drawings even more amazing
8. Density	h. Adding a line behind or below your objects as a *ground* reference
9. Horizon	i. Drawing darkness on the ground next to the shaded surface of an object
10. Bonus	j. Curving lines around an object to make it appear round
11. Practice	k. Drawing some objects larger in your picture to make them appear closer
12. Attitude	l. Drawing objects that are far away in your picture lighter and with less detail

3. How many books did I suggest you read for cool 3-D drawing ideas? _____
4. How many hours a day should you practice your drawing? _____
5. How many Creative Challenges did I toss at you in this book? _____
6. How many times did you run to the refrigerator to grab a glass of fruit juice to cool off your overheated brain from drawing with this book? _____

ANSWERS: You probably think I'm going to list all the correct answers down here. Nope! Nope! Nope! You've got to look them up in the book! Have fun!

Appendixes

A Special Note to Parents and Teachers

First off, let me congratulate you on supporting your children's artistic creative development. I can't think of anything more beneficial to your child's self-esteem and intellectual development than a strong foundation in elementary art.

The national trend of eliminating art teachers from elementary schools is growing with frightening speed. At a time when our country is being ripped apart with drug abuse, gang violence, and family crises, art needs to be inundating public schools, not evaporating from it. Art teaches children how to think creatively, assimilate information, express ideas, and solve problems nonviolently. Art offers the ultimate imagination holiday, a perfect alternative to drug abuse.

During my teaching tours to hundreds of elementary schools each year, I am always amazed by the difference in student and staff attitude between schools that incorporate an enthusiastic art curriculum and those that do not. I can feel it in the air, thick as a wave of ocean breeze, as soon as I open the front doors of the school. The front-office crew seem to be more engaging, the principal even more involved, the teachers more enthusiastic, and the children so very eager to learn! My conclusions are based on personal analysis and are far from being scientific. However, after visiting thousands of elementary schools over the past sixteen years, I feel justified in my opinion.

Schools that harness the power of art into their core curriculum turn out children that are much happier, more confident, and better equipped intellectually to face the rigors of higher schooling. If your child's school has an art teacher now, you are a vanishing statistic. You must protect this vital program from the inevitable district-budget hatchet. Write letters of support and appreciation for the art program to your principal, your district superintendent, your congressional representative. Fax letters to your senators and to the White House. Make phone calls to form an art-booster club for your child's school. Do everything I've mentioned above, or do one thing—just do something. In California, parent inaction allowed the complete evaporation of art teachers from almost every elementary school in the state. Save your art program now if you have one!

If your child's school does not have an art program, get upset. You should be. Start a letter-writing campaign to install a solid art program now. For help and guidance, you can call your state's art education association or the National Art Education Association. If you need information on how to contact these organizations, call, write, or fax me anytime. Art must be integrated into the curriculum at the elementary school level to enable our children to become globally competitive creative thinkers.

National Art Education Association
1916 Association Dr.
Reson, VA 22091

National Council on Youth Art Month
100 Boylston St.
Suite 1050
Boston, MA 02116

Appendix A

Parents' and Teachers' Questions and Answers with Mark Kistler

I've thoroughly enjoyed reading the thousands of letters kids, parents, and teachers have mailed to me over the past sixteen years. Many of the questions below are frequently asked in these letters. Hopefully my answers will help all of the kind folks who have written to me without getting any response. With my extensive travel it's very difficult to appropriately respond with my appreciation for your letters. My first priority is to mail responses to the children, and even then I seem to be forever behind. If you would like to get ahold of me personally, my fax number is listed in the Directory. If your children have been waiting for "The Mark Letter," an autographed picture, or a drawing, please be sure they have sent a SASE (10" × 12"). Doing so will ensure a response.

Mark Kistler
P.O. Box 3046
Carlsbad, CA 92009

Do you still perform school programs? How can I arrange an elementary school appearance with you? What do you teach the children at the workshops? How much does it cost?

Yes, I visit hundreds of elementary schools each year. In fact, since I was unable to secure any corporate funding for my new public television series, *Mark Kistler's Imagination Station*, much of the elementary school program fees helped me pay for the production and satellite broadcast time. So, a special sponsorship "thanks" is due to all the elementary schools who scheduled my assembly programs.

To arrange a date for your elementary school send a note to the above address, attention "Elementary Assemblies Coordinator," or fax me at (619) 431-9114. If this number has changed, check the directory. The personal appearance assembly programs consist of an actual 3-D drawing lesson presented on an overhead projector for large audience participation. My largest group to date was the Sea World performance in Sydney, Australia. I had a group of 5,000 squealing Aussie kids drawing sharks, fish, and other sea life. What a blast! To top it off, after the program I bungee-jumped from 55 meters over the water—yeeehaw!

Normally, when I visit an elementary school I split the student body into two groups with kindergarten through second graders in one, and third through sixth graders in the other. This allows me to increase the level of difficulty for the older kids. The lessons are scheduled for forty-five minutes but usually run closer to an hour, depending on the weather, what the kids had for breakfast, and if it's the day before Christmas vacation!

My visits have been billed as the "funniest" assembly of the year, which is cool—I've always wanted to be a stand-up comic for kids. Generally, I'm able to complete four drawing adventures and stories with each group; my goal is to have everyone, teachers and principals included, walk out of the program with a fistful of awesome three-dimensional renderings and a new excitement for art attacks! Following the student programs during the day, I present an evening "Family Drawing in 3-D" lesson. I invite the students to bring their entire families back for a totally cool evening of 3-D drawing adventures. My strategy is to show families how much fun drawing together can be. I challenge families to spend one evening a week drawing together rather than watching television. Ahha! A weekly creative family bonding experience that costs less than a few cents for paper and pencils!

The cost of scheduling my drawing workshops varies with your location, airline rates, and how many schools are scheduling together. For years I've been attempting to get these school programs underwritten by corporate America—I'm confident that someday I will succeed.

What other books have you written? How can I get ahold of them?

I have written several "how to draw in 3-D" books: the two books that have been published by Fireside (Simon & Schuster) are *Mark Kistler's Draw Squad* (1988), and the one you're holding right now, *Mark Kistler's Imagination Station.* You can find these at any local bookstore. Many parents have told me that they are perpetually out of stock at most bookstores, which is good news for me, but very inconvenient for you. If your bookstore does not have them available, ask them to order it for you. You will usually get the books within a week.

How did you produce the children's television series, *Mark Kister's Imagination Station*? How can I get it aired on my local PBS station?

Mark Kister's Imagination Station is a thirty-six episode children's how-to-draw-in-3-D television series. After years of failing to secure corporate funding for the series, I finally decided to fund the program myself and donate it to the national Public Television system. I hit the national speaker tour circuit very hard for two years, saved my cash, and produced the series. Simon & Schuster (being the cool publishing company that they are) published the series in book form and supported the completion of production. After all thirty-six episodes were "in the can" (television speak), it became apparent that the series was not going to be made available to the stations on the system's satellite. I had missed the national submission deadline, a perpetual problem that my editor, Dave Dunton, has had the patience to endure in publishing this book! I'm an artist, I've never been a "deadline" kind of a guy—what can I say?

Anyhow, being a relentless bulldozer when it comes to goal conquering, I paid for the satellite time myself to make the series available free of charge to all PBS stations in the country. What a nice guy, eh? If the series is not broadcasting in your area, call the programming director of your local PBS station. Each phone call is estimated at representing several hundred viewers, so call a dozen times and use different voices. No, don't do that—bad joke! Just let your programmer know that your kids would enjoy watching the show.

Is *Mark Kistler's Imagination Station* broadcast in any other countries?

My goal is to have the series aired in several countries next season. If your family in another country would like the series, mail me their television network information. I will pursue shipping the program for broadcast.

What ever happened to *The Secret City* Public Television series? Did you ever finish the giant "Commander Mark" mural? Why didn't you ever respond to my letters?

The Secret City was a sixty-five-episode children's public television series that was produced at Maryland public television during the summer of 1985. Lee Solomon, John Price, and I had a great time creating the series in New York City the year prior. The program enjoyed nearly seven successful years of broadcast on two-hundred PBS stations, and was aired in eighteen countries. Finding additional funding to continue the series proved monumentally difficult. It's very tough to convince corporate America to support a quality children's art education television program.

Yes, I did finally finish the giant "Commander Mark" mural on episode #65 of the series. The

mural now hangs in the Smithsonian Institute next to Mr. Rogers's sweater . . . *not!* The mural hangs proudly in my mother's high-school classroom in Carlsbad, California.

The television series generated over half a million letters. Much of the mail addressed to Moraga or Oceanside (California) was handled by a distribution company. My apologies if some of you did not receive responses. Try mailing to my Carlsbad address above—you will have better luck.

I did produce three episodes of *The New Secret City* that were well received by the PBS System. There is talk of more episodes, perhaps after the *Mark Kistler's Imagination Station* runs for a few seasons.

Do you ever do charity work for children's hospitals?

Yes. I love teaching these kids how to draw. Drawing helps them fill the long hours of each hospital visit. If you are on the staff of a children's hospital, or a parent with a child that is a patient, fax me a note at (619) 431-9114 or write me a letter. If I'm unable to schedule a visit, I will donate some drawing video tapes to the nurse's station.

Do you have any home videos, T-shirts, or other products available?

In 1990, I produced a wonderful home video series entitled *The Draw Squad with Captain Mark.* I no longer personally distribute these videos. The best way to find these tapes is through your local library. Keep in mind that the address on these tapes is different from my current Carlsbad address. Currently, I have *Mark Kistler's Imagination Station Home Video* available. This video contains four of my favorite episodes from the Public Television series. To receive a copy of this two-hour video, mail $19.95 to the Carlsbad address above, "Attention Home Video." Each year I print up a few hundred cool color "I Can Draw in 3-D" T-shirts for my summer school students, and super-zealous art teachers. If you would like a T-shirt, mail $19.95 to the Carlsbad address above "Attention T-shirts." The design changes every year. The sizes available are usually limited to kids' small, large, and x-large, and adults' X-large and XX-large (for me because I'm a big pasta eater!).

It might take a month to receive your shirt but they are fairly cool and the kids seem to really enjoy them. The hats are $3.00, and the large autographed "Idea Castle" posters of my pen and ink drawings are $19.95. There has been a lot of interest in my animation-type clear transparency cells that I draw and color during my workshops on the national tour. You may order these autographed cells for $39. There you have it—the Mark Kistler product line! For all you art animals that have ordered materials from me, I really appreciate your support. A huge chunk of these proceeds go to producing more "drawing in 3-D" television episodes. "Producing quality creative children's programming for today's kids"—that has a nice ring to it, doesn't it?

Do you have any "drawing games" for children?

Yes, I am completing two board games for kids. "Pondering Poets" is an alliteration drawing/word game, and "Drawing Conclusions" is a creative thinking drawing game. Check your local game store.

Why have you had such a difficult time finding funding for such a great quality children's program? What does it cost to help support the show?

Darn good question. I've tried the angle that art helps kids become better thinkers, better problem solvers, better students, happier people, and more productive citizens. This approach didn't

even get me appointments. Then I tried the angle that drawing is the best alternative to drug abuse and gang violence, because it gives children an incredible boost in self-esteem and self-motivation. *That* didn't work. Finally, I tried the angle that companies supporting a successful art series would make a fortune from selling related art products to the children's parents, because all kids love to draw with neat drawing kits! That hasn't worked either. If you can think of a better approach, let me know. (Maybe I scare sponsors away when I start groveling on my knees!) The cost to sponsor production and satellite distribution of an episode is around $1,000. If your company wants to help, cool. Call me, fax me, page me, Fed-Ex me. I'd love to buy more satellite time! Think of all the happy kids you'll be encouraging to draw! I'll spare you any further groveling.

Do you have any art schools for kids?

Each summer I like to pick a few cities to conduct my week-long summer art camps. For the past seven years I've held the class with Debbie McAngus at Northland Christian School in North Houston, Texas. I've also held the classes in San Diego, San Francisco, Seattle, New York City, St. Louis, and Denver. If you want to coordinate a school in your city, let me know. Everyone has a really good time during these classes.

As far as running a permanent school: No, I don't have any established. However, I can strongly recommend Mona Brooks's "Monart" schools. She is an amazing lady with a dynamic program. She has two bestselling books out: *Drawing with Children* and *Drawing with Teens and Young Adults.* Go buy them today, then enroll your kids in her classes.

In the early episodes of *Mark Kistler's Imagination Station* you mention the bimonthly "Mark Letter" drawing-in-3-D-lesson newsletter. How can my child receive this letter?

The newsletter is actually my testing ground for new television episodes and book lessons. If the kids like the drawing lessons in the newsletter, I'll develop the ideas further for use on the show.

What can I do to encourage my child's artistic talents?

Draw with them, paint with them, computer-sketch with them, spend "art time" with them. You are their heroes. If you draw with them you establish art as a "cool" thing to do. Check out art books from the library, read biographies of famous artists aloud to your kids. Visit museums, the zoo, and the park with sketchbooks and pencils in hand. Read the next chapter for a dozen more ideas.

Why don't you produce a movie for kids? I'd take my children to the Saturday matinee to see it!

It's amazing how many people have encouraged me to make a children's drawing-in-3-D movie for theater release. I've been working on script concepts with my friend, film producer Robert Redford—I mean Robert Neustadt. After nine years of talking we feel the ideas have had enough time to germinate. We are aiming for next year.

Is your public television series *Mark Kistler's Imagination Station* available to schools on classroom video tapes?

Yes, schools may purchase thirty-six episodes edited for classroom use. Schools may duplicate this set for student library checkout, and additional teacher resource copies. Schools may also duplicate this video set for afterschool "latchkey" programs, "at-risk" programs, and for "home

schoolers." Schools are also encouraged to duplicate copies for local children's shelters, children's hospitals, and juvenile detention centers.

I am a student artist and would like to break into the commercial art market. Do you have any work for me?

For all you high school and college art students who want illustration work, there is a lot of demand for freelance material. I am approached weekly—if not daily—to illustrate projects. Fortunately, my teaching keeps me so busy that I can not accommodate these requests. However, I do give these businesses in need of artwork copies of student "art business cards." Take your favorite illustration piece to Kinko's, reduce it to 5" × 7", write your name, address, and phone number on the copy, and mail it to me at the address above, "attention freelance artist resource directory." I will include it in my freelance artist resource directory for businesses. Perhaps this directory will help you get paid for some of your art.

I am in a business that requires some freelance art work. Will you illustrate this project for me?

I rarely have time to personally illustrate freelance projects. But I have compiled a collection of "art business cards" from several of my very talented art students who would love to help you out. This "freelance artist resource directory" is an impressive collection of diverse styles and artistic abilities. If your business would like a free copy of this directory send a large SASE to my address above, "attention freelance artist resource directory."

Do you ever have guest artists and cartoonists on your television show?

Yes. I plan on inviting artists and cartoonists to guest-teach on future episodes of *Mark Kistler's Imagination Station.* I also plan on including several guest "How to Draw in 3-D" panels in future newsletters and books. If you would like to submit some "How to Draw in 3-D" panels, mail them to the address above, "attention guest artist panel."

I liked your parent and teacher chapter in your last book, *Mark Kistler's Draw Squad.* Are you going to include more ideas from teachers in your next book?

Yup, I sure am. I meet the most incredible teachers during my travels. These teachers are the most devoted, hard-working individuals you will ever meet. Many of them have graciously shared ideas and project plans that I have used in the previous chapters and in the following pages. Read on for more great ideas to help you keep your children artistically motivated.

Introduction to Appendixes B to E

One of the most rewarding benefits from traveling to over three-hundred schools each year is the opportunity to meet extraordinary teachers. These people are amazingly dedicated to the children. Most work twelve-hour days, through holidays, and spend their summers at curriculum meetings or taking graduate classes to strengthen their teaching and family counseling skills. I am so tired of people complaining that the crisis state of affairs in this country is due to lazy ineffective teachers in our public schools. For these ignorant complainers I make this challenge: Pick *any* public elementary school in the United States, pick *any* classroom in that school, then spend one day in that classroom with that teacher. It is your legal right as a taxpayer to do this. It is a simple matter of calling the elementary school's principal to arrange an appointment on an appropriate day convenient to the school's schedule.

On your appointment day, I challenge you to show up at the school when your "host" teacher does, usually an hour and a half early to conduct volunteer drama or chorus rehearsals with the kids, or to prepare their classrooms for the onslaught of twenty-eight enthusiastic, energetic children. An hour before school starts, duck into the cafeteria to grab a bite to eat with all the "breakfast bunch" kids (families who cannot afford to feed their kids breakfast, or for the kids whose parents have to be at work at 5 A.M.). Be sure to talk with the supervising teacher; ask them what time they have to show up on campus to make sure the kids are warm and safe inside the cafeteria. Next, ask the supervising teacher how many times a month each teacher in the school gets to mandatorily "volunteer" for this sunrise service. Now walk out to the front of the school and join the teachers on bus duty who have also been on duty forty-five minutes early to chaperon the kids arriving on the early buses. The fun part comes when you get to herd 750 kids in an orderly fashion through the school halls and into their classrooms. When you are passing the office, duck in to witness teachers in the office being social workers with troubled parents, abused children, and neglected pets which have followed the kids to school.

Now it's time for the classroom. Find a seat in a back corner and sit as still as you can. After a few minutes the novelty of a "guest" in the room will wear off and the kids will get back to normal. Observe over the next few hours as the teacher is constantly in motion between the chalkboard, the overhead projector, and all the students' desks. Watch with amazement as the teacher overcomes kids falling asleep because many parents don't have a disciplined bed time; as kids have emotional, sometimes violent outbreaks due to stress at home; as kids forget things taught the day before because their brother or sister were shot last night in a drive-by; as kids tell stories of being pressured to use and sell drugs as early as the fourth grade. Teachers relentlessly overcome these daily human tragedies to excite, enchant, entertain, and enthuse these kids about reading, history, math, and learning! Have you had enough? We haven't even gotten to lunch yet! Teachers get to rotate for lunchroom cafeteria supervision or playground supervision, then it's back to the classroom for more learning. Some teachers have the pleasure of an afternoon "prepatory" thirty-minute break, which is inevitably scheduled as a family crisis intervention counseling session.

Well, you've made it to the end of the classroom day, it's back outside for bus duty. Time to go home—*not!* Now it's time for supervising the afterschool "latchkey" and "at risk" programs, followed by school play rehearsals, or afterschool sports programs, then it's to the school's computer to print out next month's lesson plans for the 6:00 P.M. principal's meeting. Time to go home?

Almost. You just need to follow your host teacher to the PTA meeting as they discuss ways to fight the never-ending state budget cuts. Wait, you can't go home yet, you really should go with your host teacher to the city counsel meeting where board members are voting on further salary and hiring budget cuts. Okay, now it's time to go home. Just drop by the pet store and pick up food for the class pet rabbit, turtle, and fish.

A simple "one day" challenge to all of the teacher bashers in the country: seems easy enough. Oh, I forgot to mention that most teachers work these "lazy" twelve-hour days for less than $24,000 annual salary. Of course, this is only after being certified through

intensive five-year college degree programs, certificates that have to be kept current annually by additional college unit classes taken on weekends, holidays, and during the summer.

Besides the thousands of teachers I've meet during my travels, I also come from a family of teachers. My grandfather is a retired high school agriculture teacher. My stepfather is a retired high school history and psychology teacher. My mother is a nationally known high school health teacher, and a California state "Teacher of the Year" nominee. My older brother teaches the fourth grade in Santa Barbara, and his wife teaches at the college campus. My older sister has spent years teaching special education kids in Seattle. My younger brother teaches high school chemistry and physics, and my younger sister has applied to be a subsitute teacher while she pursues her doctorate degree in psychology in San Diego. I'm confident she'll end up in the classroom—it's where my family belongs. We've got teaching in our blood, and we are very good at it!

On the following pages I have reprinted some notes and lesson plans teachers have kindly shared with me. Originally I had chosen sixty-seven of the hundreds of pages I have accumulated over the last few years. As my manuscript began to exceed the three-hundred-page mark, I was forced to trim back—ouch! Editing this chapter down has been a very painful process. For all the teacher's notes that I had to pull out, I promise I will include you in my next book. Each of the teachers' "More Ideas" pages that follow will list an address so you can contact them directly. I urge you to do so. They are exciting people with exciting ideas.

I must add a special apology to Martyna Bellessis and Francie Agostino. These two art teachers from Indiana compiled a ten-page excerpt from their highly acclaimed children's art history books, *The ABC Artist Series*. I couldn't fit this exciting chapter in this book but I hope you contact them to purchase their books. They are delightful. Their address is: Martyna Bellessis, The ABC Artist Series, 818 Anthony Ct., Bloomington, IN 47401.

I also had to cut out many additional ideas submitted by Mike Schmid in his chapter, "There's More to Art than Drawing." I've included his address for you to contact him for a complete collection of ideas in his ingenious art-projects book. Mike Schmid is also the cofounder of the Ft. Wayne-based "F.A.M.E." organization (Festival of Art and Music in Elementary Schools). It's a grassroots festival that has expanded to include nearly 50,000 kids every year. F.A.M.E. rivals even the wonderful work done by the New York-based "Imagination Celebration" organization. Although he insists he is too busy to put together an information packet helping other states to start F.A.M.E. festivals, write him a letter and demand information. It's an awesome program that really deserves national attention. As if this isn't enough, Mike has also cofounded the Ft. Wayne-based children's cancer camp, "Camp Watcha Wanna Do!" Each year I look forward to working in the art tent with Mike, teaching these great kids art. If you really want to stress him out, write him a letter asking for information about how to establish a summer "Camp Watcha Wanna Do" for cancer kids in your city. Go ahead, he loves to get mail. One of these years Mr. Schmid is going to win the national art-educator-of-the-year award—you can bet I'll attend that N.A.E.A. conference! Keep up the extraordinary volunteer work, Mike, you're an inspiration to all of us.

Finally, I had to entirely cut my chapter called "Kids Drawing for World Peace." From all the material I had to cut from this book I already have nearly one hundred pages for my next book. While driving between speaking engagements in New Jersey, I heard a fascinating interview on National Public Radio with Colman McCarthy, a college professor. What an amazing interview! He travels all over the country teaching high school and college kids how to resolve conflicts peacefully. I pulled over on the toll way and found a pay phone. After tracking him down in Washington, D.C., he and his wife graciously shared a ton of information with me about his organization, and about several others that focus more toward the elementary kids. If you would like an organization listing, send them a letter: Mr. & Mrs. McCarthy, Center for Teaching Peace, 4501 Van Ness St. NW, Washington, DC 20016.

Appendix B

More Ideas from Kimberly P. Kiddoo, Ph.D., Psychologist/Parent

My own interest in drawing took root the day my four-year-old son, Cristopher, collapsed into a heap of giggles while viewing a Mark Kistler drawing program (1). In between giggles, he would come up for air and manage to do some actual drawing. Peeking over his shoulder, I noticed some overlapping, contour lines, a little foreshortening, and lots of shading. This was new. Hm-m-m-mm—there was no one else in the room. Smiling invitingly, he handed me a pencil, and as I sat down to draw with him, it dawned on me that he didn't think we were "learning how to draw." He thought we were having fun.

Cristopher is five now, and in the few months since that first afternoon, drawing together has become a special part of our lives. We draw before he goes to bed at night and sometimes first thing in the morning. We draw in restaurants while waiting for food and in the car on a trip short or long. He reminds me where the car is parked.

Drawing is a window to my child's thoughts and feelings, his dreams and concerns. And it is a great equalizer between us—for while an adult's hand does more of what the eye sees, a child's ability to draw from his imagination and be creative with stories and games while drawing is remarkable. So while I encourage him to draw what he sees, he encourages me to draw what I don't see (that is, from my imagination). It has not occurred to him that there might be something he cannot draw. He fills blank page after blank page with imaginary figures, images from his memory, objects around him, or action scenarios, chatting away about the story as he draws. I, on the other hand, having only recently abandoned stick figures, am astounded when my drawing looks as I intended. Drawing together is a new experience every time and is a context in which we can individually express ourselves while interacting creatively.

I am grateful for this time together, grateful that my son found "his thing" and that we can share it. I look at him totally absorbed and at one with himself as he draws, or wiggling up and down as he figures out something in his head. I see the joyous spark of discovery in his eyes or the slow smile of satisfaction as it all falls together inside and on the paper. I know he is learning lifetime skills, attitudes, and habits that will serve him well.

There is evidence that increased drawing skill improves overall academic achievement (4, 16), not to mention the rise in self-esteem that accompanies skill development. This might be particularly true for the so called spatial child (6, 1, 2) or the visually gifted (8) child. Many people have a primarily visual mode of information processing (3, 10, 14). Architects, scientists, and engineers would fit into this group. Drawing involves complex cognitive activities, such as identifying underlying patterns, seeing new combinations, and creative problem solving. Children who think and learn visually process information primarily through images rather than through words. These children produce drawings that indicate detailed observations of the world and a much greater understanding than they would be prone to verbalize. Talking with children about their drawings gives them practice in translating their visual thinking into the verbal mode, as well as the reverse.

Children's drawings are an important aspect of self-expression and self-affirmation. They literally create and discover their thoughts and feelings as they work out their ideas on paper.

Guidelines for Parents

1. **Be a good example.** Independently of what we say, our children will model after us. Develop your own drawing skills, verbalize your problem solving as you go along ("How can I make this look more rounded?"), delight in your successes, and talk about your feelings or tell a story as you draw. Give drawings as messages or gifts. Show how a 'mistake' can be an opportunity to learn or create something new. Wonder out loud about how to accomplish something in your drawing, and let your child help you. You might be surprised—I was!

2. **Provide a wide variety** of drawing materials and resources. There are dozens of books and videos available that demonstrate different ideas. Have lots of paper and pencils handy. I keep a sketchbook and pencil handy in my car and purse. The local discount office supply store sells 5000 sheets of photocopy paper for only $15.00.

3. **Draw together as a family.** Drawing is something that can be done by all members of the family at all ages. It can be a special time for sharing that adds a creative and unique dimension to your family life. Work on a picture together; draw a family album; film your own how-to-draw video with your Camcorder; write and illustrate story books.

Try drawing from pictures of sculpture or art from books. Give visual descriptions of objects or pictures to other family members as they draw. Photocopy and assemble your child's drawings into a coloring book so he can color in or experiment while preserving the original. Encourage the children in your neighborhood to have a gallery opening of their drawings or have a family gallery open-house party.

4. **Expose your child to a wide variety of visual images.** Place various examples of visual art at eye level around your house. A 9-by-12 laser print copy from an art history book can cost as little as $1.50 and can provide a variety of visual images to stimulate your child's imagination and aesthetic sense. Point out how artists develop and change over time (Cézanne, Picasso, Kandinsky) or how many different ways there are to draw a star (Miró, van Gogh). If your young child can say, "That's how I draw it" (anything!) in response to another child's criticism, you are encouraging healthy validation of self in the process.

5. **Collect, keep, and display your family's drawings.** Date them in pencil or write an identifying note on the back. They will be a valuable record of the progress of your child's cognitive and psychological development as well as cherished memories for him. Skip the front of the refrigerator and professionally frame the ones you and he like the most. Hang them in your living room or office.

6. **Finally, don't push the river.** Children will engage in different kinds of drawing at different times. They will shift from expressive to realistic to fantasy/imagination to drawing from memory or from objects in front of them. All of these have a time and a place. Very young children will often draw spontaneously from their own inner world, while older children are more concerned with drawing realistically. Be guided by your child's need. The act of drawing is in itself valuable, independently of the product, so do not feel you must judge, evaluate, criticize, or even praise your child's drawings.

Helpful comments include those that increase or validate a child's sense of ownership and internal locus of evaluation. Tell him you like how he focuses his attention, uses his imagination, or follows through on a project. If you value these things, he will value them also.

Mark Kistler's program, in particular, inspires children (and adults) of all skill levels to get their ideas down on paper, use their imagination, be creative, think positive, and feel good about themselves as they increase their drawing ability. The principles are presented in the spirit of adventure, fun, and enthusiasm within a nonjudgmental context that encourages maximum effort and learning.

Thank you to Mark Kistler for having a vision and following it with integrity, intelligence, and the inspiration born of love for children. May all children have the opportunity to feel themselves the little creative geniuses they are meant to be.

Notes

1. Armstrong, Thomas (1993). *Seven Kinds of Smart: Identifying and Developing Your Many Intelligences.*
2. ———— (1987). *In Their Own Way: Discovering and Encouraging Your Child's Personal Learning Style.*
3. Arnheim, R. (1969). *Visual Thinking.* Berkeley: University of California Press.
4. Brooks, Mona (1986). *Drawing with Children.* Los Angeles: Jeremy Tarcher.
5. Bunchman, J. and S. B. Briggs (1994). *Pictures and Poetry.* Worcester: Davis Publ.
6. Dixon, J. P. (1983). *The Spatial Child.* Springfield, Ill.: Charles C. Thomas.
7. Edwards, Betty (1979). *Drawing on the Right Side of the Brain.*
8. Eisner, E. W. "The Role of the Arts in Cognition and Curriculum." *Phi Delta Kappan,* Sept. 1981, 48–52.

9. Hurwitz, Al (1983). *The Gifted and Talented in Art: A Guide to Program Planning.* Worcester: Davis Publications.
10. Jarrett, Cristopher Kiddoo. Private conversations, 1993–94.
11. Kiddoo, Kimberly P. (1978). Factor Analysis of Imaging and Cognitively Related Personality Variables. Unpublished doctoral dissertation. University of Missouri, Columbia.
12. Kistler, Mark (1988). *Mark Kistler's Draw Squad.* Adventure One, "Escape of the Twinkies." New York: Simon and Schuster.
13. Lowenfeld, Viktor (1987). *Creative and Mental Growth.* New York: Macmillan.
14. Olson, Janet L. (1992). *Envisioning Writing: Toward an Integration of Drawing and Writing.* Portsmouth, N.H.: Heinemann Press.
15. Silberstein-Storfer, Muriel (1982). *Doing Art Together.* New York: Simon & Schuster. (Currently out of print but may be obtained from the Metropolitan Museum of Art in New York.)
16. Thompson, Richard (1988). *Draw and Tell.* Annick Press.
17. Welter, Paul (1984). *Learning from Children.* Available from the author: P.O. Box 235, Kearney, NE 68848.
18. Williams, R. M. "Why Children Should Draw: The Surprising Link Between Art and Learning." *Saturday Review,* September 3, 1977.
19. Wilson, B., A. Hurwitz and M. Wilson, (1987). *Teaching Drawing from Art.* Worcester: Davis Publ.

Appendix C

The Art Time Line

More Ideas from Tina Arndt and Jennifer Bucher

As art educators, we strive to create lessons that call on the imaginations of our students as well as expose them to various media and processes. We have found that introducing students to the art time line helps to focus their creativity in a meaningful way. Students become aware of the place of art over the centuries and are intrigued by the people and places involved in its creation. Through activities, lessons, and imagination, students can pretend to travel back in time to be a part of history. Our students are able to make cross-curricular connections and are aware of the arts—where they were, where they are now, and where they will be in the future.

Tina Arndt is in her fourth year of teaching at Whiteford Elementary in Sylvania, Ohio. She is currently finishing work on her master's in art education.

Jennifer Bucher is in her third year of teaching at Stranahan Elementary in Sylvania, Ohio, and has taught youth art classes at the Toledo Museum of Art. She is currently finishing work on her master's in art education.

Old Stone Age

Project
"It's O.K. to Draw on the Walls"

Materials
Cellu-clay (pre-mix according to package directions), water-soluble crayons, water containers, paper towels, sketch paper, pencil, cave-art visuals, flashlight.

Motivation
1. Begin lesson by turning off lights and turning on flashlight to create a cavelike atmosphere.
2. Have students discuss life in the cave (food preparation, daily activity, communication, survival, art materials). Turn on lights.
3. Show visuals and discuss the significance of the art work to the caveman. (Paintings were done prior to the hunt to capture the animal's spirit.)
4. Discuss the process of creating art materials and animal images (paint made by mixing animal fat with various pigments, including blood, crushed vegetation, and minerals; brushes made using animal hair, bones, sticks, and stones).

Procedure
1. Have students practice sketching animals from prehistoric times. The animal should be a type hunted during the Stone Age (bison, deer, horse, mammoth, boar, antelope).
2. Pass out palm-size pieces of Cellu-clay on a paper towel. Have students flatten to pancake thickness. Encourage irregular shape to suggest cave wall.
3. Use sketch as guide to create animal image using water-soluble crayons on moist Cellu-clay.
4. Set aside to dry 3–4 days and remove from paper towel.

Further Suggestions

1. Mount cave art on crumpled brown paper.
2. Mount cave art on or near student-made caveman signature. (During prehistoric times, cavemen signed their names by placing their hands on the wall and blowing paint through a hollow bone to create a negative image of their hands.)

Egyptian

Project

"Me and My Mummymobile"

Materials

Hieroglyph chart and books (e.g., *Mummies Made in Egypt* by Aliki), 3 × 16 paper (paper with texture looks best because it resembles papyrus), black crayon or marker, 6 × 9 white paper, long strips of colored tissue paper, yarn, paper punch, toilet paper.

Motivation

1. Choose three students from class, a mummy and two wrappers.
2. While reading the book *Mummies Made in Egypt* out loud, have wrappers pretend to go through the mummification process using toilet paper as mummy linens.
3. Discuss hieroglyphs. Hieroglyphs were the symbols or letters of ancient Egypt. Each symbol represented the object pictured or certain consonant sounds. There are over seven hundred different hieroglyphs. (How many letters do we have in our alphabet?) Few Egyptians could read or write. Can you imagine trying to learn seven hundred symbols and put them together to form sentences? A few boys were intelligent enough to become scribes, the official writers of Egypt. This was a chance to escape serfdom and possibly become a government official. The scribe's writing tools consisted of a pen case, a jar of water, palette, red and black ink cakes, and string to connect everything for easy carrying. There is even a hieroglyph for a scribe.

Procedure

1. Fold 6 × 9 white paper in half the tall way and draw half a mummy on the fold. Cut mummy out.
2. Using black crayon, draw lines representing the linen wrappings on both sides of the mummy.
3. Have students write hieroglyphs on the length of the 3 × 16 paper in black crayon or marker.
4. On the back of the 3 × 16 paper, students can glue strips of tissue paper (you may want to use the traditional Egyptian colors of turquoise, red, and gold).
5. Staple 3 × 16 paper end to end with the hieroglyphs on the outside so it forms a ring.
6. Punch three equally spaced holes in the ring and one in the mummy's head. Tie three short pieces of yarn on the ring and one longer piece on the mummy so that all four strings can be brought together in the center so the mummy hangs down. This is the means to hang the mobile.

Further Suggestions

Have students create modern hieroglyphs!

Greek

Project

"Lovely Ladies"

Materials

6 × 36 white paper (or smaller), pencil, water colors, tempera paint, colored pencil (teacher's choice), scrap paper, 8½ × 11 white paper, heavy book (dictionary, encyclopedia), visuals of the Porch of the Maidens, Greek temples, capitals, and Greek dress.

Motivation

1. Begin lesson by choosing a student to stand in front of the class while holding a heavy book on top of his/her head. Give no explanation of this.
2. Discuss elements of Greek architecture: pediment, columns, capitals (Doric, Ionic, and Corinthian). Show visuals of temples displaying these features. Show visuals of the Porch of the Maidens.
3. Discuss how the columns were used to support the weight of the building.
4. Ask student volunteer how he/she is feeling at this point (answers will vary—tired, stiff neck, sore arms). Have student sit down.

Procedure

1. Ask students to imagine that they are a caryatid. It has been their job over the past 2,500 years to have a capital on their head and to support the building. (What would they feel like? What have they seen over the past 2,500 years? What occurred that made bits and pieces of them fall off? How has the world changed?) Write ideas on scrap paper.
2. Students should draw their interpretation of a caryatid on the 16 × 36 paper. The caryatid should be dressed in Greek-style clothing and must have a Doric, Ionic, or Corinthian capital upon its head.
3. Students should add color and shading, using the teacher's choice of materials. Cut out when finished.
4. Have students write a descriptive paragraph from the viewpoint of the caryatid, using the ideas from their scrap paper.

Further Suggestions

1. Display caryatids with creative writing mounted on 11 × 14 colored paper. Decorate border paper with Greek-style pattern as time allows.
2. Have a Greek banquet! Dress in togas, have an Olympics, play Greek music, and serve Greek foods.

Medieval

Project

"Dragons à la Carle"

Materials

Various sizes of white paper, tempera paints in assorted colors, newspaper, objects and gadgets to be used for experimental painting (sponges, toothbrushes, combs, corrugated cardboard, paper towel rolls, yarn, craft sticks), styrofoam meat trays to be used for paint, *Dragon's Dragons* by Eric Carle.

Motivation

1. Share pictures of dragons in Eric Carle's book *Dragon's Dragons*. Point out his use of painted papers assembled to create a whole image. Ask students how they think the art work was done (printing, painting, with what objects).
2. Discuss the dragons of the Middle Ages (what they were like, the legends, and battles with knights). Have students name some of the parts of a dragon (eyes, nose, claws, tail, wings, fire, scales, polka dots).

Procedure

1. Cover tables with newspaper and students with paint shirts, and set up several paint stations. Each station should have two or three like colors of paint, tray of painting objects, and a stack of white paper.
2. Show students how to manipulate different tools at each station to create a variety of effects.
3. Student should move around the room, creating a painting at each center. Remind them to paint all the way to the edges of the paper.
4. Set papers aside to dry, and clean up.
5. When papers are dry, students will use them to create a background with the larger pieces and a dragon with scraps. Encourage sharing and stress the layering of pieces to add details (eyes, wings, nose, teeth, toenails, patterns).
6. Don't forget to place the dragon in an environment! This gives the dragon à la Carle extra personality.

Further Suggestions

Illustrate a story (individual or whole class) in the style of Eric Carle.

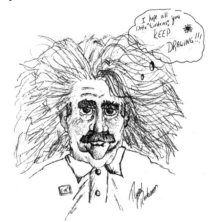

Renaissance

Project

"Marvelous Michelangelo"

Materials

Visuals of the Sistine Chapel, 12 × 12 white paper, masking tape, pencils, crayons or color pencils, simple drawing with holes poked along contour, chalk.

Motivation

1. Show pictures of the Sistine Chapel. Try to show the whole ceiling, close-ups, and pictures taken since it has been restored.
2. Discuss Michelangelo's background and work on the chapel ceiling. Michelangelo enjoyed creating sculpture, not painting, but Pope Julius II asked him to do the ceiling. He worked sixty-eight feet up on scaffolding every day for four years. He worked alone, having food sent up, and climbed down only to sleep. The hardest part was bending backward to work on the ceiling. He became so accustomed to this position that when he read, he would also bend backward.
3. The Sistine Chapel's ceiling illustrates a story. Michelangelo created the images a section at a time, starting with a *cartoon* (sketch) that he poked holes in and then blew chalk dust over to get the drawing on wet plaster. He then painted on the wet plaster, a technique called *fresco* painting.

Procedure

1. Demonstrate how the cartoon would work with the simple drawing with holes.
2. Have students imagine that they are Michelangelo and that you are Pope _____ and have just hired them to do a ceiling mural. In order to help students relate to Michelangelo, tell them that they will be working from underneath their desks.

3. Tape paper on the bottom of desks.
4. Students should think of a story they have read, seen, or made up to illustrate.
5. Once they are ready, students should position themselves under the desk and begin to draw. (Caution. Remind students not to erase right above their faces!)
6. When students are done illustrating, they are ready to color with your choice of materials.

Further Suggestions

1. Have each student create a section of a story to create a mural. Display this on the ceiling.
2. Wear paint shirts and have students try to paint with watercolors under the desks.

Appendix D

More Ideas from Vicki Sheridan

Teaching art at Turkeyfoot Elementary School in Coventry Township, Ohio, has been very rewarding. An activity I love to do with my fourth-graders starts on the first day of school. The students are told that I am a multibillionaire and they are now architects. I have decided that I want to build a city, but I will need an architect. How convenient that I have a room full of architects in front of me! The catch to the story is, only the architect with the best design will be hired for the job. This person will not only get the two-billion-dollar contract but also the penthouse apartment and a little red sports car. After they draw their city, I collect the drawings and put them away.

We spend the next few art classes discussing and drawing 3-D shapes such as cones, spheres, cubes, and cylinders. There is also emphasis on shading the objects. I then give the same city assignment, except that it is to be drawn in 3-D. We discuss the design, the light source, and contour lines. When the project is completed, the long-forgotten first attempt is brought out of hiding. The students may now compare their drawing abilities from the first week of school as against several weeks later. The reaction of the students is priceless: "I didn't draw that!" "This is embarrassing!" "That's not mine!" Every child sees a one hundred percent improvement. Their excitement and feelings of success show on their faces. These children will never draw the same again.

It is very rewarding not only to the students but also to myself. Mark Kistler's lessons really reinforce my own 3-D lessons and show the students that *the sky is the limit.*

Vicki Sheridan
Art Teacher
Turkeyfoot Elementary School
Coventry Local Schools
Akron, Ohio

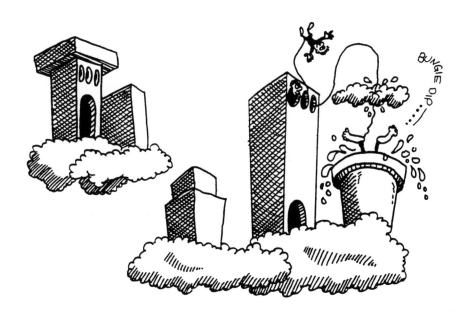

Appendix E

There's More to Art Than Drawing

More Ideas from Mike Schmid

Three-dimensional art, statues or sculpture is as old as drawing! At the same time early people were drawing on cave walls, they were also making clay statues and pottery, and carving stone, wood, and bones into beautiful objects. As humans became more civilized, the quality of their work improved. People from different parts of the world made up different ways to make three-dimensional images (statues). The artists who invented these processes were the leaders in technology of their time. If it weren't for the artists, many of the things we use today would not be here!

This appendix is about three-dimensional projects that you can do at home. Some of them require help from a parent and you SHOULD NOT try them without help. Some of them are simple kinds of things you can do on your own with no help. I tried to put together some projects from different parts of the world and included some important information about them.

There are lots of other books published that have great ideas about different kinds of sculptural projects you can do! Check with your art teacher or go to the library. Librarians are usually really cool people that really like helping people find stuff. If you tell them what you want, they can probably find you a book that will help!

Words that you should know:

Sculpture—Any type of artwork that you can walk around and see different sides. Statues are one form of sculpture.

Relief—A type of sculpture that is flat on the back, a picture that is carved out and from the background.

Papier-mâché—A type of glue that holds paper pieces together. Wallpaper paste works best.

Kachina Dolls

Kachina dolls come from the Pueblo Indians. The Pueblo are a nation of Native Americans who live in the southwestern United States. Their history extends far before Columbus "discovered" America for the Europeans! In many of their ceremonies, men dress as kachinas and act the parts of the supernatural beings they represent. These kachinas are like spirits or saints. They are not worshipped, but they are used to teach the history and culture of the Pueblo, Hopi, and Zuni Indians. To Hopi children, some kachinas are like Santa Clauses who bring them gifts of kachina dolls. These dolls are hung throughout the house as reminders to the children. You can find many pictures of kachina dolls in your school or public library. Just ask the librarians about them and they will be happy to show you many books on kachina dolls.

Kachina dolls are usually carved out of wood, but this project has you making them out of wire and papier-mâché. You can fashion yours after one you find in a book, or make up your own.

You will need the following materials:

1 coat hanger (the easy-to-bend kind)
1 pliers are helpful but not necessary
1 4-inch block of wood
1 2-inch nail
1 hammer
 masking tape
 newspaper

papier-mâché paste
construction paper scraps
extra stuff like feathers, beads, cloth scraps, *fake* fur scraps

You should have a parent or an older brother/sister to help with the first part.
Steps:

1. Take your hanger and play American Indian (bow and arrow) and stretch the hanger out! (See figure 1.)
2. Take hold of the loop end inside your fist and bend it over. The pliers might help bending the ends together. (See figure 2.)
3. Take hold of the loop end in one fist and the hook in the other, and push them together. Use the pliers to bend the ends of the arms together. (See figure 4.)
4. Pound your nail all the way through the block of wood.
5. Bend your figure's arms and legs into positions you like.
6. Tape one leg to the nail so that your figure is standing up.
7. Crumple some newspaper and fit between wires. Put a ball of paper in the hook for a head. Use small wads of wet paper to form feet, hands, facial features, or whatever you want.
8. Cover with strips of newspaper dipped in papier-mâché paste, wrapping them around as if you are putting a cast on a broken arm.
9. Let dry overnight.
10. Cover with colored construction paper strips dipped in papier-mâché paste. These can be applied in patterns so that there will be no painting required.
11. Let dry overnight.
12. Glue *extras* on, things like feathers, beads, dry beans, dry rice, small stones, fur, cloth scraps . . . whatever you can find.

Daruma Doll

These dolls are like larger versions of the Weeble Wobble People! You can tip them but they won't stay down! They are named after the ancient Buddhist priest Bodhidharma. Bodhidharma sat meditating and praying for so long, his arms and legs disappeared! Even without his arms or legs, he still traveled all over China teaching. The Daruma doll represents the strength of his will to succeed in spite of his physical challenges. In Japan, the Daruma doll is a good-luck charm, sort of like a rabbit's foot! Japanese people buy them at the beginning of the year to bring good luck.

Some types can be used to make a wish come true. These types don't have an iris in their eyes, only the white part! To make a wish come true, you need to make the wish while you paint or draw in one iris. When your wish comes true, you paint in the other iris.

There are lots of great books on making Japanese art. One really good book is *Matsuri: Festival, Japanese American Celebrations and Activities,* by Nancy K. Araki and Jane M. Horii. You should go to the library and ask the friendly librarian to help you find a book that will help you learn more about the Japanese and their art!

To make a Daruma doll you will need:

1	small paper sandwich bag
	masking tape
	newspaper
	papier-mâché paste
6″	real heavy yarn
	red construction paper scraps
	white construction paper scraps
1	cup plaster of Paris or a stone the size of a plumb

The whole process will take at least two days, so be patient!

Procedures

1. Start by stuffing a couple of loosely crumpled sheets of newspaper into your lunch bag.

2. Tape down the flaps and wrap the corners to make it sort of round. This should make it about the size of a grapefruit.

3. Using long strips of newspaper dipped in papier-mâché paste, wrap the stuffed bag with a layer.

4. Using strips of red construction paper dipped in papier-mâché paste, cover with a layer.

5. Alternate between newspaper and construction paper, covering with layers until you have at least five layers. End with a layer of red.

6. Decide where the face is going. Fasten a circle of heavy yarn around where the face is to be and cover with a couple of layers of red paper.

7. End with a layer or two of white construction paper in the face area.

8. Paste two small wads of paper for the eyes.

9. Let dry a couple of days.

10. When totally dry, cut a large hole in the back of the doll and tear out the newspaper inside it.

11. Pour the mixed plaster of Paris into (or tape the stone inside) the doll. Let the plaster set up about thirty minutes.

12. Close up the hole in the back and use construction paper and papier-mâché paste to cover the hole.

13. Paint on one eye (while you make your wish) and the rest of the face.

14. When your wish comes true, paint in the other eye.

Kachina Dolls

1. Pull hanger straight

2. Grab end fold over

3.

4. Grab ends Push together

5. Head arms Legs

6. Pound a 2" nail though a 4" square of wood

7. Bend arms and legs, Tape to nail

8. Stuff crumpled news paper between wires and wrap with news paper "maché" Strips 2-3 Layers

9. Use small scraps of color construction paper and paper maché to cover

Daruma Dolls

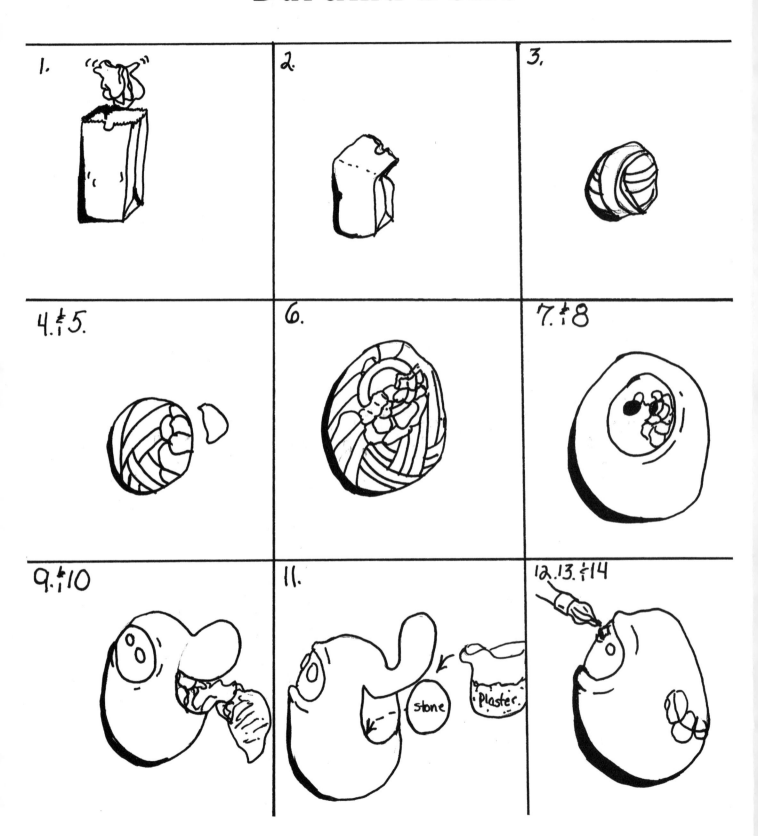

1.

2.

3.

4. & 5.

6.

7. & 8

9. & 10

11.

stone Plaster

12. 13. & 14

If you like these project ideas, you're going to love ''Mike's Educators Packet.'' This package includes ideas for home and classroom projects. The projects are all written with information about the historical context from which they came. There are two- and three-dimensional projects that are easy, fun, and educational. For information on how you can get your package, send a self-addressed *stamped* envelope to Mike's Educator Package, 2732 Eastbrook Drive, Fort Wayne, IN 46805-1902.

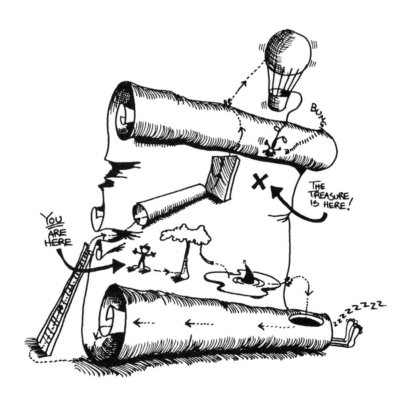

About the Author

Over the past sixteen years Mark Kistler has taught millions of children how to draw in 3-D at over five thousand elementary school assembly workshops around the world, including Australia, Germany, England, Scotland, Mexico, and the United States. His starring roles as Commander Mark and Captain Mark in the hit children's public television series *The Secret City, The Draw Squad,* and *The New Secret City Adventures,* have been viewed in eighteen countries with over forty million viewers. His most recent self-produced public television series, *Mark Kistler's Imagination Station,* is currently airing on nearly one hundred PBS stations nationwide.

Mr. Kistler has written and illustrated many popular children's drawing books, including *Learn to Draw with Commander Mark* and *Mark Kistler's Draw Squad.* As a result of his television series and drawing books, Mark Kistler has generated over one million letters containing 3-D drawings from children around the world. Mark deeply believes that learning how to draw in 3-D builds a child's critical thinking skills while nourishing self-esteem. His positive messages on self-image, goal setting, dream questing, environmental awareness, and the power of reading have inspired millions of children to discover their awesome individual potential.

When Mark is not waiting for connecting flights at airports, he enjoys sailing his Catalina sloop in the blue Pacific waters off the coast of sunny southern California. Mark lives in Carlsbad, California.

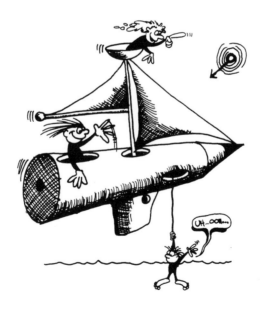